THE Everything ART HANDBOOK

Walter Foster

Quarto is the authority on a wide range of topics.
Quarto educates, entertains, and enriches the lives of our readers—
enthusiasts and lovers of hands-on living.
www.quartoknows.com

Artwork and photographs on page 6 (top right) © Nolon Stacey, (bottom left) © Elin Pendleton; page 10 courtesy of Laguna Art Supply Store; pages 12 ("Taboret"), 128, 174 (top, bottom right), 180-181, 192, and 194-199 © Joseph Stoddard; pages 12 (bottom), 13, 14 ("Drawing Board"), 19-21, 27-28, 29 ("Marker"), 30-34 (except electric sharpener), 38-39, 48, 49 (except bottom left), 56, 57 (bottom left), 59 ("Colored Pencil Techniques"), 66-67, 74-77, 79 ("Pen & Ink Techniques"), 130-137 (except "Fabrics" on page 131), 139-140, 142 ("Setting Up a Palette"), 145 ("Frisket"), 160-161, 175 (except "Pans"), and 176-179 © Elizabeth T. Gilbert; page 16 ("Aluminum watercolor easel") courtesy of Alvin & Co. www.alvinco.com; page 18 © Carol Rosinski; page 22 (bottom left) © Joanna Mendoza; pages 22 (top, bottom right), 23 (top right), 50 (top), 51, 55 (top), 57 (top, bottom right), 78-79 (except pen & ink techniques), 80-81, and 94-111 © Jim Dowdalls; pages 24, 117, 123, and 126-127 © William F. Powell; page 29 ("Graphite Pencil") © Kate Lehman (www.katelehman.net); page 35, 37 © Jacob Glaser; page 36 © Christopher Speakman; pages 40-41 © Steve Pearce; pages 42-43 and 59 (still life) © Cynthia Knox; pages 23 (bottom left) and 44-47 © Jennifer Gennari; page 46 ("Libyan Sibyl") © Lance Richlin; page 50 © Huy Huynh; page 55 (bottom) © De Tran; page 59 (water wheel) © Pat Averill; pages 60-65 © Eileen Sorg; pages 68-73 © Alain Picard; pages 82-93 © Laura Lavender; pages 112-113, 115, 125, 184-185, and 200 ("Lighting the Subject") © Brenda Swenson; page 114 (top, bottom left) © Barbara Fudurich, (bottom right) © Scott Burdick; page 116 and 164-165 © WFP; pages 118-119 © Debra Kauffman Yaun; pages 120-121 and 142-143 (except "Setting Up a Palette") © Nathan Rohlander; page 122 © William Schneider; pages 121, 145 (except "Frisket"), and 146-147 © Tom Swimm; page 131 ("Fabrics") and 141 © Patti Mollica; pages 6 (top right) and 144 © Lori Lohstoeter; pages 182-183 © Pat Averill; pages 148-155 © Varvara Harmon; pages 156-159 © Alicia VanNoy Call; pages 166-169 © Marcia Baldwin; pages 170-173 © Glenda Brown; 186-187 © Paul Talbot-Greaves; pages 188-191 © Deb Watson; pages 200-201 ("Making Elements Pop," "Analogous Color Scheme") © Geri Medway, ("Complementary Color Scheme," "Triadic Color Scheme," "Tetradic Color Scheme") © Joan Hansen, ("Split-Complementary Color Scheme") © Rose Edin; pages 202-209 © David Lloyd Glover; pages 210 and 218-221 © Jennifer McCully; pages 214-215, 222-229, and 232-239 © Cherril Doty and Suzette Rosenthal; pages 216-217 © Cherril Doty & Marsh Scott; pages 230-231 © Linda Robertson Womack. All other images © Shutterstock.

Cover Design: Melissa Gerber
Page Layout: Ashley Prine, Tandem Books

6 Orchard Road, Suite 100
Lake Forest, CA 92630
quartoknows.com
Visit our blogs at quartoknows.com

Printed in China
1 3 5 7 9 10 8 6 4 2

THE Everything ART HANDBOOK

TABLE OF CONTENTS

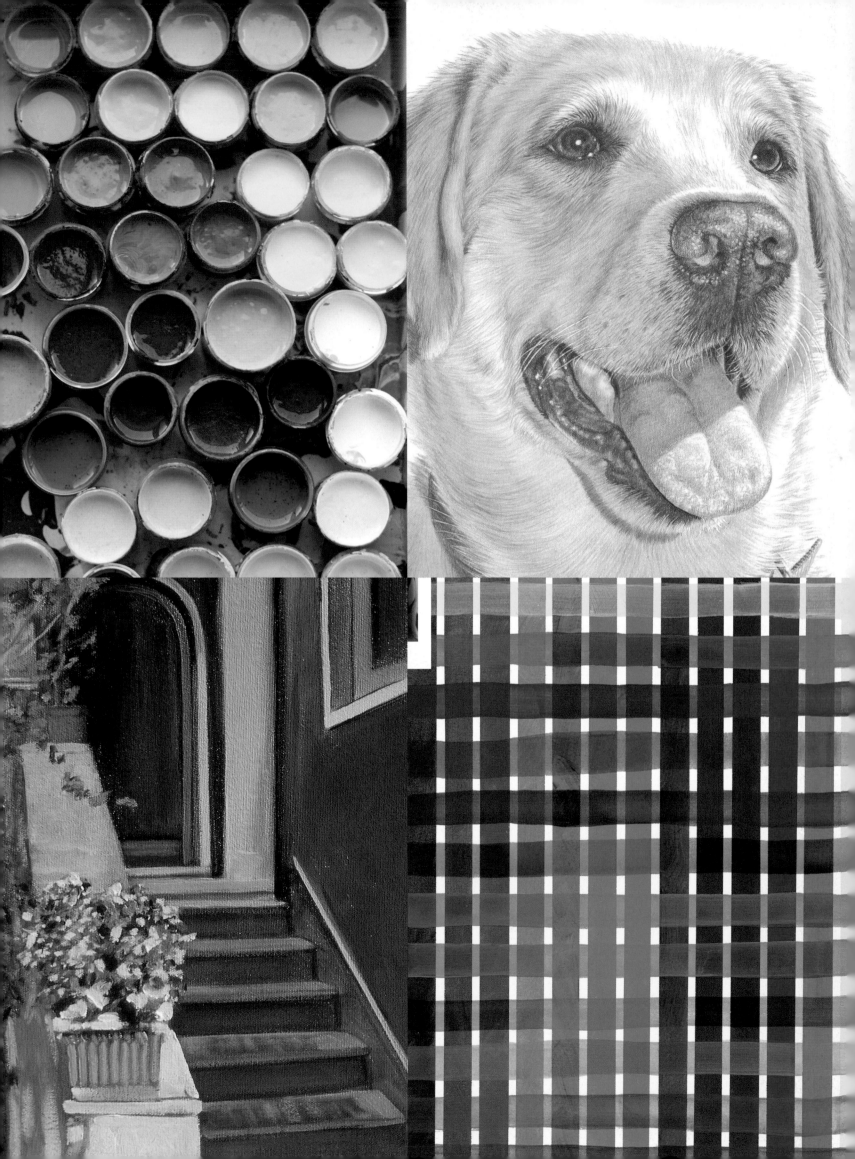

INTRODUCTION

"I work in whatever medium likes me at the moment."

—Marc Chagall

For some people, art is a luxury to be enjoyed as decoration or pursued as a hobby. For others, art is essential, quenching a thirst for expression in a way no other outlet can. Regardless of the function art serves for us, we could all use a little more of it in our lives than we usually allow.

The Everything Art Handbook is for those who want to try their hand at art, but may not know where to begin. The world of art can be daunting for beginners, but this basic, all-inclusive resource will help aspiring artists find the right path to begin their artistic journey.

This book is also for experienced artists who may want to delve into a new medium for the first time. Are you a master of graphite pencil drawing, but you've always longed to work with color? Try your hand at colored pencil or pastel—or maybe even dabble with acrylic or watercolor. Bored with the traditional art forms? Mixed media may be the modern approach you need to drive your artwork forward.

The Everything Art Handbook is divided into five sections to help you explore the basics of each art form and decide which medium fits your interests best. Each section provides an introduction to each medium, from introductory tools and materials to basic techniques—and how to use those techniques in step-by-step projects and artwork.

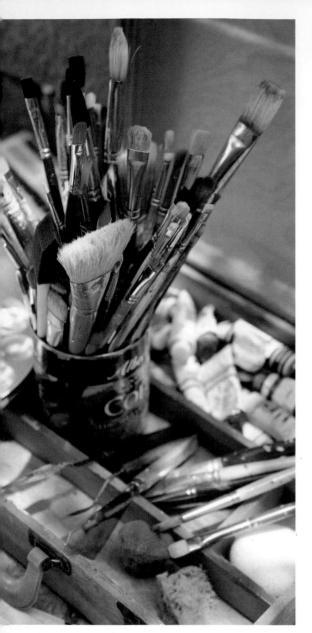

GETTING STARTED

Few things excite artists more than the sensory experience of art—the smell of an old studio, the buttery feel of oils under a palette knife, the velvety strokes of a charcoal stick, or the juicy splatters of fresh watercolor paint. The materials alone hold a special place in the hearts of artists, representing possibility, adventure, and a chance to live fully in the moment.

Artists of today are treated to the most accessible and diverse scope of materials ever available. With such breadth, however, beginning artists are at risk of overlooking essentials or failing to understand the nuances of their tools. Beginners can use this section to jump-start a collection of materials, and seasoned artists can use it to expand their studios and push beyond their comfort zones. Ultimately, the goal is to give you the knowledge and power to most effectively and efficiently express yourself through art.

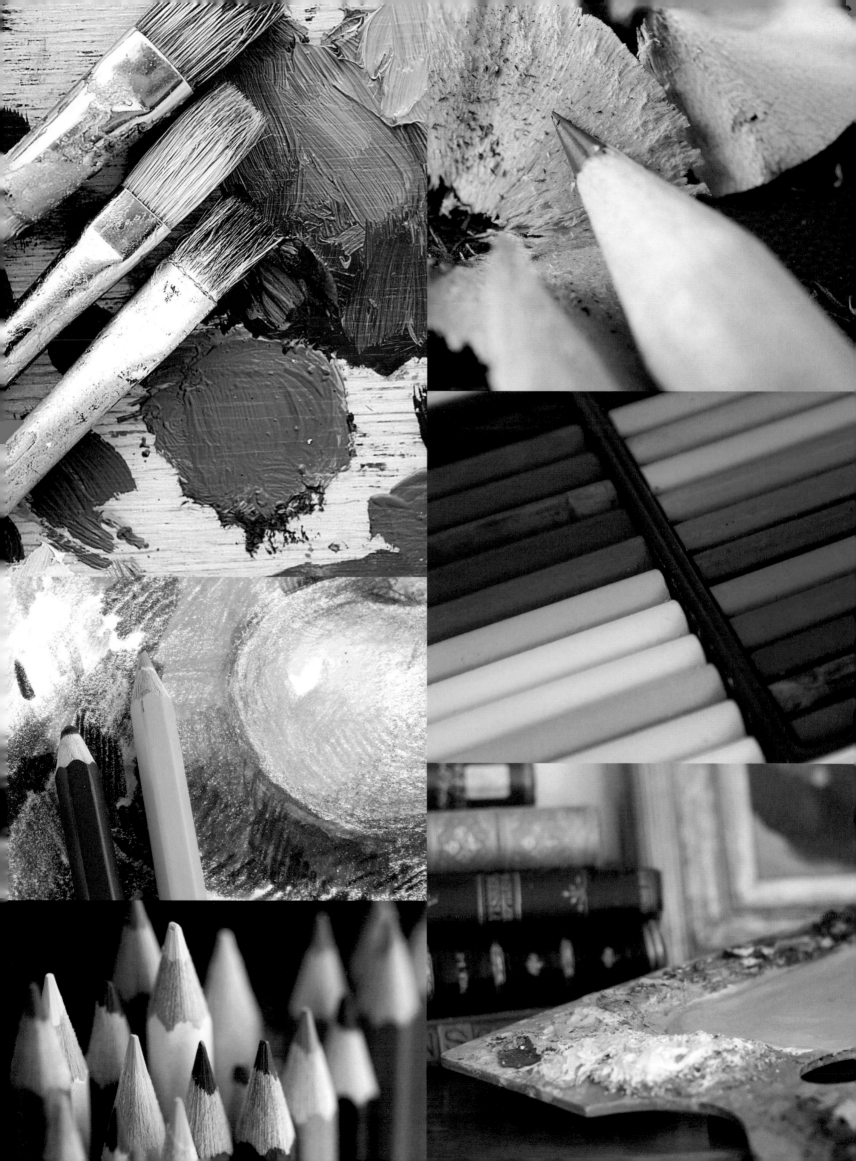

SETTING UP A STUDIO

Designating a space for making art is a great way to stay organized. However, many of us are limited when it comes to space and resources, and we must work with what we have. More than anything else, comfort, convenience, and good lighting—not expansive space or fancy equipment—are the most important elements of an effective workspace.

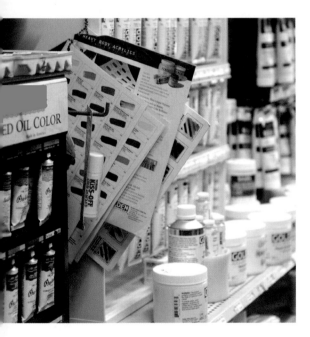

PURCHASING MATERIALS

Access to art supplies is easier than ever for today's artists. Below are a few ways you can expand your own studio. Remember that higher-quality materials yield higher-quality results and less frustration for the beginner, so purchase the best you can afford.

Art & Craft Stores

Seeing rows and rows of materials just waiting to be used provides instant exhilaration for most artists. Art & craft stores, which carry many of the basic art materials found in this book, offer a tactile experience, allowing you to hold the materials in your hand and see true pigment colors before purchasing. Chain art stores are predictable in what they carry and sometimes lean toward the hobbyist, providing affordable alternatives to professional-grade materials. (See "Student Grade vs. Artist Grade," below.) Independent stores can vary widely in what they carry but offer an inspiring assortment of traditional and modern products.

Student Grade vs. Artist Grade

Art materials come in two grades of quality: student and artist (or professional). Artist-grade materials are more costly than student-grade paints; they contain less filler, yield richer colors, afford the artist more control over the medium, and are less likely to fade over time. Purchasing artist-grade materials up front will likely save you frustration in the long run.

Online Retailers

For artists familiar with the colors, brands, and specific tools they need, online retailers can provide discounted prices while shipping conveniently to your home or studio. Online shopping is also a great way to find rare items unavailable at stores near you. As you compare prices, though, be sure to factor in any shipping costs.

Estate & Garage Sales

An estate sale can be a great place to save on art supplies. You might find desks, easels, storage units, and still life props (such as vases, bowls, or silk flowers) at bargain prices. Some drawing pencils and well-maintained brushes could also be useful, but it's best to purchase fresh media, such as paint and pastels, as they can dry out or spoil over time.

Consider joining an online community of artists. Nowhere does information flow more readily than in social networks, keeping you abreast of developments in the field and aware of new products from leading manufacturers. A community can also help you answer any specific questions you might have about your tools and materials.

SKETCHBOOKS

There are all kinds of sketchbooks available, but spiral-bound varieties are great because they lie flat when opened. Sketchbooks come in a variety of sizes, from 6" x 9" to 11" x 14". Stay clear of books with thin paper; denser papers are better able to handle washes of color without bleeding through or warping the paper.

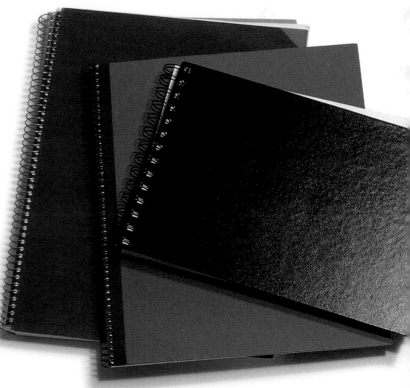

Spiral-bound sketchbooks allow you to remove and replace pages—an advantage if you like to share or frame your sketches.

Sketching on Location
One of the great advantages of keeping a sketchbook is that it's small enough to go with you anywhere—from outdoor flower markets to historical buildings! No matter where you are or what you're surrounded by, you have before you a wonderful opportunity to sketch—and don't feel as if you have to wait for the perfect image to begin sketching.

TOOL ORGANIZATION

Keeping your materials organized and easy to access plays a huge role in your efficiency as an artist. Consider enlisting the following tools for storing or transporting your materials.

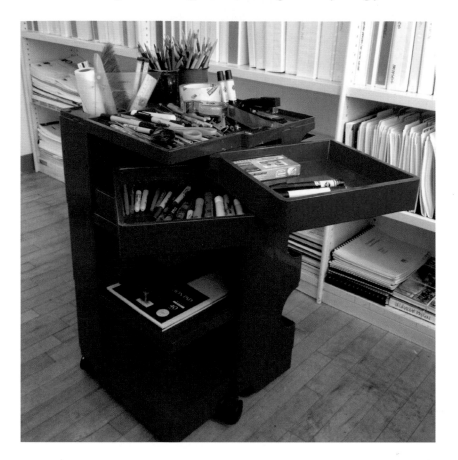

Taboret

A taboret is a small storage unit with cupboards, drawers, trays, or shelves for holding art materials. Taborets can double as tabletops; artists often use them to support a palette, brushes, and mediums during a painting session.

STORING ARTWORK

An art studio is more than a workspace; it can be a safe place to store finished work. Below are a few guidelines for creating optimal conditions.

- An ideal studio has a cool, dry environment that is inhospitable to mold, for the sake of both your artwork and your art materials.
- Store drawings and dried watercolors in short stacks, separated by acid-free tissue paper. Large, wide, shallow drawers or cupboard shelves are great for this. Remember: It's a good idea to use spray fixative over dry media to prevent smudging and pigment loss during storage.
- Canvases and frames should be stored vertically to save space and protect them from the consequences of stacking such as scratches and excess pressure. Wrap canvases with plastic to prevent dust from settling on the paint.
- A great way to "store" your artwork is to mat and frame it!

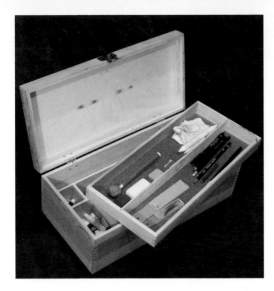

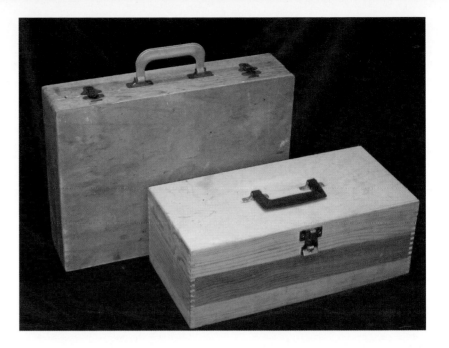

Wooden Art Box

Sometimes called "pochade boxes," wooden art boxes are available in a range of sizes and shapes. They often come with dividers that create compartments of varying sizes. Some are available with removable trays that allow you to stack layers of tools.

A flatware holder doubles as a convenient organizer for dry media—one compartment for graphite pencils, one for charcoal, one for Conté, and so on.

Simple drawers lined along shelves are handy for categorizing tube paints.

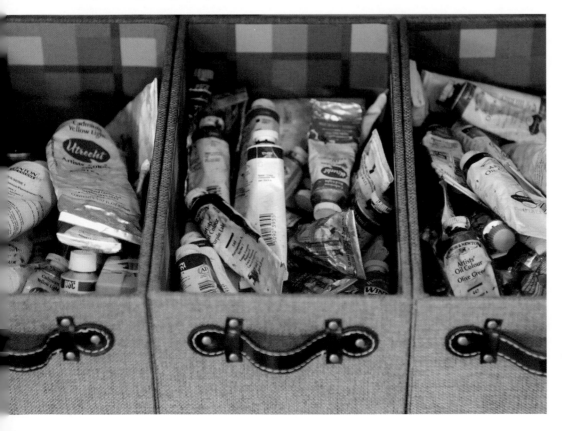

Bins, Drawers & "Found" Organizers

Plastic bins and old drawers are great open-topped options that keep tools categorized while offering easy access. Old tackle boxes are great for storing or drawing on the go. Garage sales, thrift stores, and dollar stores are good resources for these items.

WARNING Remember to store liquids upright and secure their lids tightly. Also, do not store paints, oils, or solvents near heat.

WORKING SURFACES & EASELS

Your working surface should depend largely on the medium you use most often. For artists who draw and work with dry media, a flat or slightly tilted surface is best; for artists who paint with oil or acrylic, an easel is the traditional choice.

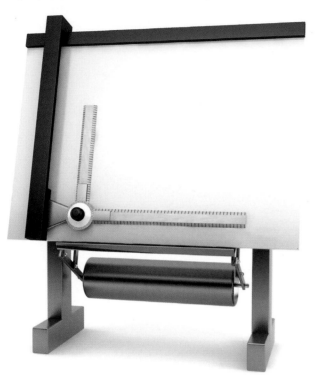

Drawing & Drafting Tables

Drawing and drafting tables feature large, smooth surfaces that tilt to varying degrees. Often made of wood, composite wood, or tempered glass, these desks sometimes feature ledges or compartments along the side for holding pencils, erasers, or other drawing materials. Some even include straightedges on the surface, wheeled legs, and drawers for storing materials.

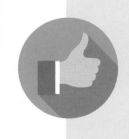

A simple sheet of composite wood can serve as an inexpensive drawing surface. However, you might find the sharp corners and edges less desirable than a drawing board designed for comfort.

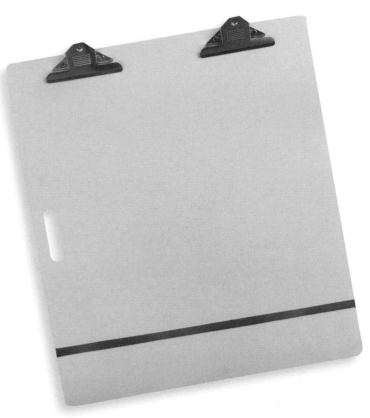

Drawing Boards

A drawing board offers a sturdy, smooth, and portable surface for supporting your paper as you draw or paint. You can use it in your lap and rest it against the edge of a table; and, if you wish, you can secure your paper to the board with clips or artist tape. Many wood-surfaced drawing boards feature a honeycombed core to reduce weight; others are made of composite wood or plastic. Drawing boards are available in a range of sizes, but an 18" x 18" board is a great size for beginners.

Studio Easels

Studio easels are sturdy, freestanding canvas supports. Traditionally they are made of wood, but you can also find lighter-weight metal varieties. Studio easels often fold flat, so you can tuck them away into a corner of the studio if needed; however, they are more cumbersome than portable easels (such as box easels, page 16). Below are two common studio easel formats.

DRAWING BOARDS MAY INCLUDE
- Rounded corners and edges
- Handle
- Clamps
- Rubber band around body
- Adjustable straight edge
- Stand for tilting on a flat surface

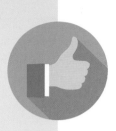

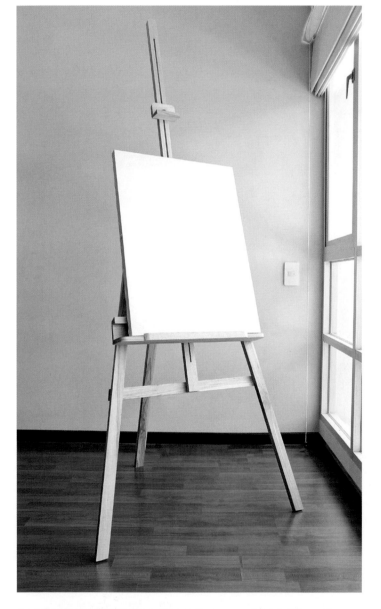

An A-frame easel is perhaps the most common format. The main frame, which is shaped loosely like an "A," is supported by a third leg. This easel requires a good amount of floor space, and the legs are vulnerable to accidental kicks.

An H-frame easel is a classic format that can support large canvases. An adjustable main frame is anchored to a small base, which sometimes features wheels for easy pushing.

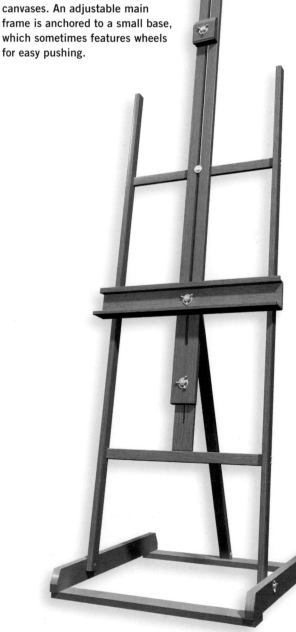

Portable Easels

Also called a French easel, a box easel is a great option for artists who work outdoors. This portable unit collapses into a compact box and features a handle for easy toting. The easel has three adjustable legs that support a wooden box; the lid serves as a canvas support with a ledge, and the box acts as a drawer holding materials.

Box easel, closed and ready for traveling

Box easel, open and ready for painting

Watercolorists who paint on site often choose to work on pads or spiral sketchbooks, while others stick to single sheets attached to a hard board with clips or artist tape. To support your paper while painting, consider a watercolor easel that allows for a slightly tilted surface. Many are available in collapsible, lightweight metal formats, making them easy to carry on site.

Aluminum watercolor easel

Image courtesy of Alvin & Co.
www.alvinco.com

Tabletop Easels

This type of easel sits atop any flat surface and holds your work upright as you paint. They are usually mini H-frames or mini A-frames in format. Tabletop easels are sometimes used to display finished artwork on desks or countertops.

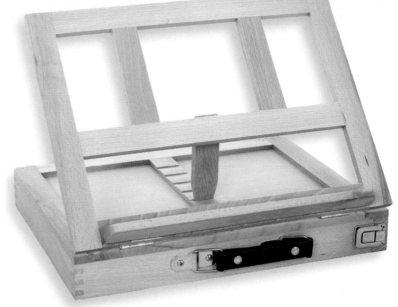

Box-style tabletop easel

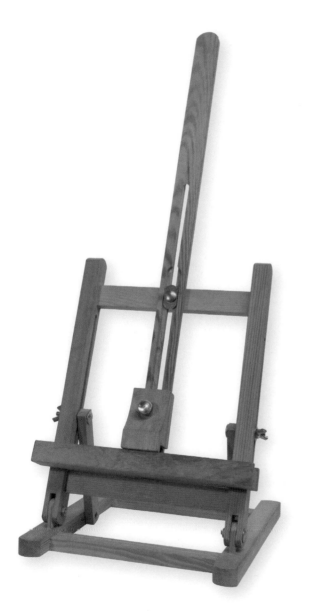

Standard H-frame tabletop easel

A comfortable chair is an important aspect of an artist's studio. A chair with a padded seat, back support, adjustable height, and wheels is ideal and can help prolong your studio sessions (A). For painters who like to stand frequently at the easel and enjoy freedom of movement, a simple elevated stool is a great choice (B).

CHOOSING A WORKSPACE

Every artist's dream is to have a large, airy studio with a north-facing window. But the reality is that any place you find to paint—a spare bedroom, a basement corner, or the kitchen table—is suitable. Choose your workspace to match your style. Some people like to stand to allow free arm movement; others sit at a table for more precise work; and some prefer to sit in an oversized chair. Select an easel, table, or lap desk to hold your paper while you work. And wherever you do work, you will need good lighting, such as a floor lamp, desk light, or clamp-on light. As an artist, you may prefer to use a "natural" or "daylight" bulb, which mimics sunlight and is easy on your eyes.

DRAFTING OR DRAWING TABLE You can angle these tabletops for comfort. If space is short, get a folding table.

LAP DESK A laptop board with an attached pillow allows you to put your feet up, lean back, and draw.

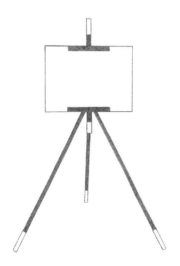

EASEL An easel will hold your work upright, so you can work standing or sitting.

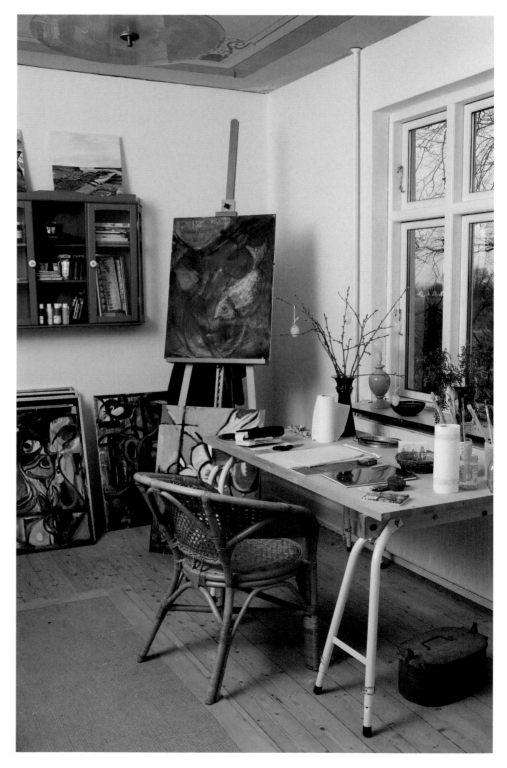

LIGHTING

Traditionally, the best lighting for artwork is plentiful natural light coming from the north. This shows color and values in their truest forms, prevents rays of light from falling directly on the work, and reduces eyestrain for the artist. An ideal studio features large, high north-facing windows. Artists who don't have the luxury of north light or who work at night must use artificial lighting to illuminate their workspaces. There are myriad possibilities for lighting a studio; ultimately, personal preference will guide the way.

STUDIO LIGHTING CONSIDERATIONS	
Temperature	The light in your studio should be neutral in color, so avoid a setup that leans too cool or too warm. Some artists use a combination of incandescent and fluorescent bulbs, while others rely solely on daylight simulation bulbs.
Direction	Most professional studios feature both general overhead lighting as well as task lighting, which focuses light on a smaller workspace. Both overhead and task lighting should be positioned so as not to create shadows of your hand across your work. For example, if you are right-handed, light should come from above and from the left; if you are left-handed, light should come from above and from the right.
Presentation	Artists can often find out how commissioned artwork will be displayed and lit. Many find it beneficial to paint their work in the same lighting conditions to help control how the viewer will see the colors and values.

A

B

C

Shown is the same drawing board under three different types of light: cool light from the shadows of late afternoon (A), a warm incandescent bulb (B), and a full-spectrum daylight bulb (C). If natural northern light is not available, full-spectrum daylight bulbs (or a combination of warm and cool lighting) bring out the truest colors and values.

TECHNOLOGY IN THE STUDIO

An artist's studio today can look very different from a studio 50 years ago; it might even resemble an office. If you have the urge to keep modern technology from encroaching on your art space, consider that technology can actually help you simplify several creative processes.

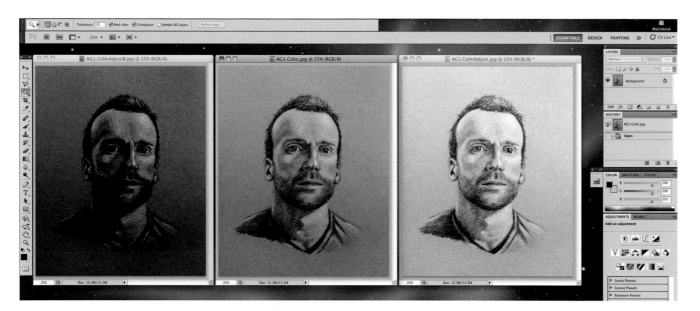

EDITING SOFTWARE This software allows you to manipulate digital copies of your artwork. Once you open a scan or photograph of your work in the program (such as Adobe® Photoshop®), you can adjust the brightness, contrast, color, and other aspects to bring the work closer to the original or to your vision.

LIGHT BOX This illuminated table or surface allows artists to view lines beneath paper, making tracing a cinch. Many artists today use a light box to transfer the outlines of a sketch onto a fresh sheet of drawing paper, which helps avoid early erasures.

DIGITAL CAMERA A high-quality digital camera can be an artist's best friend when it comes to gathering references. It can capture fleeting scenes and allow you to work in the comfort of your studio. Digital cameras take away the stress and cost of film and prints, so you can take several photos of the same scene. You can also photograph your finished work in a well-lit environment. Make sure the camera can produce decent-sized prints such as 8.5" x 11" at 300 dpi (dots per inch).

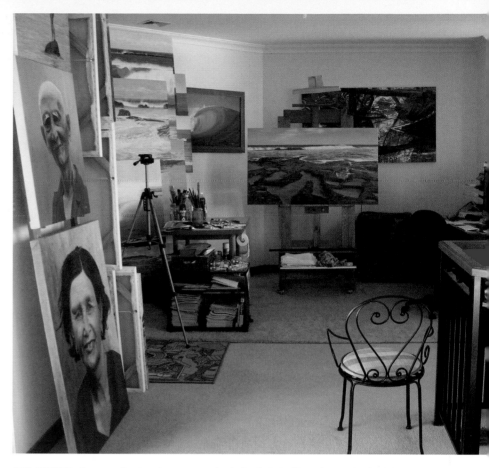

PRINTER AND SCANNER Often available in one unit, printers and scanners are useful tools for the artist. Use a printer to print reference photos or to print a light sketch on your drawing paper. Some printers are even compatible with canvas paper. A high-quality scanner is invaluable for artists who want clean, large, and evenly lit digital copies of their work.

COMPUTER A computer has become a staple in the studios of many artists. From storing references to acting as a new medium for creating or altering work, the perks of a computer are many.

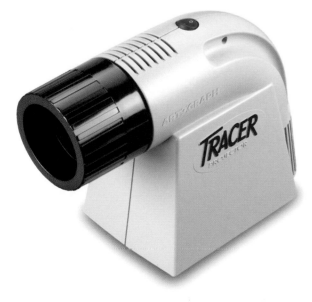

OPAQUE PROJECTOR This device uses light and lenses to display an image of your choice (such as a printed photograph) at a large size onto a nearby surface. To bypass the sketching process and ensure correct proportions, some artists project their reference photos onto paper or canvas and trace the most important lines and shapes.

WAYS TO USE A COMPUTER IN THE STUDIO

- Store and organize digital copies (scans or photographs) of your own work.
- Store and organize your own photo references.
- Use image-editing software to alter your photo references or your artwork, assist in composition and design, and analyze color.
- Use the Internet to search and view the work of others for ideas and inspiration.
- Join online art communities for a place to share ideas, ask questions, and network.

FINDING
INSPIRATION

The most important aspects of making art are sensitivity, focus, and passion. We are all born with the ability to create; as adults, we still have the ability to "tap into" our creative side, but it takes practice, patience, and guidance.

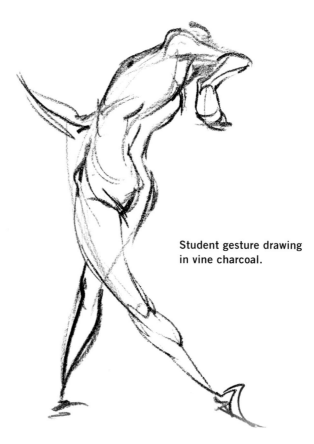

Sensitivity

Sensitivity refers to the handling of tools, as well as the ability to use visual sense to isolate the structure, organization, and mood of a subject. By manipulating the pressure of a drawing tool on paper, the artist can create multitudes of variable line weights. This is called "mark-making," and most of us have been doing it since before we could talk or walk. With direction, mark-making can be refined to the point where recognizable subject matter can be created.

Student drawing by Joanna Mendoza.

Student gesture drawing in vine charcoal.

Focus

In drawing, focus refers to the ability to concentrate on and develop a clear image of the subject. It is about attempting to depict a three-dimensional form on a two-dimensional surface. This is a visual alchemy that artists have struggled to achieve since the days of the first cave paintings. Focus is an essential skill that can be achieved with patience, practice, and the right environment. Most importantly, try to clear your mind of clutter and negative thoughts, and avoid undue visual or aural distractions.

Passion

Passion in drawing, as in life, is the desire for something meaningful that can fulfill, entertain, heal, and ultimately satisfy the creative impulse. You can attain sensitivity and focus, but without the third leg of the stool— passion—you won't have the desire to create art all the time. And that is what makes a successful artist—working tirelessly, constantly, and happily, over and over again.

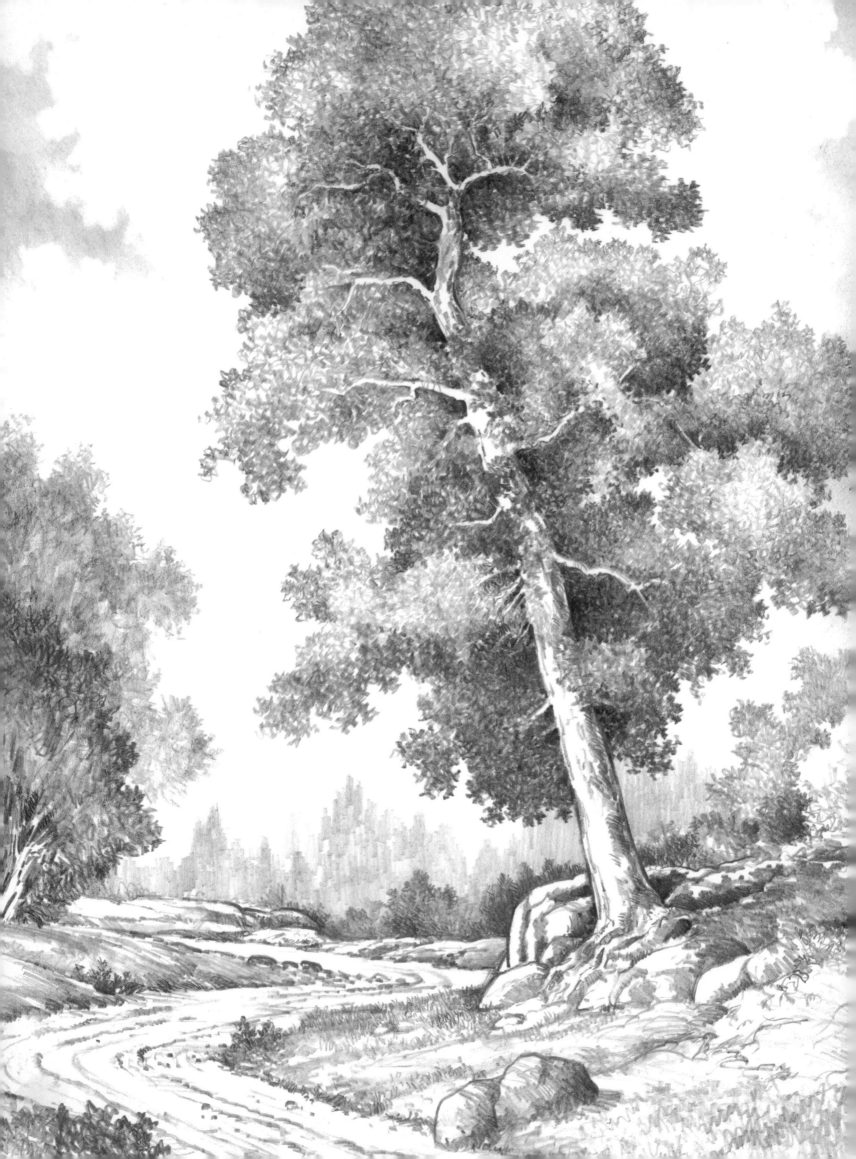

DRAWING

From simple doodles and geometric patterns to photo-realistic renderings, drawing can result in a vast range of styles and degrees of intricacy. But the importance of drawing isn't about breadth—it's about what the process cultivates in the artist.

You may have heard the saying, "Drawing is the foundation of all art;" this statement hits the nail on the head! Drawing (most simply described as mark-making on a two-dimensional surface) forces us to concentrate on the most basic of the elements and principles of art as we attempt to represent the world around us. Drawing promotes the study of proportion, form, light, shadow—everything you need to thoroughly grasp before moving on to other forms of visual art, such as painting or mixed media.

SURFACES & SUPPORTS

Over the years, paper has become an invaluable tool for record keeping and making art. Today a variety of papers are both affordable and readily available. Because drawing paper can vary widely, artists generally describe a paper using the following properties: material, weight, texture, finish, brightness, and color.

Papers made from cotton rags are called "rag paper;" these strong sheets are made up of the longest cotton fibers. Aside from art, rag paper is used for important documents that need to last or withstand wear and tear, such as money.

MATERIAL

The majority of paper today is made out of cellulose fibers derived from wood pulp, cotton, or a blend of the two. Generally speaking, the higher the content of cotton, the higher the quality of paper.

WEIGHT

Paper weight is measured in either pounds per ream (500 sheets) or grams per square meter (gsm or g/m2). Using gsm to describe a paper's weight is more consistent and perhaps more descriptive; however, the pound system is more common in the United States. Remember: The greater the lb or gsm, the thicker the paper.

STANDARD PAPER WEIGHTS	
35 lb / 50 gsm	newsprint
45 lb / 60 gsm	kraft paper
60 lb / 90 gsm	sketching paper
80 lb / 130 gsm	drawing paper
100 lb / 260 gsm	heavy drawing paper
140 lb / 300 gsm	watercolor paper
300 lb / 638 gsm	heavy watercolor paper

BRIGHTNESS & COLOR

Art papers are available in nearly every color imaginable. Most artists work on papers that range from bright white to cream; however, some artists use the tone of the paper as a middle value and apply the highlights and shadows using charcoal or Conté crayon. This is a quick way to produce dramatic results.

You may notice that some papers and canvases are labeled "acid-free." This means that the surface will not yellow or deteriorate as time passes. Unless you're drafting rough sketches, make it a point to work on acid-free surfaces. You never know which pieces you'll want to last!

TEXTURE & FINISH

To understand texture and finish, run your finger across several different papers. The surface quality plays a role in how the paper responds to and accepts the medium.

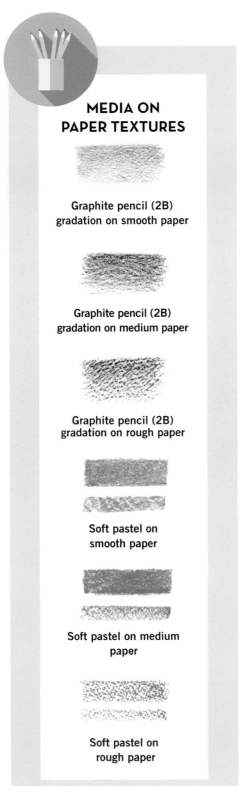

MEDIA ON PAPER TEXTURES

Graphite pencil (2B) gradation on smooth paper

Graphite pencil (2B) gradation on medium paper

Graphite pencil (2B) gradation on rough paper

Soft pastel on smooth paper

Soft pastel on medium paper

Soft pastel on rough paper

Rough Paper

Rough papers have a prominent "tooth," which refers to the bumps and grooves on the paper's surface. These raised areas catch your medium as you stroke across the paper.

👍 GOOD FOR COARSE, EXPRESSIVE STROKES 👎 NOT GOOD FOR FINE DETAIL

Smooth Paper

Smooth papers have little to no tooth, and medium papers have a tooth somewhere in the middle. Papers with minimal tooth are best for artists who work in fine detail.

👍 GOOD FOR FINE DETAIL 👎 NOT GOOD FOR SOFT MEDIA

Laid-Finish Paper

Papers with a laid finish feature fine, parallel grooves that catch the drawing medium and give the artwork a ribbed texture.

👍 GOOD FOR CHARCOAL, PASTEL, AND CONTÉ CRAYON 👎 NOT GOOD FOR HARD PENCIL

Wove Finish

Papers with wove finish are smooth with a subtle woven or mesh pattern. It is the standard finish for stationery used for printing and writing.

👍 GOOD FOR CONTROLLED, DETAIL WORK 👎 NOT GOOD FOR EXPRESSIVE MEDIA

Matte

In almost all cases, artist paper has a matte or "uncoated" finish, which is nonreflective and receptive to wet and dry media.

👍 GOOD FOR DRAWING PAPER 👎 NOT GOOD FOR PRINTING

Gloss

Gloss paper is slick and reflective; the lack of friction makes it difficult to accept and control a medium.

👍 GOOD FOR PRINTING 👎 NOT GOOD FOR WET OR DRY MEDIA

FORMATS

Paper comes in a variety of formats, and your choice should depend on your requirements and personal taste. Below is a breakdown of available formats.

Pads & Books

Paper pads consist of a stack of papers on a firm cardboard backing, which allows you to sketch without a table if needed. The papers are attached along one edge with tape, glue, or a plastic or metal spiral. These formats are available in a range of manageable sizes that suit artists on-the-go. However, many artists choose to remove single sheets and work on another surface to prevent indentations transferring to the papers beneath.

Rolls

Paper is available in rolls, often a cheaper option per square inch than pads or loose sheets of paper. However, the savings may not be worth the time involved in cutting your own sheets. Also, paper that has been freshly cut from a roll has a tendency to curl.

Loose Sheets

For a serious drawing, loose sheets are a great choice because they have clean, ready-to-display edges. This format also allows you to experiment with different paper types without having to buy multiple sheets of the same surface.

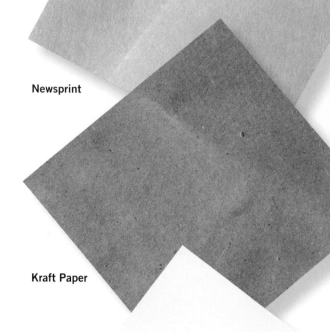

Newsprint

Kraft Paper

Drawing Paper

 A good, convenient drawing paper choice for beginners is an 80-lb., 9" x 12" pad.

TYPES OF PAPER

The suggestions that follow highlight the most common types of paper available to artists. Remember that you are not limited to the suggestions in this book, and some surfaces may suit you and your medium in a way not described.

Newsprint

A thin, inexpensive drawing surface that is perfect for creating loose sketches. Artists often use newsprint for gesture drawing or thumbnail studies.

GOOD FOR QUICK SKETCHES

NOT GOOD FOR FINAL WORK

Kraft Paper

Also referred to as "butcher paper," some artists prefer the warm tones of this paper for sketching and gestural drawings.

GOOD FOR TONED STUDIES

NOT GOOD FOR WET MEDIA

Drawing Paper

This large category covers paper that is suitable for graphite and other dry media. Heavier weights are more appropriate for serious drawings.

GOOD FOR FINAL WORK

NOT GOOD FOR WET MEDIA

BRISTOL BOARD COMPARISON

Graphite pencil (2B) on the vellum side of Bristol paper

Graphite pencil (2B) on the plate side of Bristol paper

MARKER PAPER COMPARISON

Marker (brush tip and pointed tip) on marker paper produces crisp lines that don't bleed. The paper also allows for layering to darken a marker's value.

Marker (brush tip and pointed tip) on unsized, cold-pressed paper produces rough lines that readily bleed into the fibers, creating dark, irregular strokes.

BRISTOL BOARD

This popular surface features two drawing surfaces: plate finish on one side, and vellum finish on the other. The plate side has a very smooth texture that works best with graphite, pen and ink, and even airbrush. The vellum side is rougher and works best with dry media that requires some tooth.

 GOOD FOR DRY MEDIA NOT GOOD FOR WET MEDIA

ILLUSTRATION BOARD

Thick, multi-ply paper or paper mounted to a hard core, creating a sturdy surface that does not easily crease, warp, or curl under dry media. Generally speaking, artists use illustration board for work that they plan to scan or photograph.

Some artists use illustration board with wet media such as watercolor, gouache, or acrylic; however, some will not accept the paint effectively and can warp or bow under the moisture of paint. If you do choose to use it with wet media, consider painting an "X" on the back to curb warping. Remember to read the manufacturer's medium suggestions as well.

 GOOD FOR SCANNING/ PHOTOGRAPHING NOT GOOD FOR LONGEVITY

MARKER PAPER

Marker paper has a smooth surface ideal for achieving the crisp, graphic look of marker drawing. It is coated to minimize absorption, which prevents the ink from bleeding or feathering and allows for layering and mixing.

 GOOD FOR MARKERS/ PEN AND INK NOT GOOD FOR GRAPHITE

VELLUM PAPER

"Vellum" can refer to the finish of a surface, but in this case it refers to a translucent paper. The translucent quality of this durable surface makes it a good choice for technical drawing or tracing.

 GOOD FOR TRACINGS NOT GOOD FOR BRIGHT DRAWINGS

Vellum

GRAPHITE

Perhaps the first medium that comes to mind when you think of drawing, graphite is a great starting point for a beginning artist. Not only do you have most of the materials lying around the house, but this medium responds well to an eraser and welcomes preliminary strokes and experimentation.

RECOMMENDED SUPPORTS

- Newsprint
- Kraft paper
- Sketch paper
- Smooth drawing paper
- Medium drawing paper
- Vellum paper
- Cold-pressed paper

HARDNESS

The quality of line and tone you achieve from graphite is related in part to its hardness. The lead (or graphite center of a pencil) is labeled by number and letter. H pencils are hard; they contain a higher ratio of clay to graphite and produce a light gray line. B pencils are soft; they contain a higher ratio of graphite to clay and produce softer, darker lines. The higher the number that accompanies the letter, the harder or softer the lead is. F and HB (which is the lead of a common "number 2" pencil) are considered neither hard nor soft.

9B and 9H pencils are the softest and hardest leads available. Beware of the extremes; very hard pencils can score your paper, and very soft pencils crumble and smudge easily. Hard leads sharpen to a fine tip, making them great for detail work, whereas soft leads are better for blending. A great starter set of pencils might include 6B, 2B, HB, 2H, and 4H leads, which provides an ample range of hardness for most artists.

PENCIL HARDNESS

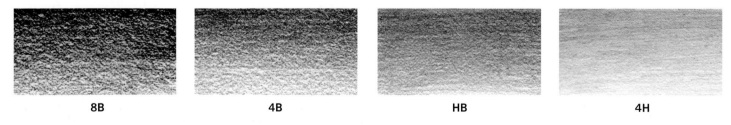

| 8B | 4B | HB | 4H |

Pictured here are gradations of 8B, 4B, HB, and 4H leads over medium drawing paper, allowing you to see differences in stroke quality and darkness.

TYPES

Graphite is available in a variety of forms, allowing artists to choose the best instrument for their needs. You can find all of these forms at most art & craft stores.

Wooden Pencil
The most common type of pencil is wood-encased graphite. These thin rods—most often round or hexagonal when cut crosswise—are inexpensive, easy to control and sharpen, and readily available to artists.

Flat Carpenter's Pencil
Some artists prefer using a flat carpenter's pencil, which has a rectangular body and lead. The thick lead allows you to easily customize its shape to create both thick and thin lines.

Mechanical Pencil
Mechanical pencils are plastic or metal barrels that hold individual leads. Some artists prefer the consistent feel of mechanical pencils to that of wooden pencils; the weight and length do not change over time, unlike wooden pencils that wear down with use.

Woodless Graphite Pencil
These tools are shaped liked wooden pencils but are made up entirely of graphite lead. The large cone of graphite allows artists to use either the broad side for shading large areas or the tip for finer strokes and details.

Graphite Stick
Available in a full range of hardnesses, these long, rectangular bars of graphite are great tools for sketching (using the end) and blocking in large areas of tone (using the broad side).

Carpenter's Pencil

Mechanical Pencil

Woodless Pencil

Graphite Stick

HOLDING A PENCIL
Vary how you hold a pencil to create a range of lines and strokes. There are two common ways to hold a pencil: the underhand position (A) and the writing position (B). The underhand position is great for loose sketches, shading, and broad strokes, whereas the writing position is ideal for detail work.

B

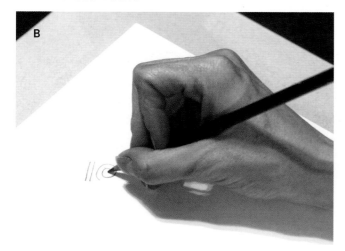

A

Hold the pencil as you normally do while writing (left). This gives you a good amount of control over the point of the pencil, allowing you to work accurately and in small areas.

To assume this position (right), pick up a pencil with your hand over the shaft, holding it between the thumb and index finger. The remaining fingers can rest alongside the pencil. Draw with your entire arm rather than your wrist.

SHARPENERS

Sharpening instruments give you control over your pencil tips, which in turn gives you control over the quality of your lines. Whether you're working in graphite, charcoal, or pastel, there is more than one way to sharpen a pencil. Experiment with the tools that follow and discover the sharpening method that works best for you.

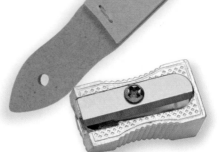
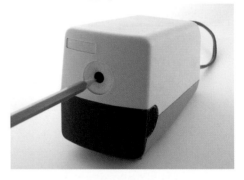

Handheld Sharpeners

Handheld sharpeners shave pencil ends into cone shapes, exposing the lead and creating sharp tips. Use a handheld sharpener over a trash bin and make sure your fingers are free of graphite after sharpening.

Electric Sharpener

Electric sharpeners simply and efficiently create long, sharp, uniform pencil points. However, they can eat away a pencil quickly, shortening its lifespan. Take care to avoid oversharpening.

Knife

Sharpening with a handheld knife, such as a pocket knife, takes skill and effort but allows you to customize the tip. For example, you can expose a good amount of the lead center in order to shade broader areas and sharpen less often. This method is the only suitable way to sharpen a flat carpenter's pencil. Hold the knife at a slight angle to the pencil shaft, and sharpen away from your body. Remove only a little wood and graphite at a time for greater control.

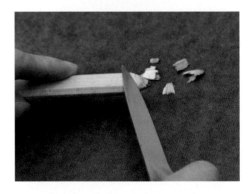

⚠️ **WARNING** When working with a sharp edge, always point and cut away from the body and extremities.

Sandpaper Pad

This tool is essentially a soft block of sandpaper with a handle. Some artists do the bulk of their sharpening with a different tool and simply use a sandpaper pad to hone or chisel the lead tip. These pads come with a few sheets of sandpaper stapled to the surface. When the top sheet has run its course, simply pull it off to reveal a fresh surface. Remember: The finer the grit of the paper, the more control you will have over the point.

At left are two common ways to sharpen a pencil. The first tip is a simple point created with a handheld sharpener; the second is a chiseled tip honed with a sandpaper pad. Try using a sandpaper pad to clean blending stumps.

ERASERS

Erasers are not only a means for removing mistakes; they are also effective drawing tools in themselves. You can use them to pull out light lines, add crisp highlights, subtly lighten areas of tone, and more.

The type of eraser you choose should depend on your medium, the scale at which you plan to work, and the degree of removal you're seeking. Below are the most common eraser types and formats to help you choose wisely.

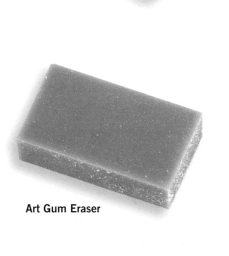

Rubber Eraser

Rubber Eraser

This inexpensive block or wedge-shaped eraser is effective for removing large areas of tone. It is usually pink or white and is made of synthetic rubber. Gently rubbing the eraser over the paper lifts away tone but also leaves behind crumbs, which you must blow or brush away. Rubbing it excessively can damage a paper's surface, smear the graphite, or leave residue. Most seasoned artists avoid these erasers for serious work.

When working with an eraser that leaves behind crumbs, keep a blow bulb or a large, soft brush, such as a drafting brush, on hand to clean your paper and working area.

Art Gum Eraser

These brown, rubbery erasers typically come in thick blocks. They are gentle on a paper's surface, but they crumble easily and require frequent blowing or sweeping of your support. Because of their thick shape and crumbly nature, they are best for erasing large, broad areas.

Art Gum Eraser

Vinyl & Plastic Erasers

Usually white with a soft plastic feel, vinyl and plastic erasers leave behind a very clean surface and are gentle on the paper's fibers when used carefully. When working with large areas of heavy tone, these erasers can cause smearing, but they are effective in removing lighter marks and tones. They leave behind small, light crumbs that are easily brushed away. You can also cut these erasers into shapes and edges for more precise erasures. They are available in blocks and sticks.

Vinyl Eraser

Kneaded Eraser

The kneaded eraser (usually gray) is a favorite for graphite artists. It is pliable like clay, allowing you to form it into any shape. Knead and work the eraser until it softens; then dab or roll it over areas to slowly and deliberately lighten the tone. This eraser does not leave behind crumbs. To "clean" it, simply knead it. The eraser will eventually take in too much graphite, and need to be replaced.

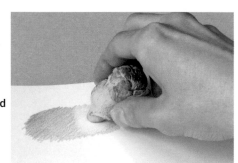

Kneaded Eraser

ERASER USAGES

Rubber Eraser	Best for use with graphite
Art Gum Eraser	Best for use with graphite and charcoal
Vinyl & Plastic Eraser	Best for use with graphite and colored pencil
Kneaded Eraser	Best for use with graphite and charcoal

Use a kneaded eraser to dab or roll for soft, subtle lightening.

BLENDING TOOLS

Blending is an important aspect of realistic drawing. The ability to produce subtle and seamless gradations of tone can help you create the illusion of three-dimensional form. There are a variety of tools available to help you blend graphite, including a few common household items. Experiment with a variety of tools to find the blender that best suits your goals and style.

Blending Stumps

These white sticks are made of soft, packed paper. Similar to a pencil, the dual tips are shaped like cones. Use the broad side for blending large areas and the tips for smaller areas. To clean off graphite buildup, simply rub and roll the tips over fine-grit sandpaper (or a sandpaper pad). You can also use "dirty" stumps to apply tone to your paper.

Tortillons

Similar to blending stumps, tortillons are small hollow sticks of tightly-rolled paper. You can even use tortillons, as well as other blending tools, to apply soft tones to paper.

Chamois

A chamois is a soft leather cloth that is ideal for blending large areas evenly and smoothly. You can also pull the cloth taught over a finger for more precise blending.

Brushes

Brushes aren't just for paint; you can use soft-haired brushes for creating very soft, smooth graphite blends. The shorter the bristles, the more control you have over the edges of your blends. Angled brushes are particularly useful for blending tone along straight lines. Some artists bypass pencils and apply graphite powder using brushes, spreading and pushing the tone around the paper's surface.

Tissue

A facial tissue or paper towel is an inexpensive, yet effective, blending tool. Fold it to blend broad areas, or wrap it around your finger to blend smaller areas. You might also try cotton cosmetic pads and swabs.

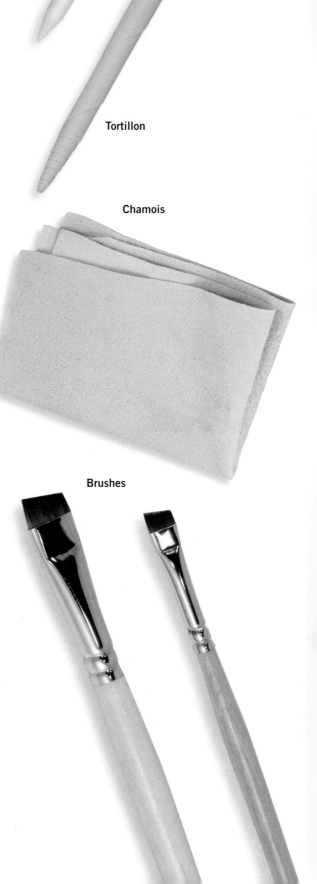

Blending Stumps

Tortillon

Chamois

Brushes

A chamois is the best tool for blending large areas of tone. It yields even, feathery soft blends.

BASIC PENCIL TECHNIQUES

SHADING DARKLY By applying heavy pressure to the pencil, you can create dark, linear areas of shading.

CROSSHATCHING For darker shading, place layers of parallel strokes on top of one another at varying angles. Again, make darker values by placing the strokes closer together.

HATCHING This basic method of shading involves filling an area with a series of parallel strokes. The closer the strokes, the darker the tone will be.

You can create an incredible variety of effects with a pencil. By using various hand positions and shading techniques, you can produce a world of different stroke shapes, lengths, widths, and weights.

GRADATING To create gradated values (from dark to light), apply heavy pressure with the side of your pencil, gradually lightening the pressure as you stroke.

SHADING WITH TEXTURE For a mottled texture, use the side of the pencil tip to apply small, uneven strokes.

BLENDING To smooth out the transitions between strokes, gently rub the lines with a blending tool or tissue.

CREATING FORM

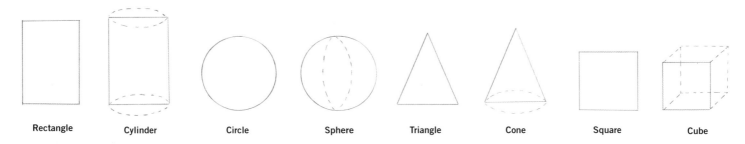

| Rectangle | Cylinder | Circle | Sphere | Triangle | Cone | Square | Cube |

The first step when creating an object is to establish a line drawing to delineate the flat area that the object takes up. This is known as the "shape" of the object.

ADDING VALUE TO CREATE FORM

A shape can be further defined by showing how light hits the object to create highlights and shadows. First note from which direction the source of light is coming. (In these examples, the light source is beaming from the upper right.)

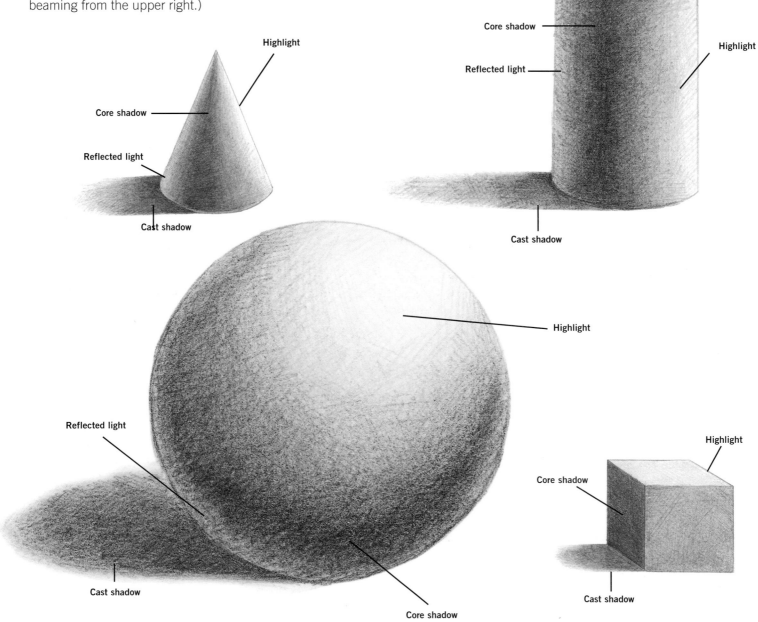

CREATING TEXTURES

SCALES Drawn as a series of interlocking stacked plates, scales will become more compressed as they follow forms that recede from the picture plane.

WOOD If left rough and not sanded down, wood is made up of swirling lines. There is a rhythm and direction to the pattern that you need to observe and then feel out in your drawings.

Texture shouldn't be confused with pattern, which is the tone or coloration of the material. Blindly filling an area with texture will not improve a drawing, but using the texture to build a shadow area will give the larger shape its proper weight and form in space. You should think of texture as a series of forms (or lack thereof) on a surface. Here are some examples to help you.

CLOTH As wrinkles move around a form and away from the picture plane, they compress and become more dense.

METAL Metal can range from slightly dull as shown here to incredibly sharp and mirror-like. The shapes reflected will be abstract with hard edges, and the reflected light will be very bright.

SHORT, FINE HAIR Starting at the point closest to the viewer, the hairs point toward the picture plane and can be indicated as dots. Moving out and into shadowed areas, the marks become longer and more dense.

FEATHERS AND LEAVES As with short hair, stiff feathers or leaves are long and a bit thick. The forms closest to the viewer are compressed, and those farther away from the viewer are longer.

CURLY HAIR With curly hair, it's important to follow the pattern of highlights, core shadow, and reflected light. Unruly and wild patterns will increase the impression of dreaded or tangled hair.

DRAWING METHODS

Humans have stylized ideas of what every object looks like, and we often translate this to our drawings and paintings. For example, we might draw a face with circles for eyes and a triangle for the nose. Once we learn to truly observe an object, we find that these ideas interfere with our ability to render realistically. Use the exercises below to help train your eye to draw what you *really* see instead of what you *think* you see.

NEGATIVE SPACE DRAWING

Draw only the negative space (or space between the main objects) of a scene. If you try this, you'll notice yourself focusing more on the accuracy of shapes than how you *think* the objects should look, resulting in a more realistic representation.

DRAWING UPSIDE-DOWN

Draw from a reference that has been turned upside-down. You'll find that disorienting yourself a bit will bring your focus on the shapes and distract you from your brain's misleading ideas.

> Fixative is a spray that helps preserve a finished drawing, sealing the dry media to prevent it from blowing away or smudging. Charcoal, chalk, and pastel are examples of dry media that need to be "fixed" to remain stable over time. Many graphite artists opt to seal their work as well.

MEASURING PROPORTIONS

The traditional or "classical" method for developing a drawing involves laying in carefully assessed proportions of your subject. This is particularly important in portrait drawing, where creating a likeness depends on the accurate placement of each line, curve, and shadow. Artists often use a pencil and thumb method to measure proportions.

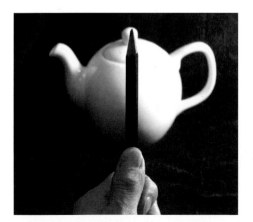

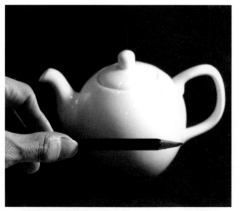

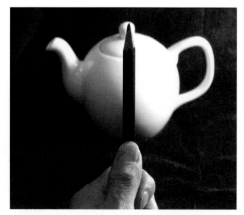

STEP 1 Using your nondominant hand, hold a pencil and extend your arm straight out toward your subject. Hold the pencil vertically and slide your thumb up or down to assess the height of your subject and its features.

STEP 2 Then hold the pencil horizontally to measure and assess alignments. For example, how does the width compare to the height? How does the width of the base relate to the width between the spout and the handle?

STEP 3 Now turn the pencil to assess angles and alignments. For example, at what angle does the handle align with the bottom of the spout? Record the results on your paper, adjusting your marks as necessary.

TRACING

A light box is a special desk or inexpensive box with a transparent top and a light inside. The light illuminates papers placed on top and allows dark lines and shapes to show through for easy tracing. Photocopy or print out your reference to the desired scale and place it on the light box, securing it with artist tape. The light illuminates the drawing underneath and will help you accurately trace the lines and shapes onto your new sheet of paper.

GRID DRAWING

This method helps you break down the subject into smaller, more manageable segments. First photocopy your reference or a traced line drawing, and then draw a grid of squares (about 1 inch in size) over the photocopied image. Then draw a corresponding grid over your drawing paper. Once you've created the grids, simply draw what you see in each square of the line drawing in each square of the drawing paper. This method is ideal for transferring scenes from small reference photographs onto larger canvases.

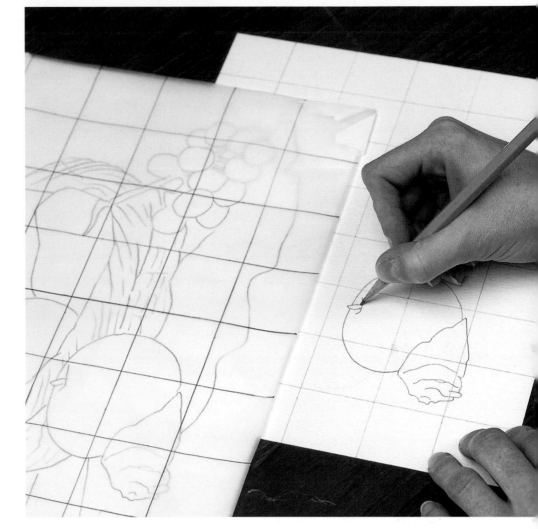

TRANSFERRING AN IMAGE

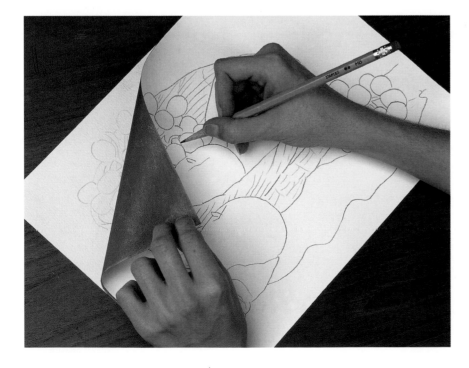

This is a simple method for tracing the main outlines of your reference onto a support. First print out your reference at the size you plan to draw it. Then place a sheet of tracing paper over the printout and trace the outlines. Coat the back of the tracing paper with an even layer of graphite and place it over a clean sheet of drawing paper, graphite-side down. (Instead of coating the back of the tracing paper, you might choose to purchase and use transfer paper, which already has one side coated with graphite.) Tape or hold the papers together and lightly trace your outlines with a ballpoint pen or stylus. The lines of your tracing paper will transfer to the drawing paper below.

SHAPE & CONTOUR

This simple composition of a pear and two apples on a white background explores composition, shape, and basic value shading. Developing realistic shape and contour as well as effective contrast will help develop a convincing three-dimensional look.

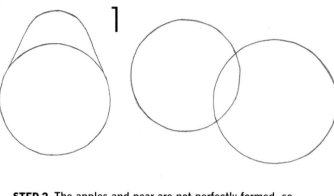

STEP 1 Sketch three slightly different-sized circles, and block in the top of the pear shape.

STEP 2 The apples and pear are not perfectly formed, so you will need to reshape some areas. Add the stems, and lightly draw in the areas where the shadows, highlights, and reflections will be.

When in the beginning stages, draw your lines even lighter than what you see here. To reduce smudges, keep a clean piece of paper under your drawing hand as you work.

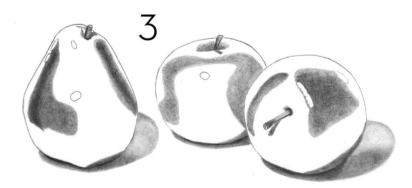

STEP 3 Using a 4B pencil, draw in the darkest values first in the cast shadows and at the base of the two outer fruits' stems. Using small, circular, overlapping strokes, fill in the darker-value areas on the pear and the apple on the right. Use slightly lighter pressure around the edges of these areas, creating a gradation.

Graphite can produce every value from light gray to black. A *value scale* helps us choose the right pencils and pressure to use in a drawing.

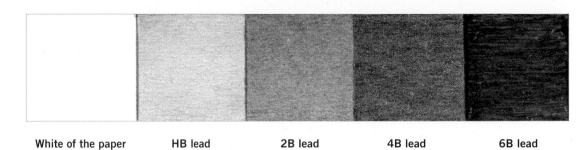

| White of the paper | HB lead | 2B lead | 4B lead | 6B lead |

STEP 4 Continue with overlapping circular strokes on the lighter areas using an HB pencil. Leave some white of the paper to show the highlighted areas on the fruit.

4

Drawing in the darkest values helps you envision all of the values you will use to create effective contrast and a realistic, three-dimensional look.

STEP 5 Use a kneaded eraser to lift out some of the lighter areas on the fruit. You can also sharpen a stick eraser to a point using a utility knife to bring out the spots and other fine details. Use a larger eraser to clean up any smudges in the areas around your drawing.

5

BLENDING

Rendering light-colored subjects on white paper can be challenging. Edges that are backlit or bright white can easily fade into the paper, yet we want to avoid creating hard lines. The solution is to lightly shade the outline with a blending tool and keep the area inside the shading white or light.

1

STEP 1 Sketch the outline with an HB pencil. HB lead can be erased easily as you change the outlines into soft sections of fur.

2

STEP 2 Block in the facial features. To render authentic eyes, the catchlights (white reflections) are important. Take your time with their placement, and keep your strokes soft.

Apply lots of pressure to the irises and pupils to make them as dark as possible.

3

STEP 3 Next work on the facial fur, using light strokes. Block in the rest of the darker fur, and then lightly erase extra graphite with the tip of a kneaded eraser.

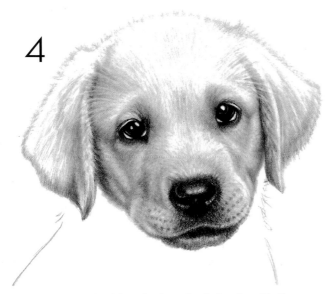

4

STEP 4 Blend the lighter fur into the darker fur with the corner of a soft chamois cloth. Then add more graphite to the darker areas and blend with a small tortillon.

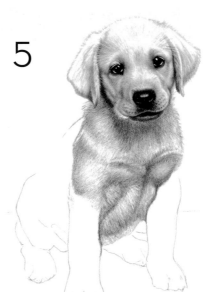

5

STEP 5 Start laying graphite on the body, using smooth strokes. Then block in the darkest areas. Don't worry about exact placement. Blending will smooth everything out.

Keep a clean sheet of paper under your drawing hand as you work to prevent skin oils from getting on the paper and saturating the graphite.

6

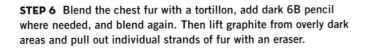

Graphite loses density as it is blended, so you may need to reestablish the darker areas.

STEP 6 Blend the chest fur with a tortillon, add dark 6B pencil where needed, and blend again. Then lift graphite from overly dark areas and pull out individual strands of fur with an eraser.

7

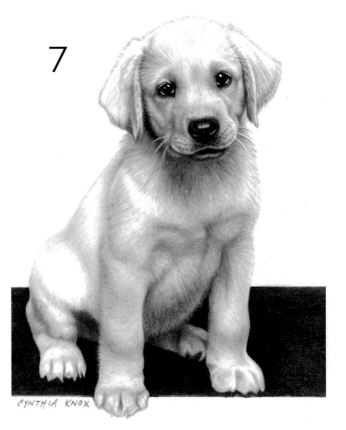

CYNTHIA KNOX

STEP 7 Lightly erase the outlines on the back of the puppy. Then use a dirty blending tortillon to lightly "draw" the puppy's back and back leg. Lightly fill the areas with a 2B pencil and blend. Repeat this on the front legs. Lift and lighten graphite with a kneaded eraser, and add light fur streaks and whiskers. To finish, add a dark surface below the pup to ground him in the scene.

DEVELOPING DETAILS

The more you practice sketching the parts of the figure—from hands and feet to facial features—the more confident you'll become when it comes time to approach a complete figure drawing. A portrait study is more than just a practice piece; it can stand alone as a fascinating composition. Starting with basic blocking and slowly developing the details layer by layer, an engaging portrait full of life will begin to emerge.

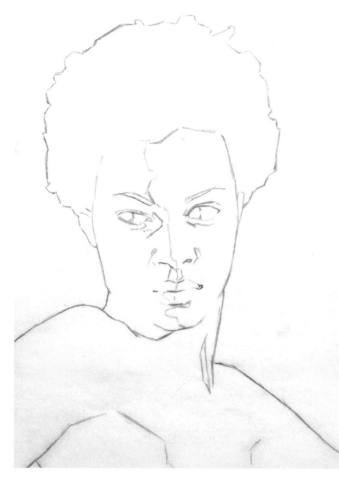

STEP 1 Begin the portrait by blocking in the shape of the head, starting with the hair. Next place the features using simple straight lines, without getting too involved. When you feel confident of the placement and size of everything, it's time to begin developing the drawing.

STEP 2 At this stage, fill in the shadow shapes, which helps show the anatomy of the face and how light moves across the form. Fill in the value of the hair as one big shape. In addition to separating the light side from the shadow side of the face, also indicate the darkest values of the portrait.

It's easy to become attached to the idea of drawing the perfect eye or mouth, but foundation is key. You won't produce perfect features without first determining their correct size and placement.

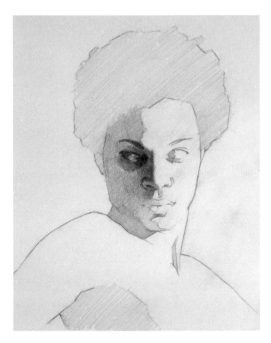

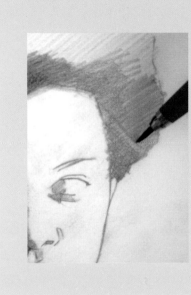

When building up graphite, it can be tricky to push darker without developing a shine that ruins the texture of the paper. One solution is to gently apply the graphite in a crosshatching pattern. This method gradually darkens the paper without destroying it.

STEP 3 At this point, begin "pushing" values, or taking advantage of the full value range. The white paper establishes the lightest value. On the other end of the spectrum, push the shading on the darkest values with an HB pencil.

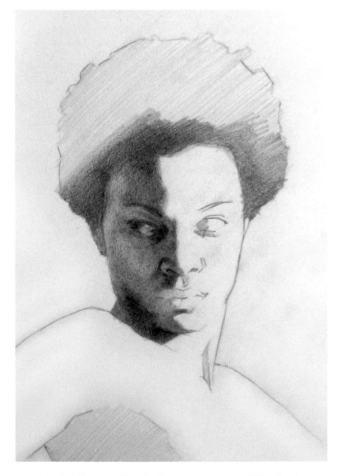

STEP 4 Continue working in the same manner, filling in the middle-value variations. Use crosshatching to develop the values and graduate the darks toward the lights. Nothing on the shadow side of the face will remain as light as on the opposite side.

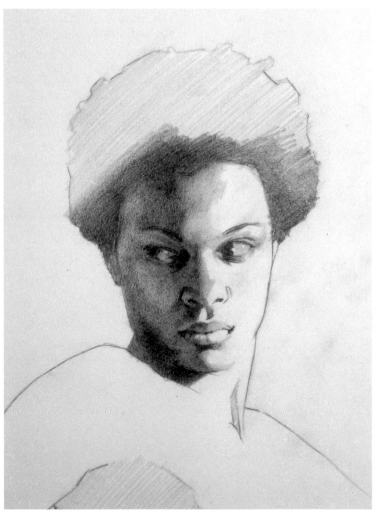

STEP 5 Now begin work on the light side of the face, starting with the darker values and moving toward the light. Beginning with the eye, fill in the individual shapes of the dark values; these shapes convey the model's anatomy and reveal the flow of light over the form.

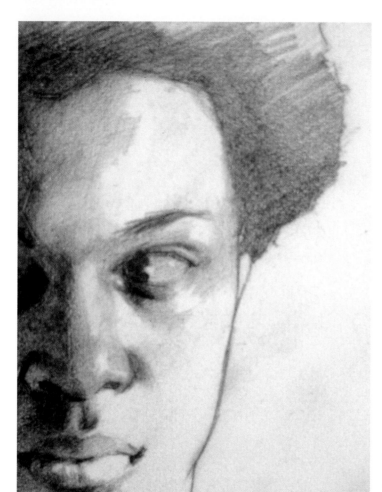

STEP 6 When working over the light side of the face, apply patience, a light touch, and a bit of technique to develop the proper shapes and keep the skin feeling smooth and natural. Develop the dark shapes first and then lightly fill in the lighter ones.

WORKING WITH BASIC SHAPES & VOLUMES

Look closely at any object and you'll see that it is made up of basic shapes and—if you look further—basic forms. For example, the human body is made up of stacked and skewed spheres and cylinders. Focusing on these forms and suggesting them on the paper as you build a sketch will help you produce a more accurate three-dimensional quality.

View the exercise at right by artist Lance Richlin. At top is his rendition of Michelangelo's study for the Libyan Sibyl. At bottom, he has reduced the figure to its most basic forms, exaggerating the shadows and minimizing the surface shading to emphasize the volumes. These volumes represent bumps and bulges that might lie within the body, indicating the underlying structure. Try creating a volume study of your own subject to better understand its forms.

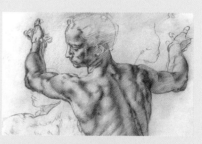

Study of Michelangelo's Libyan Sibyl on the Sistine Chapel by Lance Richlin

Interpretation of the forms based on Michelangelo's work by Lance Richlin

When you run a pencil very lightly over a light-value area, it creates a kind of "glazing" effect, which pulls together all the values and unifies the shape—marrying varied values while still retaining their distinct shapes. It's a great technique for problem areas, where individual shapes draw too much attention.

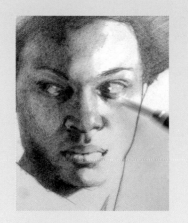

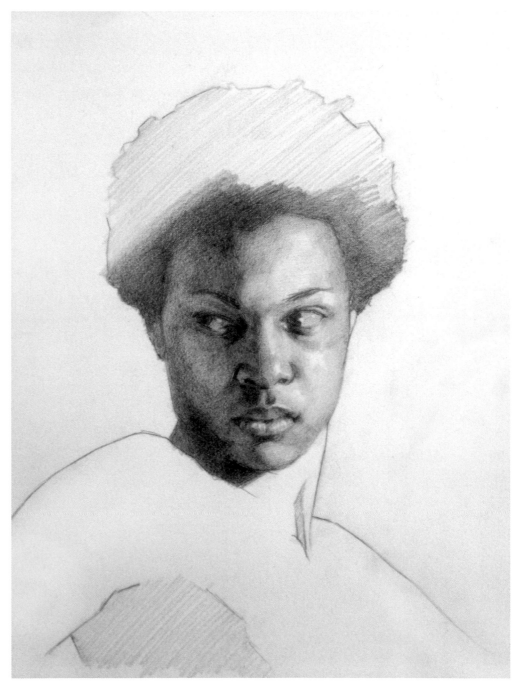

STEP 7 The final step requires nothing more than refining the established shapes and values. Locating and developing these subtle value shifts gives the illusion of a three-dimensional face. Use an H pencil, perfect for compressing values; because the pencil is so hard, it leaves only a faint indication of graphite behind.

CHARCOAL

Charcoal is one of the most versatile drawing media available, capable of rich, velvety darks, easily achieved midtones, and subtle shading differences. It is an easy medium to learn, albeit messy—and there are ways to control that characteristic. A full range of tonal values can be developed much faster and easier with charcoal than with graphite. Unlike graphite, charcoal also lends itself very well to blending with a cloth, stump, or even a finger.

RECOMMENDED SUPPORTS
- Newsprint
- Rough drawing paper
- Fine-toothed drawing paper
- Cold-pressed paper
- Laid drawing paper
- Toned paper (with tooth)

Note: Some manufacturers offer "charcoal paper." This surface generally has a laid finish or fine tooth.

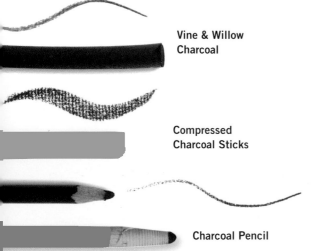

Vine & Willow Charcoal

Compressed Charcoal Sticks

Charcoal Pencil

TYPES

Charcoal is available in three basic forms, which feel and look very different from one another. It's important to experiment and find the one that suits your personal preferences.

Vine & Willow Charcoal
These lightweight, irregularly-shaped rods of charcoal are made of burnt grapevine and willow tree. Vine produces a gray line, whereas willow produces black. Both types can be easily brushed away from paper, making them a common choice for preliminary sketches on a canvas before oil painting.

Compressed Charcoal Sticks
Compressed charcoal is mixed with a binder, such as gum, which makes it adhere more readily to paper and produces creamier strokes than vine or willow charcoal. Compressed charcoal sticks come in a range of hardnesses, including soft, medium, and hard—or they are listed by number and letter, similar to pencil hardness.

Charcoal Pencils
These compressed charcoal tools in a pencil format offer maximum control, allowing you to create fine, precise strokes. Some are wood-encased, so you can sharpen them as you do graphite pencils. However, some charcoal pencils have tips wrapped in paper. To expose more charcoal, simply pull the string to unwrap the paper. Hone the tips with a sandpaper pad or knife. Charcoal pencil sets usually come with a white "charcoal" pencil (which is usually made of chalk and a binder—not charcoal). You can use this pencil with your black charcoal pencils to create dramatic images on toned paper.

CHARCOAL TECHNIQUES

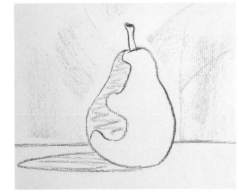

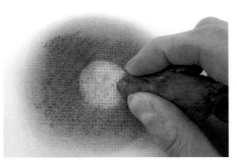

Preliminary Sketches

Artists often use vine or willow charcoal to create preliminary sketches before painting in oil, delineating outlines and areas of value. You can remove this type of charcoal easily with a kneaded eraser or dust it away with a bristle brush.

Negative Drawing

Because charcoal lifts easily from the paper, some artists choose to draw in the negative. This refers to first applying charcoal tone and then "drawing" with erasers, most often dabbing up tone with a kneaded eraser to model your forms.

Shading & Stroke Direction

Because the dark, rough strokes of charcoal are especially visible in shading, you might choose to shade using strokes (or hatch lines) that follow the same direction—especially if you plan to leave your strokes unblended.

 Charcoal pencil tips break easily, especially when using a handheld or electric sharpener. You may find it easiest to sharpen them with a knife and then hone the tip with a sandpaper pad.

CHARCOAL EXAMPLES

Blending

Blending charcoal is similar to blending graphite. Above is compressed charcoal over laid-finish paper, blended with a chamois (on left) and a blending stump (on right).

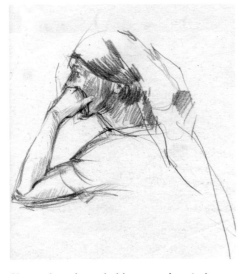

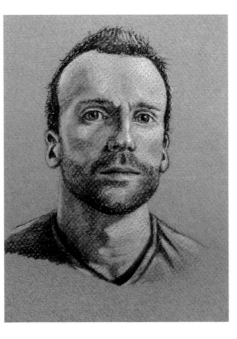

Charcoal produces bold, expressive strokes and is easy to blend, making it ideal for quick life drawing sketches and gesture drawings.

Many artists opt to draw on toned paper. The value of the paper acts as a middle value to which you can add shadows and highlights. Because a middle value is already in place, you can develop forms quickly and boldly.

CAST DRAWING

A tonal drawing from cast sculpture is a great introduction to using charcoal to indicate the tonal range across a fully lit form. Cast sculptures can be found and purchased online, as well as from local statuary stores.

Remembering that all good drawings start with an overall gesture sketch, begin by considering composition, placement on the page, size, etc. Small thumbnail sketches at the outset are a very valuable tool for composing and cropping the subject (A).

Once the gesture drawing is lightly sketched in, refine the drawing for accuracy, checking the proportion, understanding perspective angles, and lining up structures horizontally and vertically. This initial sketch can be developed with vine or willow charcoal and then strengthened and refined with charcoal pencil. You may find it helpful to work on tracing paper as well, as you develop your skills, so that you can experiment with changes before committing them to your final piece.

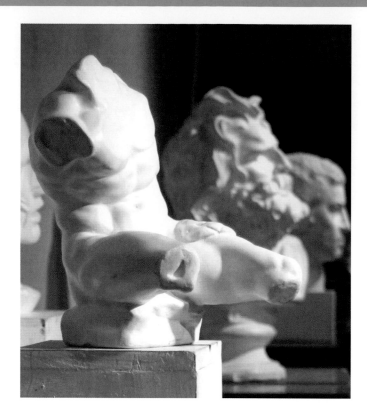

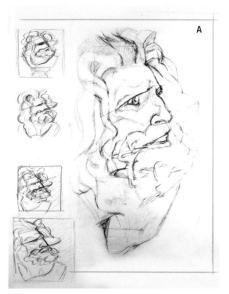
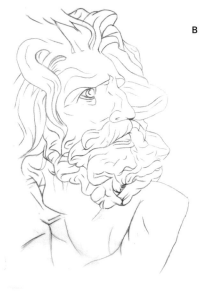
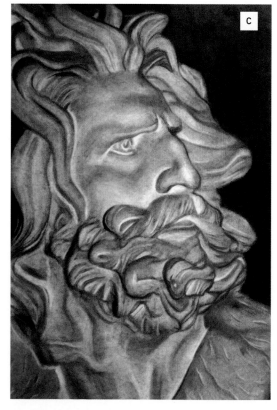

Once the sketch is refined on tracing paper, it can be transferred to a suitable drawing surface by rubbing charcoal over the back of the sketch and tracing the contour lines to transfer the line drawing to the drawing paper (B). After transferring a clean sketch to drawing paper, it is ready for tonal development (C).

Final charcoal drawing by student Huy Huynh.

Chiaroscuro

Chiaroscuro depends on an understanding of direct light, transitional light to shade, core shadow, reflected light, and cast shadow. This is the lighting phenomenon that you see on the subject. Next let's discuss the actual application of charcoal to create this lighting situation accurately.

Tonal Contrast

How we perceive the actual values of a subject depends on the contrasting relationship of values that are adjacent to it. The dark background for this cast statue creates more contrast between the subject and the background, as well as a low-key and dramatic lighting situation. Tonality is a relative situation, based on the effects of lighting and adjacent values. When you compare the statues to the right, you can see the relative differences in the appearance of the values, especially in the shaded areas—particularly the core shadows, which appear darker in the statue with the lighter background.

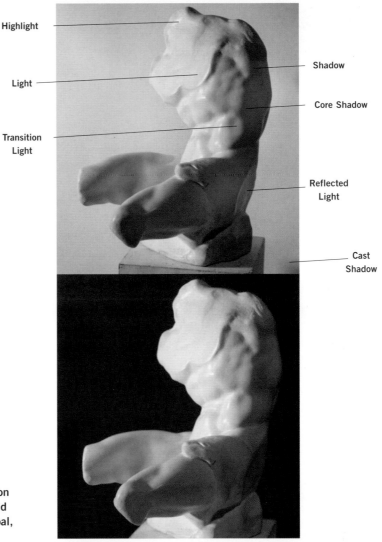

Highlight

Light

Transition
Light

Shadow

Core Shadow

Reflected
Light

Cast
Shadow

This is the same lighting situation as above, with the exception of a dark background. This arrangement is more dramatic, and dark-value backgrounds are fairly easy to develop with charcoal, compared to most other drawing media.

Use a variety of charcoal to create this scale from very light to rich, velvety black. From left to right: vine charcoal, compressed charcoal, and charcoal pencil, all blended with a chamois or tissue.

Tonal Techniques with Charcoal

Start with a value scale like the one above, using all the charcoal materials you plan to use in your drawing. It's important to remember that using lighter to darker tools—and generalized techniques before details—is a key to success.

The best way to fully understand the strengths and weaknesses of each material is to experiment. Most people work best when they have all these tools at their disposal, along with a logical progression in which to use them.

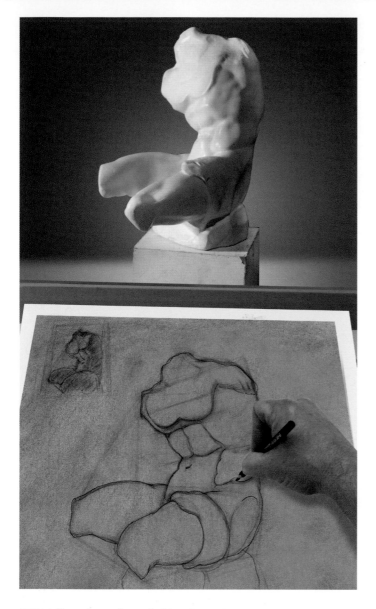

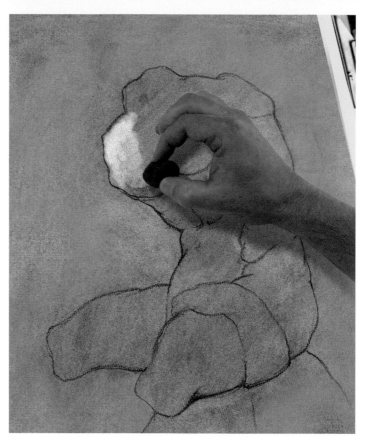

STEP 2 Next begin to pull out the generalized lighting on the form with a kneaded eraser. Don't attempt to achieve too much detail at this stage; it will likely disappear and need to be redone toward the end of the tonal process.

STEP 1 Tone the surface of white charcoal paper with vine or willow charcoal, stroking across the paper with the side of the charcoal. Then rub softly with a chamois or tissue. After sketching a small thumbnail in the upper corner, create an overall gesture sketch with a stick of vine charcoal, which is light, soft, and easily changeable. When you're satisfied with the sketch, go over it lightly with a hard or medium charcoal pencil.

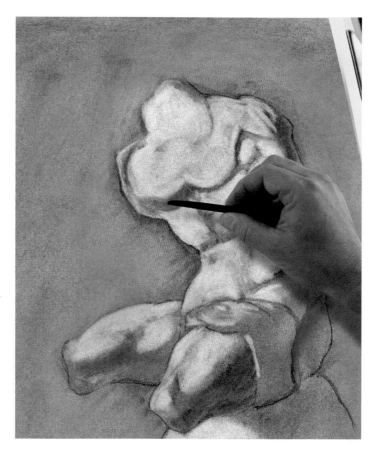

STEP 3 After pulling out the generalized lights, add in the overall shadows—the third value—with vine or willow charcoal.

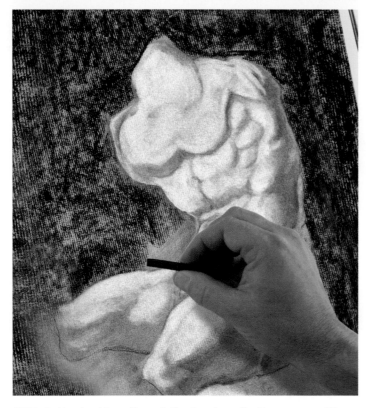

STEP 4 About midway through the tonal application process, it's a good idea to block in the background value, especially if it is a dark background. This makes it easier to judge the values within the subject.

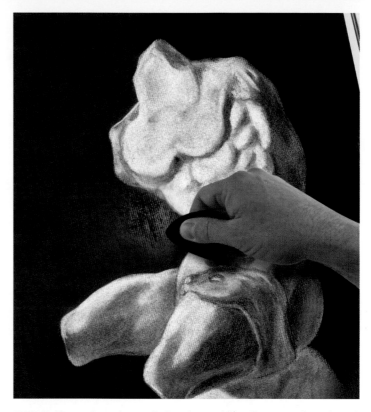

STEP 5 Use a chamois to rub the charcoal into the paper for soft and even tone. Compressed charcoal provides a velvety, rich black. At this point, apply a light spray of workable fixative over the entire surface to help adhere the compressed charcoal to the paper.

STEP 6 Apply the finishing touches. Clean up and refine the edges with a kneaded eraser. Then use charcoal pencils (soft grade), to create dark core shadows and cast shadows on the form. You can use a stump or tortillon to smooth the darker surfaces. Finally, use a white charcoal pencil sparingly to accent the lights and create highlights. It is best not to blend whites, as it tends to muddy them; use the whites conservatively, and leave them alone.

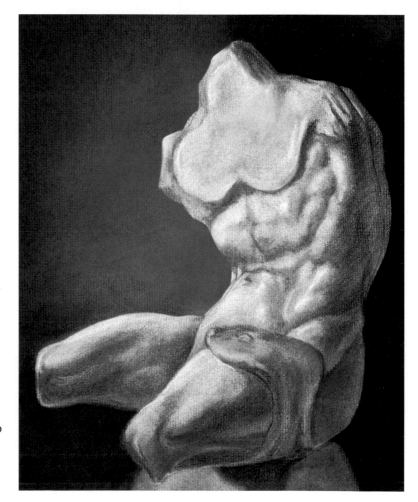

FIGURE DRAWING AND CHARCOAL

The speed at which the artist can attain a full value range makes charcoal a natural medium to use for figure drawing. Charcoal can be used for 1- to 2-minute gesture drawings, as well as intermediate poses of 20 to 40 minutes and, of course, for tonal drawings of longer duration. When used on toned paper, the addition of white charcoal for lights and highlights can be expedient as well as dramatic.

This is a 1-minute student gesture drawing in vine charcoal.

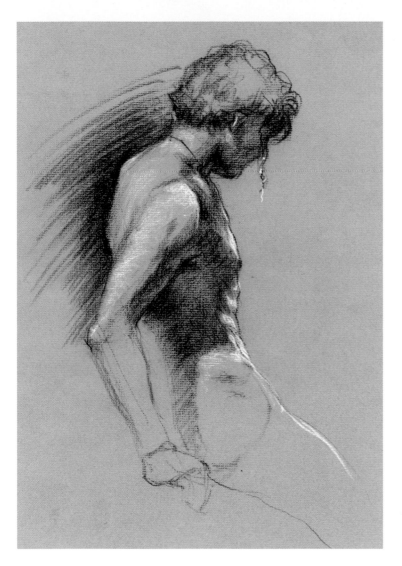

Here is a quick study in black and white charcoal pencil on toned paper. On this middle-value paper, the paper tone becomes the middle value for the softer shadows and reflected light on the figure. The use of white pencil is limited, as it can too easily dominate the value structure.

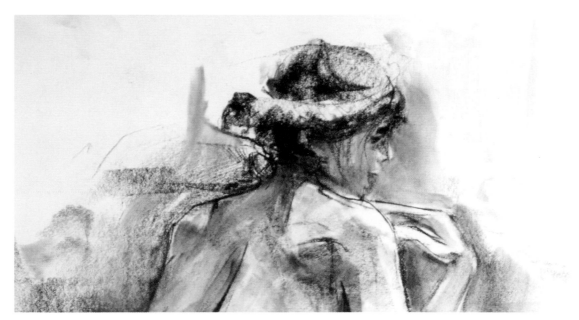

Charcoal has been used for centuries by artists wishing to portray the human body with dramatic form, mass, volume, and effective tonality. Student charcoal drawing by De Tran.

CONTÉ CRAYON

Also called sketching crayons, sketching sticks, or Conté sticks, Conté crayon is a simple and expressive medium composed of pigment, graphite, and fine clay. The thin, rectangular sticks (with a square cross-section) resemble pastel.

RECOMMENDED SUPPORTS

- Medium drawing paper
- Rough drawing paper
- Fine-toothed drawing paper
- Cold-pressed paper
- Toned paper

TYPES

Most often available in black, white, gray, sanguine (reddish-brown), bistre (brown umber), and sepia, Conté crayons deliver rich, textured strokes that glide easily across the paper. They work well for creating quick sketches, such as life drawing studies, but you can also use them to create realistic renderings.

Conté crayons were invented near the end of the eighteenth century in France, and they continue to be used today—especially for drawing the human figure. Their warm, rich tones of sanguine, terra cotta, sienna, and black lend a unique tonal quality to a drawing that few other mediums can. Though waxier than charcoal, with a claylike feel, Conté crayons can be used like charcoal. This medium has hard edges that can be used to draw fine, semi-permanent lines, and it also has superior blending capabilities. Conté crayons come in sets containing several different shades of red and brown, as well as gray, black, and white. They are a very versatile and tactile tonal drawing medium that every serious drawing student should try.

Shown at left are Conté sticks on medium drawing paper. You can use them to produce tight lines, broad strokes, and lightly blended areas of tone. If desired, sharpen the sticks using a sandpaper pad. Conté is also available in pencil form for finer strokes.

COPYING THE MASTERS

A great way to improve your drawing technique, with any medium, is to copy a Master drawing, working in the style of the Master artist. Working with the same tools and in the same style and line quality as the Master artist, you will learn to bring that type of quality, and perhaps spontaneity, to your own work. Conté crayon and charcoal are excellent media for replicating the type of tonality and line work used by the Masters.

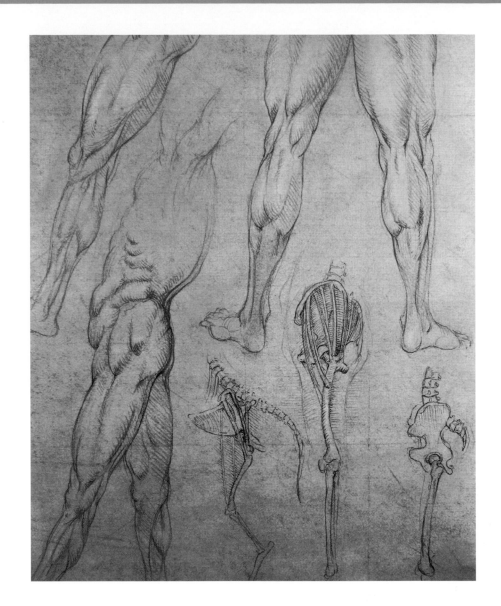

Conté crayon does respond to erasers, particularly art gum and kneaded; however, it can smear and does not come off the surface entirely.

Artists often pair Conté crayon with toned paper, such as gray, cream, or light brown. If using a gray support, artists work with black and white Conté; if using a cream or light brown support, artists generally work with sanguine and white Conté.

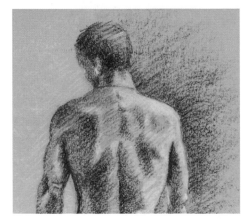

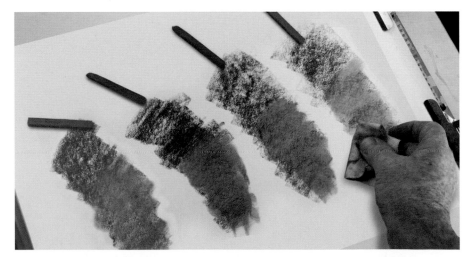

Conté crayons typically come in a variety of earth tones historically related to the color of the soil in different parts of France. They contain a waxy binder that gives them a silky, smooth application and appearance. This range includes a very dark brown (bistre), as well as a very light, reddish orange (sanguine).

COLORED PENCIL

Colored pencils have come a long way from the tools we remember using in grade school. Artists from around the world have picked up these little wood-encased sticks of pigment and taken gallery owners and the viewing public's breath away with their finely crafted works of art.

TYPES

Colored pencils are wood-encased leads made of pigment and wax or kaolin clay. Wax is more common and affordable. The wax leads are soft and allow for smooth, controlled blends. This medium works well on multiple surfaces, from smooth to rough to toned surfaces. Many artists find it easiest to work on a surface with at least a slight tooth. Colored pencils have a multitude of great attributes to offer both the budding and seasoned artist. They are portable, inexpensive, non-toxic, user friendly, and for those interested in exploring their full range, absolutely indispensable. Artistic styles from loose and sketchy to fully developed photo-realistic "paintings" can all be achieved through this medium. You are only limited by the boundaries of your own imagination and your willingness to try.

Colored pencil artwork requires few supplies, but you may find the following helpful:
- Drawing board
- Electronic pencil sharpener
- Erasers
- Drafting brushes (to sweep pencil crumbs)
- Artist tape (to hold your paper in place)

Shown are wax-based colored pencils. A set of 24 colors offers a good starting point for beginners, covering the spectrum of color plus white, black, gray, and browns.

RECOMMENDED SUPPORTS
- Smooth drawing paper
- Medium drawing paper
- Fine-toothed drawing paper
- Bristol board
- Toned paper

COLORED PENCIL TECHNIQUES

Varying Strokes

Experiment with the tip of your pencil as you create a variety of marks, from tapering strokes to circular scribbles.

Gradating

To create a gradation with one color, stroke side to side with heavy pressure and lighten the pressure as you move away, exposing more of the white paper beneath the color.

Hatching & Crosshatching

Add shading and texture to your work with hatching (parallel lines) and crosshatching (layers of parallel lines applied at varying angles).

Layering

You can optically mix colored pencils by layering them lightly on paper. In this example, observe how layering yellow over blue creates green.

Stippling

Apply small dots of color to create texture or shading. The closer together the dots, the darker the stippling will "read" to the eye.

Burnishing

For a smooth, shiny effect, burnish by stroking over a layer with a colorless blender, a white colored pencil (to lighten), or another color (to shift the hue) using heavy pressure.

Blending

To blend one color into the next, lighten the pressure of your pencil and overlap the strokes where the colors meet.

Scumbling

Create this effect by scribbling your pencil over the surface of the paper in a random manner, creating an organic mass of color.

COLORED PENCIL EXAMPLES

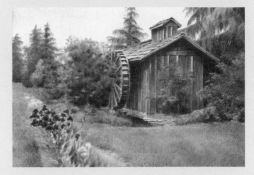

Some artists use colored pencil on toned papers. In this example, artist Eileen Sorg applies colored pencil over black paper for dramatic, glowing results.

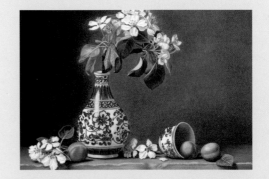

Artist Cynthia Knox uses colored pencils to create a classic and photo-realistic still life, imitating the luminous quality of oils.

WARMING UP

Just as you warm up before exercising, it helps to limber up your drawing muscles (including the right side of your brain) for the task at hand (pun intended). On a piece of scratch paper, play with different scribbles and lines, change the pressure, and try holding your pencil in a different way.

Experimenting with Lines

Warm up by drawing random squiggles and lines. Familiarize yourself with the different types of lines your pencils can create, and experiment with every kind of stroke you can think of, using both a sharp point and a blunt (dulled) point. Practice the strokes at right to help you loosen up.

Holding the Pencil

The way you grip the pencil will have a direct impact on the strokes you create. Some grips will allow you to press more firmly on the pencil, resulting in dark, dense strokes. Others hinder the amount of pressure you can apply, rendering your strokes lighter. Still others give you greater control over the pencil, allowing you to create fine details. Experiment with each of the grips below.

CONVENTIONAL GRIP For the most control, grasp the pencil the same way you write, with the pencil resting firmly against your middle finger. This grip is perfect for smooth applications of color, as well as for making hatch strokes and small, circular strokes. Try to relax and let the pencil glide across the page.

OVERHAND GRIP Guide the pencil by laying your index finger along the shaft. This is the best grip for strong applications of color made with heavy pressure.

UNDERHAND GRIP When you cradle the pencil in your hand, you control it by applying pressure only with the thumb and index finger. This grip can produce a lighter line, but keep in mind that when you hold the pencil this way, your whole hand should move (not just your wrist and fingers).

CREATING FORM

Value is the term used to describe the relative lightness or darkness of a color (or of black). By adding a range of values to your subjects, you create the illusion of depth and form. Color can confuse our eyes when it comes to value, so a helpful tool can be a black-and-white copy of your reference photo (if you're using one). This will take color out of the equation and leave only the shades of gray that define each form. Value defines form, not color, so if you choose the appropriate values, the color isn't important—you can draw purple trees or blue dogs and still captivate your viewers.

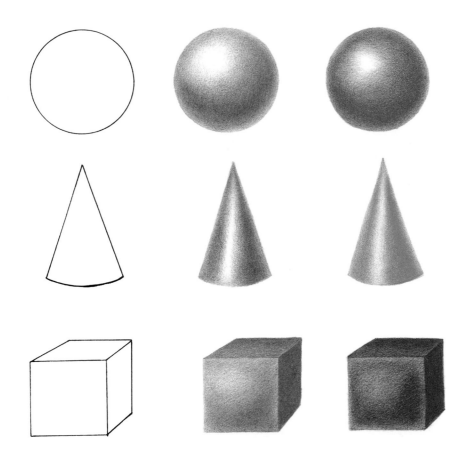

Creating Form with Value

In this example, you can see that the gray objects seem just as three-dimensional as the colored objects. This shows that value is more important than color when it comes to creating convincing, lifelike subjects. It's a good idea to practice this exercise before you begin the projects so you can get a handle on applying values. First draw the basic shape. Then, starting on the shadowed side, begin building up value, leaving the paper white in the areas where the light hits the object directly. Continue adding values to create the form of the object. Squint your eyes to blur the details so you can focus on the value changes. Add the darkest values last. As the object gets farther away from the light, the values become darker, so place the darkest values on the side directly opposite the light.

Value Scale

Another helpful tool for understanding value is a value scale showing the progression from white (the lightest value) to black (the darkest value). Most colored pencil brands offer a variety of grays, which are distinguished by naming them either "warm" or "cool" and then adding a percentage to indicate the concentration of color, such as "cool gray 20%." (Lower percentages are lighter.)

COLOR AND VALUE

When drawing animals like this tree frog, subtle shifts in color and value are important for defining the animal's anatomy. In this project, the grays on the throat and the oranges on the feet are layered to help create the illusion of roundness and dimension. Delicately changing the amount of pressure you use when applying color is very helpful to create realism when drawing live subjects.

Colored pencil does not lift from the paper as easily as graphite or charcoal; some residue will almost always stay behind. If you must erase, an electric vinyl eraser will deliver the best results.

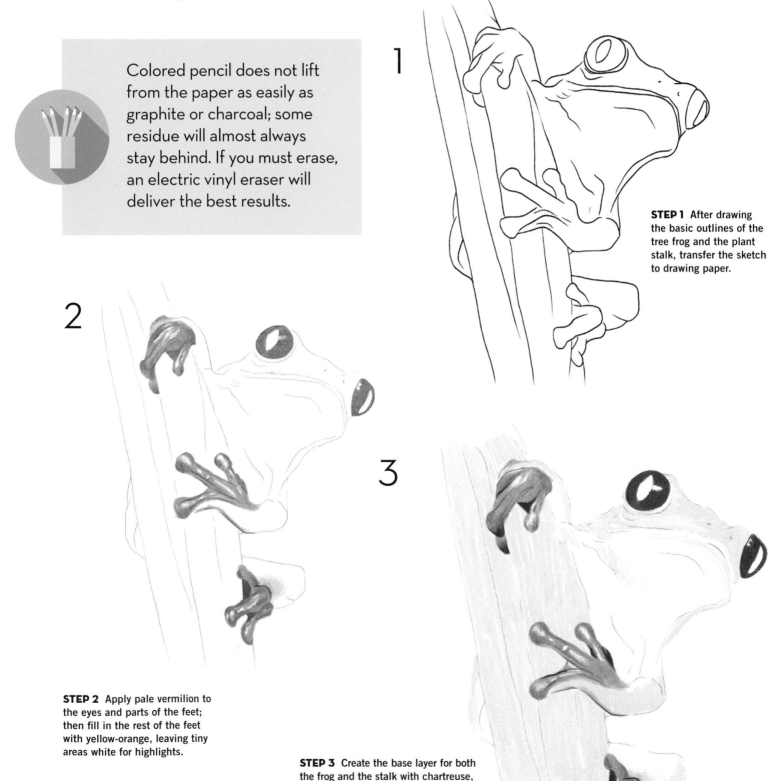

1

STEP 1 After drawing the basic outlines of the tree frog and the plant stalk, transfer the sketch to drawing paper.

2

3

STEP 2 Apply pale vermilion to the eyes and parts of the feet; then fill in the rest of the feet with yellow-orange, leaving tiny areas white for highlights.

STEP 3 Create the base layer for both the frog and the stalk with chartreuse, leaving areas of the frog white for now. Then apply crimson red to the eyes and the deepest shadows on the feet.

4

5

STEP 5 Fill in the pupils, nostrils, and dark areas on the feet with black. Then shade the throat and chest with warm gray 20% and some black. Continue to deepen the stalk and frog with grass green.

6

STEP 4 Use spring green on the stalk and the frog's eyes and legs. Then apply true blue to the frog's mouth, legs, and parts of the chest.

STEP 6 Add shadows to the stalk with a layer of green ochre followed by black cherry. To finish, use black cherry to brighten up the shadows on the frog's throat and chest.

TEXTURE

The photo of this lovely yellow rose reveals a singular water droplet on the lower petal. Raindrops and dewdrops give flowers a fresh appearance, and they are quite simple to draw. Stroke in the direction of the petals' natural lines and add color in layers to define the softness and dimension of the flower.

STEP 1 Outline the exterior of the rose with black to establish the background edging. layer the large top petal with jasmine and yellowed orange. Then add orange in the dark areas. With yellow ochre and then a burnishing of white, complete the base coat. Then use pumpkin orange and a touch of crimson red in the reddish areas.

STEP 2 Still working on the outer petals, build up the shadow areas with burnt ochre and blend with yellowed orange and canary yellow. For the bright reddish areas, add a crimson red topcoat. Then use dark umber on the left petal, and burnish everything with white.

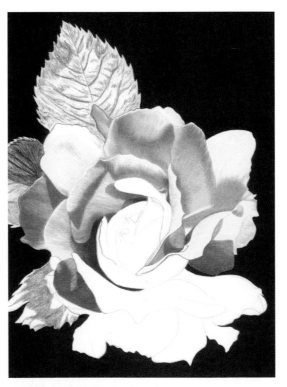

STEP 3 In the background, create a rich, dense hue first with black, then Tuscan red, indigo blue, and a final burnish of black. Give the background leaves an initial coat of black using light pressure.

When using wax-based pencils, your work may develop bloom—a light fog over the drawing as a result of wax rising to the surface. To eliminate this, let the drawing sit for two weeks and then rub a tissue, cotton ball, or cotton pad gently over the blooms to catch and remove the wax.

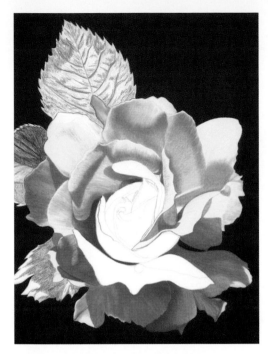

Lightly outline the water drops and fill them in with goldenrod. Then blend them down using white.

STEP 4 On the lower left petals, follow a jasmine wash with pumpkin orange. Then apply orange, crimson red, yellowed orange, and canary yellow. For the highlights, use jasmine, white, and pumpkin orange.

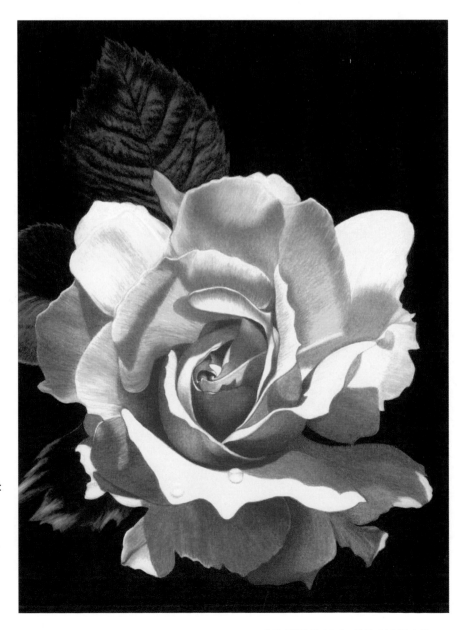

STEP 5 Add jasmine and pumpkin orange at the bud's base. Next layer yellowed orange over both sides and cover the red area to the left with Tuscan red. Then use crimson red with a light, circular touch on both sides of the bud and canary yellow for the yellow areas. For the orange areas of the bud, use yellowed orange, pumpkin orange, orange, and finally crimson red.

PASTEL

Pastel is considered both a drawing and a painting medium, combining the best of both worlds. It offers rich color and painterly effects without the hassle of wet media. It is versatile in appearance; you can create delicate strokes, bold strokes, soft blends, rough textures, or airy sketches. Because pastel involves no drying time, the colors stay as true as the moment you stroke, making it perfect for the spontaneous artist who treasures immediate results.

RECOMMENDED SUPPORTS
- Rough drawing paper
- Fine-toothed drawing paper
- Sanded pastel paper
- Cold-pressed paper
- Laid drawing paper
- Toned paper (with tooth)

Note: Some manufacturers offer "pastel paper" or "sanded pastel paper." These surfaces generally have a mesh or finely rough texture, respectively.

SOFT PASTELS

Pastels are powdered pigment mixed with a binder of methyl cellulose, gum arabic, or gum tragacanth. They are available in both hard and soft varieties, with the softer pastels containing a higher pigment-to-binder ratio. Paper is an important part of the pastel equation. No matter what type of pastel you choose, work on paper that has a textured surface so the raised areas catch and hold the pastel. You might also opt for toned paper, which enriches the colors with a subtle, uniting hue and prevents distracting bits of white paper from showing through. If desired, sharpen your pastels using a sandpaper pad.

Shown are soft pastel sticks accompanied by short strokes over laid paper. A set of 24 colors offers a good starting point for beginners, covering the spectrum of color plus white, black, gray, and browns. Soft pastel is also available in pencils, which wear down quickly but reduce the mess of pastel on your fingers.

SOFT PASTEL TECHNIQUES

Unblended Strokes
To transition from one color to another, allow your pastel strokes to overlap where they meet. Leaving them unblended creates a raw, energetic feel and maintains the rhythm of your strokes.

Blending
To create soft blends between colors, begin by overlapping strokes where two colors meet. Then pass over the area several times, using a tissue, chamois, or stump to create soft blends.

Gradating
A gradation is a smooth transition of one tone into another. To create a gradation using one pastel, begin stroking with heavy pressure and lessen your pressure as you move away from the initial strokes.

Stroking over Blends
You can create rich colors and interesting contrasts of texture by stroking over areas of blended pastel.

Scumbling
This technique involves scribbling to create a mottled texture with curved lines. Scumble over blended pastel for extra depth.

Masking
Use artist tape to create clean edges in your drawings or to mask out areas that should remain free of pastel.

Generally used alongside with soft pastel, hard pastel is less vibrant and is best for preliminary sketches and small details. Like soft pastel, hard pastel is available in both sticks and pencils.

CREATING DEPTH & FORM

Let's put some of your newfound knowledge to use in a simple step-by-step demonstration. Using this drawing of a single apple, learn to convey light and shadow with color to achieve depth and form for a realistic painting.

To clean your pastel sticks, place them in a shallow container of cornmeal or raw ground rice. Be sure to wipe your hands on a cloth or paper towel when you switch colors.

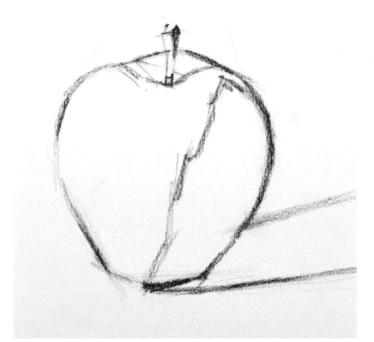

STEP 1 Draw the outside shape of the apple and the edge of the cast shadow on the table. Then draw the division of light and shadow on the apple.

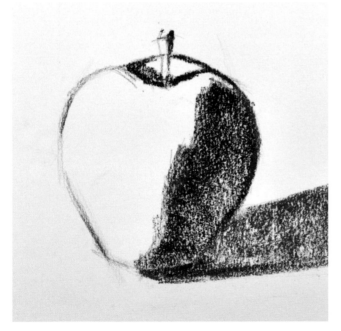

STEP 2 Fill in the shadow shapes with side strokes of soft pastel, using light pressure. Keep the shapes simple at this point.

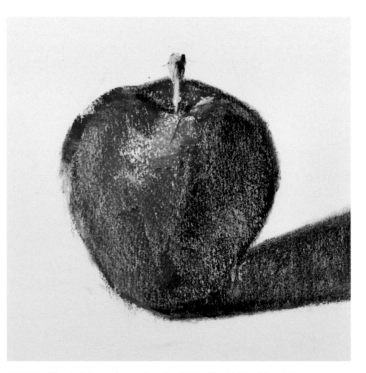

STEP 3 Use bright, crisp colors to fill in the light side of the apple. Blend to transition colors and create a gradation of light and shadow.

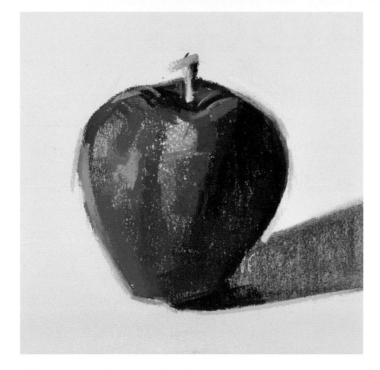

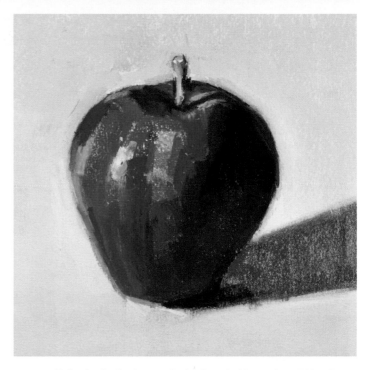

STEP 4 Restate the darks with soft pastel. Apply heavier, more colorful strokes to the light side of the apple.

STEP 5 Paint in the background with broad side strokes. This allows you to adjust the shape of the apple by blending and overlapping edges. Apply the highlights in soft pastel.

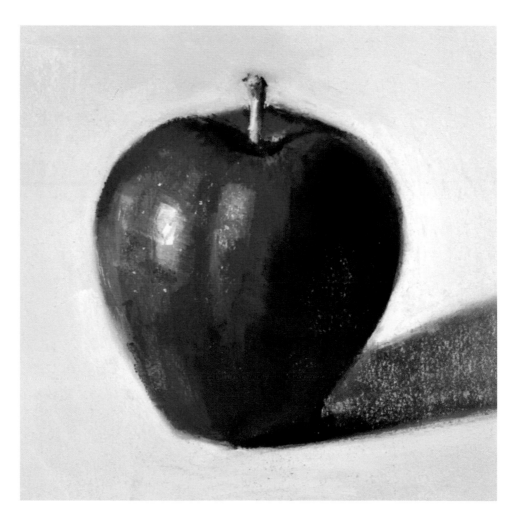

STEP 6 Blend and refine the surface of the apple. Apply stippling and linear strokes to convey the texture of the skin. Refine the edges to finish.

WORKING WITH EDGES

In this demonstration, we'll explore how to create the impression of colorful fall foliage without actually painting all those leaves. We'll also discuss how to handle edges between the sky, land, and trees to produce a dazzling painterly effect.

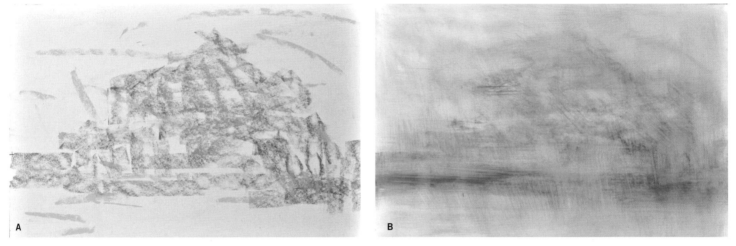

STEP 1 Begin by applying soft pastel in shades of yellow and golden ochre to develop a warm glow in the underpainting (A). Even at this initial stage, look to establish the overall shape of the cluster of trees. Then apply a light wash of mineral spirits with a hake brush. Notice how the grainy strokes of pastel become transparent and look like wet paint (B). The wash will dry within minutes.

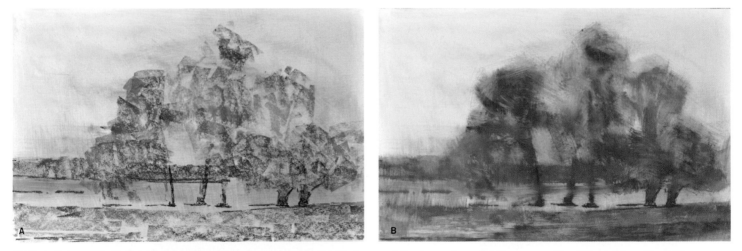

STEP 2 Using side strokes of soft pastel, begin to mass in the basic shapes of the trees, foreground grass, and background tree line with greenish ochre, orange, and burnt sienna tones. For the thinner trunks and the division of the shapes, use linear strokes (A). Then take a hake brush and a light wash of mineral spirits and drag the brush lightly over the pastel to fuse these areas together into blurry soft-edged masses (B). Be sure to allow the edges to bleed together and overlap.

STEP 3 Using side strokes of soft pastel, begin to paint in the blue sky and river, changing the direction of your strokes often. Now is also the time to begin creating short choppy strokes and flicks within the trees to suggest sky holes peeking through the foliage.

Washes are an exciting way to create a wet, transparent look. You can apply a wash of alcohol, water, or mineral spirits over your pastel strokes to achieve this painterly effect. Just remember that you must use a sanded surface that is compatible with washes.

STEP 4 The darkest values of the painting are the greens. Use a few different shades of green, from very dark to warm middle values that anchor the foreground grass, the shaded area of the trees, and the background tree line in shadow. Then apply dark brown to develop the trunks and branches, using linear strokes of soft pastel.

STEP 5 Continue to add colorful reddish strokes to the tree foliage. Mix in some mauve sparkles to the trees and the background. Then switch back to the sky and build up more strokes all along the edges of the trees and background.

STEP 6 Now it's time to restate the darks with more careful attention to detail. Resist the urge to blend at this stage! Just build up strokes in a mosaic effect. Add warm greenish lights to the trees and foreground grass where it is lit by the sun.

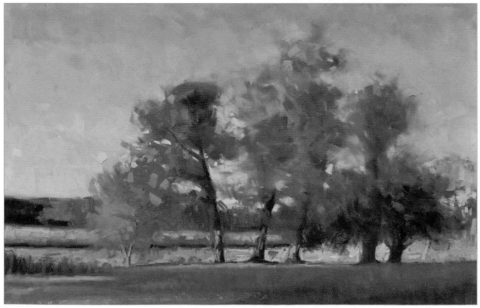

STEP 7 Use your pinky finger and carefully drag it across the strokes to fuse the foliage together with the background. Blend and fuse the varied colors of the foliage together into unified masses. This sets up the painting for the final application of strokes.

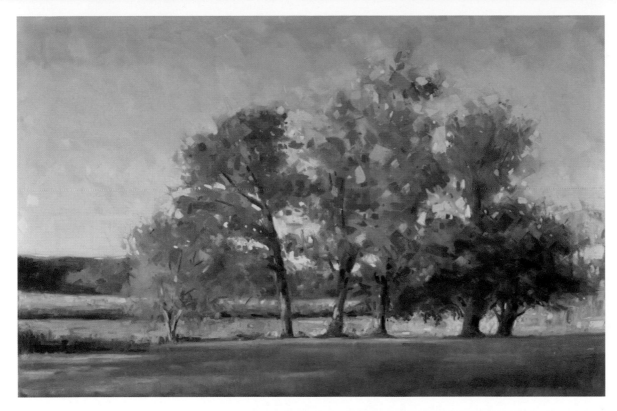

STEP 8 Now that you have established the soft transitions through blending, restate the dark accents with greens and add radiant strokes of red to create a dazzling shimmer of color. Boldly add orange and yellow ochre strokes to the lights.

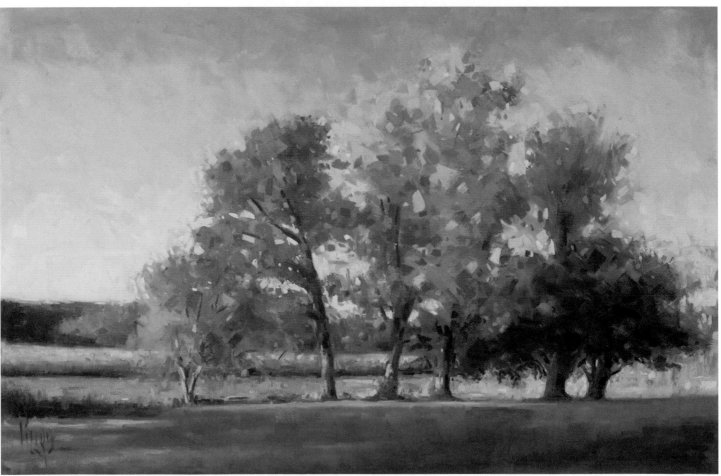

STEP 9 Refine the image by adding smaller strokes that convey the impression of detail in the trees, suggesting branches. Add more sky hole flicks of blue and violet and brighter yellow highlights in the sunlit grasses. Finally, add a few more radiant strokes of red and orange to the foliage to give a rich, saturated look to the painting. Resist the urge to overwork, keeping lots of unblended strokes that sparkle against the blue sky.

OIL PASTEL

Oil pastels are sticks of pigment mixed with oil and a wax binder, giving them a smooth, creamy consistency. Some manufacturers produce water-soluble wax pastels, which are not as creamy but can be used to create watery blends. Oil pastels are richly pigmented and allow for a combination of expressive mark-making and blended areas of tone.

RECOMMENDED SUPPORTS

- Any drawing paper
- Canvas
- Wood panel
- Stone, metal, glass, fabric, and even plastic!

Note: You can manipulate the consistency of oil pastel with linseed oil and solvents used in oil painting. However, be sure to work on primed canvas, board, or sized paper.

OIL PASTEL

Oil pastels harden but do not dry or crack as time passes, and they are compatible with almost any support. They are often used to accent or supplement other media; you can use them in conjunction with oil paint, as they respond to solvents, or even over dried acrylics or watercolor. However, you can also create wonderful works of art using only oil pastel.

PAPER TEXTURES

Oil pastel is very responsive to the texture of its support. Shown here is oil pastel on rough paper, laid paper, vellum-finish Bristol board, and toned pastel paper.

Rough Paper

Laid Paper

Vellum-Finish Bristol Board

Toned Pastel Paper

Shown is a small range of oil pastel sticks. A set of 24 colors offers a good starting point for beginners, covering the spectrum of color plus white, black, gray, and browns.

OIL PASTEL TECHNIQUES

Stroking
You can create a variety of expressive strokes with oil pastel, from tapered lines to stippled dots. Press and spin the end of round sticks for circular marks. Use the broad side of a pastel stick to create wide strokes that capture the full texture of your support.

Smudging
Use a clean finger, blending stump, tortillon, or a chamois to smudge the pastel into smooth coverage.

Scratching
Scrape away lines and designs in already-applied oil pastel using a sharp, stiff point such as the end of a paintbrush handle or a palette knife. You can "erase" oil pastel by scraping the color off the canvas.

Blending
You can blend colors by stroking one color vigorously into the next, overlapping strokes where the colors meet.

Working over Other Media
Oil pastel works well as a textural accent over other media such as watercolor (shown at left) or acrylic washes.

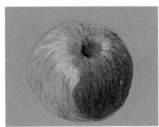

Working over Toned Paper
Applying oil pastel over toned paper unifies the drawing with a hue and creates rich colors quickly without too much buildup.

You may have to warm up your sticks before a drawing session to help the oil pastel spread smoothly on your support. Try warming them in your hand or holding them near a candle flame.

PEN & INK

Whether you are working with traditional dip pens or markers, pen drawing requires a developed, nuanced understanding of the instrument. Each pen delivers ink to the paper differently; the pressure, angle, speed, and stroke direction determine the length, width, intensity, and character of your strokes. Pen drawing usually involves distinct lines that, unlike other drawing and painting media, cannot be significantly altered once drawn. As a result, you must be comfortable, well practiced, and confident in your movements to find success.

RECOMMENDED SUPPORTS

- Smooth drawing paper
- Hot-pressed watercolor paper (especially if pairing with washes)
- Vellum paper
- Marker paper (especially if using spirit-based ink)

Dip Pen

Fountain Pen

TYPES

Pens vary in how they deliver ink to the paper, calling for different methods of handling and stroking. Experiment with as many types as possible and choose the pen that best suits your personal style.

Dip Pen

This traditional writing instrument features a long handle that attaches to a metal nib (or writing tip). When dipped in ink, the cupped shape of the nib holds a small amount of ink on its underside. Upon stroking the nib along paper, a slit in the metal splits a bit and allows ink to flow to the paper. The ink lasts for a few strokes, and then you must re-dip the nib.

Once you are comfortable with the instrument, you can create very expressive lines. This type of pen requires a great amount of practice to master; you need to get a feel for what angles work, how much pressure to apply, and how often to dip the pen. You must clean the pen after each use to prevent ink from drying and clogging the nib.

Fountain Pen

Like the dip pen, a fountain pen features a split metal nib. The pen's barrel includes a reservoir of ink (sometimes in cartridge form), which eliminates the need to frequently reload the pen. Fountain pen nibs are not quite as flexible as dip pen nibs, so the line quality is limited. Most fountain pens come with caps to prevent ink from drying on the nib.

Ballpoint Pen

A ballpoint pen has an ink reservoir in the barrel and a metal ball at the end that rolls along the paper, releasing ink onto the surface. This pen can create even strokes, subtly tapering strokes, or subtle bone strokes (which have a bit more weight at each end), depending on the amount of pressure applied. Because the ink is almost pasty in consistency, and nothing but gravity draws ink to the tip, this type of pen does not work at extreme angles or upside down.

Markers & Felt-Tip Pens

Markers and felt-tip pens deliver ink from a reservoir through fibers such as nylon. They can hold a variety of inks, including non-waterproof, waterproof, alcohol-based, and spirit-based.

Soft-Pointed Tip

This common tip shape has a rounded point and is available in a range of sizes. Use the tip for thin lines and the sides for thicker lines.

Brush Tip

The brush tip functions much like a firm paintbrush. The fibers taper at the tip, allowing you to adjust the width of lines based on the angle and amount of pressure you apply.

Chiseled Tip

This style of tip has a flat, angled edge that can be small and subtle or as wide as 2 inches for great coverage. It allows for thin, thick, or calligraphic strokes that vary in thickness.

Fine-Pointed Tip

This tip delivers ink to the paper through a fine bunch of fibers encased in a thin metal tube. The thin, consistent lines are great for architectural sketches, comic book inking, and general sketching.

Ballpoint Pen

Soft-Pointed Tip

Brush Tip

Chiseled Tip

Fine-Pointed Tip

TYPES OF INK

The ink you choose determines the flow, intensity, and durability of your medium. In addition to pen drawing, you can use many inks with a paintbrush or even an airbrush. Be sure to purchase acid-free ink for longer lasting artwork.

Nonwaterproof Ink This ink offers great intensity and flow, so it is less likely to clog in a nib. However, it is susceptible to smudging and runs if it contacts moisture.

Waterproof Ink This is a permanent, durable ink. Find an ink brand known for good flow, as waterproof inks are more likely to clog in the nib.

India Ink This carbon-based ink is known for its rich blackness and durability.

Acrylic Ink This water-based polymer ink is bold in color and waterproof when dry. It also mixes well with acrylic paints.

Alcohol-based Ink This quick drying ink is permanent, waterproof, and transparent, yielding vibrant colors that resist fading. These inks work well on glossy surfaces.

Spirit-based Ink This ink for felt-tip pens is permanent and waterproof. It holds up well for layering techniques and works best on bleedproof paper.

INK

Aside from carving in stone, ink is probably the most permanent of art media. Permanent India ink lasts as long as the paper on which it is drawn. This permanence can be intimidating for artists of any skill level; however, it does not need to be.

Ink has been used as a communication medium for thousands of years, and its versatility in print and the world of art makes it a medium that any artist should attempt to be comfortable with. It takes patience and practice to work successfully with ink, but the results are well worth the effort.

Organic subjects like this collection of exotic dried flowers are ideal for the beginning student's introduction to ink line drawing. Hard edges and straight lines can be avoided and replaced with long, flowing organic lines that offer the opportunity to gain confidence with the medium.

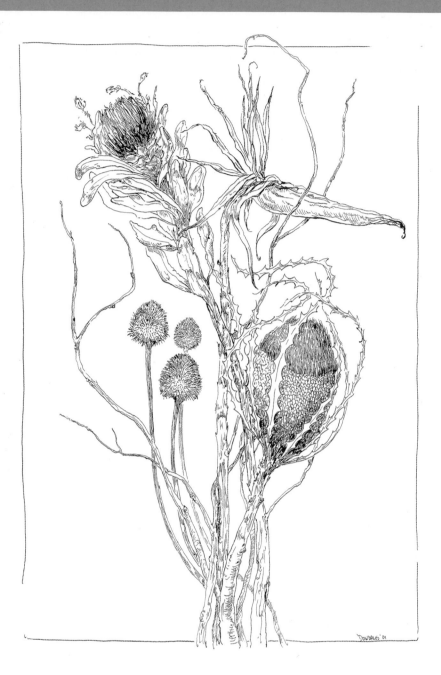

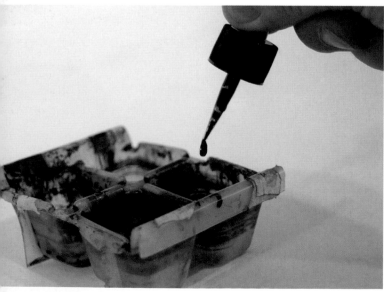

A common misconception about ink is that it is too heavy and black and difficult to draw with. I suggest that students dilute black India ink with a ratio of approximately 3 or 4 parts ink to 1 to 2 parts water. Part of an ice cube tray works well as an ink reservoir when using a diluted mixture, as the depth of the well allows most of the pen nib to be submerged into the ink.

Adding water to ink directly out of the bottle gives it more flow, but doesn't dilute it enough to affect its velvety black appearance.

PEN & INK TECHNIQUES

Hatching & Crosshatching

These are the traditional shading techniques for pen and ink. To hatch, apply a series of parallel lines; to crosshatch, apply layers of parallel lines. The closer together the lines, the darker the shading will appear.

Stippling

Press the end of the drawing nib onto the paper to create small dots. Use this technique for shading or texturing; the closer together the dots, the darker the shading will appear.

Gradated Ink Wash

Some artists use washes to accent or shade their pen and ink drawings. To create a gradation, apply a dark wash of ink and add water as you move away, stroking side to side.

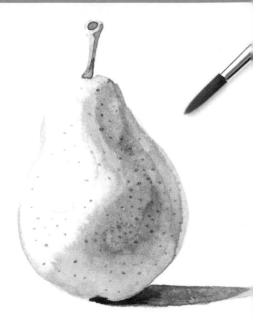

Drawing with Washes

You can forego pens altogether and simply work with an ink and brush, similar to watercolor.

Combining Shading Techniques

In this simple sunflower sketch, you can see the use of crosshatching (stem), stippling (face), and wash (petals, face, and stem).

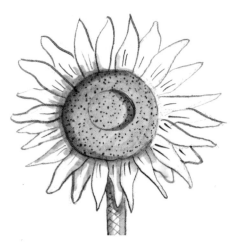

The smaller the pen nib, the finer the line will be. To achieve very light lines for gesture drawings, simply add more water to the mixture. Rounded nibs tend to flow across the paper, as opposed to fine-point nibs, which can be "scratchy" in a quick sketch.

Creating Tone with Dots

One way to create tonal variation in ink drawing is with a technique called "stippling." To stipple means to create tone out of an accumulation of dots created with the point of a pen. To create a true dot, the pen nib should be held completely perpendicular to the paper, depositing the ink as a point without dragging it into a line. While stippling is time-intensive, this technique is favored for its ease in creating gradual tone and value changes.

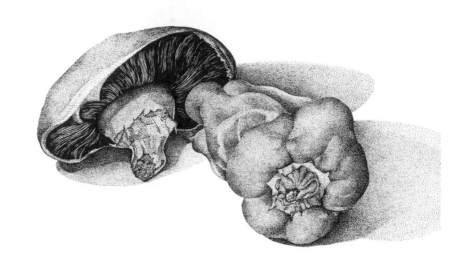

Above is an ink stipple value scale. A variety of values can be accomplished by adding more dots of ink placed closer together or by changing the size of the nib to create larger, darker dots.

Creating Tone with Line

Creating tone with ink can also be accomplished with line, or linear mark-making. The line can be hatched (one direction), crosshatched (multiple directions), or scribbled to create tone. Creating a value scale with linear marks is a vital way to understand how to add techniques to an artist's "toolbox" and create interesting and complex drawings.

This type of tonal application can be employed for a variety of subjects, including still lifes, portraits, and architecture. The combination of crisp, clean ink marks with a variety of subtle-to-strong application techniques makes this linear mark-making a versatile way in which to build a successful value drawing.

This student's architectural drawing incorporates line and value with ink nibs and brush.

Create a line value scale using hatching and crosshatching with various ink nib sizes for value development from light to dark.

Creating Tone with Washes

Another way to create tone with ink is to dilute the ink in various shades of gray, from very light (lots of water) to very dark (less water), and apply the resulting washes with a brush.

The types of brushes most often used for this purpose are very soft and absorbent natural-hair brushes, such as squirrel or beaver. (The hair for these brushes is humanely harvested, and the brushes are inexpensive.)

Brush quality is important, as the chemical constituents in ink can be harsh on brush fibers. Avoid using expensive brushes with this technique. As is the case with any tonal technique, it is important to first create a value scale in order to get a feel for the appearance of the ink wash and its application.

An example of four washes used in an ink line drawing.

Experiment with the water/ink ratio until you achieve four distinct values from light to dark. With four washes, plus the white of the paper and the straight black ink from the bottle, you will effectively have six different values to work with.

HAND LETTERING

From creative calligraphy to illustrative illumination, lettering is a beautiful way to write and draw words. In hand lettering, the rules of typography are meant to be broken. You can customize letters and words and push the boundaries, developing your own rules and methods as you go. The letterform style in this section is based on old calligraphy styles but do not strictly adhere to the guidelines of traditional pointed pen calligraphy hands, such as Copperplate and Spencerian. It is inspired by masterful letterers of earlier times, but also is thoroughly modern and can be unique to you.

GETTING STARTED

Before we dive into the art of lettering, it's important to go over the three basic steps of beautiful calligraphy: (1) Tools, (2) Techniques, and (3) Strokes.

TOOLS

The basic tools for the calligrapher are pen nibs, a pen holder, ink, and paper. Art supplies can be expensive, but be sure to select the highest quality of materials you can afford—you truly get what you pay for. Low-quality tools can be difficult to use. It's always a good idea to purchase a small quantity of a few different types of supplies to experiment with and find the ones that suit you best.

Pen Nibs

For the kind of calligraphy we'll be exploring, a pointed pen nib is required. Pointed pen nibs are made from flexible metal and are sharply pointed. The pressure the calligrapher places on the nib causes the tines of the nib to spread, producing those lovely thin-to-thick swells we all love. Pointed pen nibs come in a wide variety of styles. Some are more pointed, some are very stiff, and some are very flexible. Be sure to purchase a few different types to see which styles you like best.

— tines

oblique pen

Pen Holder

An oblique pen holder is necessary for Spencerian- and Copperplate-style calligraphy, which is written at a steeply slanted angle—up to 55 degrees! The position of the nib in the metal holder (called the flange) plays an important role in your writing. Experiment with the position of the nib as well as the angle of the pen, to see what works best for your writing style. If the pen nib is at the wrong angle, the point can scratch the paper, producing blobs and smears instead of graceful lines. Be ready for some splatters as you become accustomed to using pointed pen nibs. Just keep going!

Ink

A calligrapher must have ink! You can find calligraphy ink at your local art & craft store. I recommend black ink because it tends to have the best texture. Most art stores carry many different types of beautiful inks; however, not all of them work well with a pointed pen. Try out several different kinds to find your favorites. Additionally, there are many other kinds of writing fluids that can be used with a pointed pen nib, but we will dive into those later! My favorite types of ink are sumi, walnut, and acrylic.

Some of the supplies mentioned here, especially pen nibs and pen holders, are specialty tools that may not always be available locally. If you can't find a tool at your local art supply store, there are a number of online retailers that carry these supplies, including John Neal Bookseller, Scribblers, and Paper & Ink Arts.

Paper

Paper choice is an important aspect of pointed pen calligraphy. The paper must be smooth; otherwise the fibers of the paper will get caught in the tines of the nib, and you will have an ink explosion on your hands (and everywhere else)! Most rough, handmade papers and thick, textured papers, while lovely, are not suitable for pointed pen work. Art supply stores typically carry several different types of paper. Be sure to choose a paper intended for calligraphy or illustration. As with all tools, purchase a small quantity of several different types of paper to see which ones you like best. My favorite paper choices are smooth bond paper; lightweight illustration paper; and smooth (hot-pressed), lightweight watercolor paper.

LETTERING TECHNIQUES

Calligraphy with a pointed pen is all about pressure and angles. The pressure of the calligrapher's hand on the pen nib is what produces the desirable thick-and-thin lines of the letters. The angle at which the pen is held creates an elegant slant and gives shape to the letters.

Pay attention to how much pressure you apply to the pen, as well as how tightly you grip it. Your hand shouldn't hurt after a practice session of calligraphy. Hold the pen lightly, and apply gentle pressure.

Handling the Pen

The movement of the pen nib must always align with the slant of the letter being drawn. Creating beautiful, thick-and-thin sections of letterforms is all about the amount of pressure you place on the nib. Since pointed pen nibs are flexible, applying more pressure causes the tines in the nib to spread, creating a thicker line. Therefore, apply less pressure for a thin line.

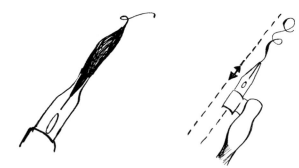

Glide the pen nib gently in the direction of the split in the tines to reduce ink splatters across the page!

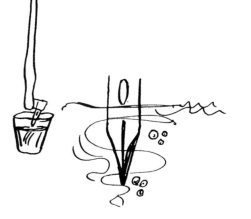

Cleaning & Maintaining the Nib

It is important to regularly clean your pen nib as you work. Dirty nibs are susceptible to degrading, due to certain types of ink. They are also more likely to cause splattering and bleeding. Crisp lines and swells require a clean pen nib!

Clean your pen nib by swishing it in water every couple of sentences. Dry it on a lint-free towel. I keep a few old rags on my desk for this purpose.

Setting Up Your Workspace

Set up your work area so that the light source shines from the opposite side of your working arm to avoid casting shadows on your work. Place all your inks and tools to the side of your working arm to avoid drips and spills. If you are right-handed, set up your space as demonstrated here. If you are left-handed, reverse the setup.

Using a Guard Sheet

Always place a piece of scrap paper under your hand—even when you're just practicing! The natural oils in your hand can affect ink flow and cause smudging and smearing. Try using a playing card or similar slippery-coated paper to help your hand glide as you work.

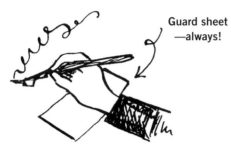

Guard sheet
—always!

Pen nibs don't last forever. Once your nib looks worn or the tines are bent or separated, it's time to replace it. Be sure to clean your new pen nib prior to use; some new nibs are coated with a material that maintains it until use but will inhibit ink flow.

Yes!

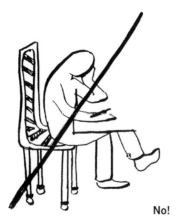

No!

PRACTICING PROPER POSTURE

Posture is very important in calligraphy. I regularly check to make sure I am not hunched over my table. Take a moment every once in a while to check your posture. Below are some tips for proper posture:

👍 Keep your feet on the floor, your back straight, your arms and shoulders loose, and your head in line with your neck.

👍 Use a tabletop easel or a board propped against your table to keep your work at a 45-degree angle. This helps keep your back straight.

👍 Keep your hand gliding, not planted.

STROKES

The movement of the pen nib must align with the slant of the letters. Pulling the pen nib in an unnatural angle across the paper can result in splatters as the tines catch on the grain of the paper.

Up and Down Strokes
As a general rule of thumb, put pressure on downward strokes and gently glide the pen on upward strokes.

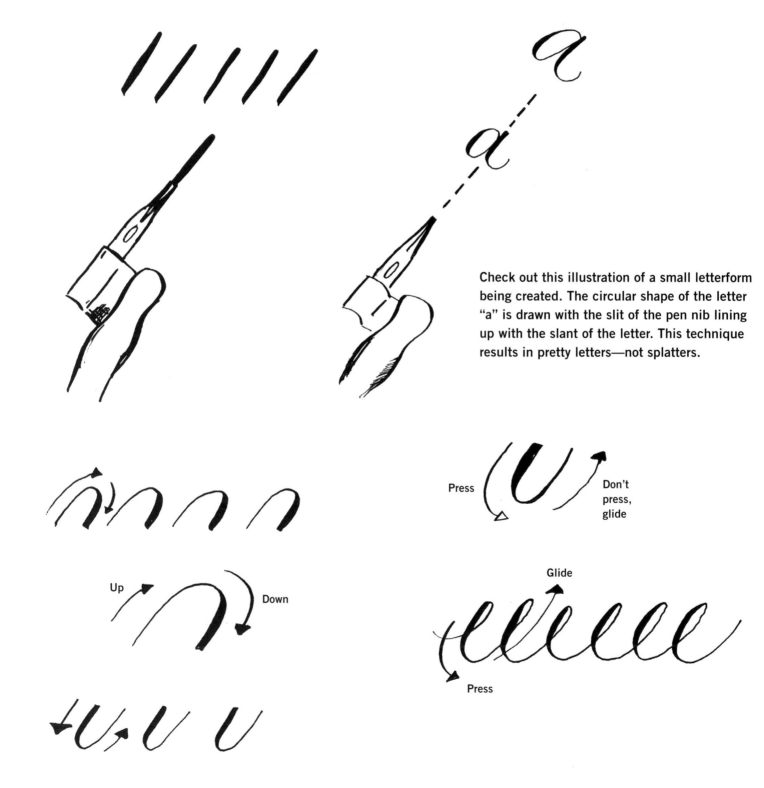

Check out this illustration of a small letterform being created. The circular shape of the letter "a" is drawn with the slit of the pen nib lining up with the slant of the letter. This technique results in pretty letters—not splatters.

Thick and Thin Strokes

Aim for smooth transitions when joining thick and thin strokes together. Practice drawing connecting circles to perfect this technique.

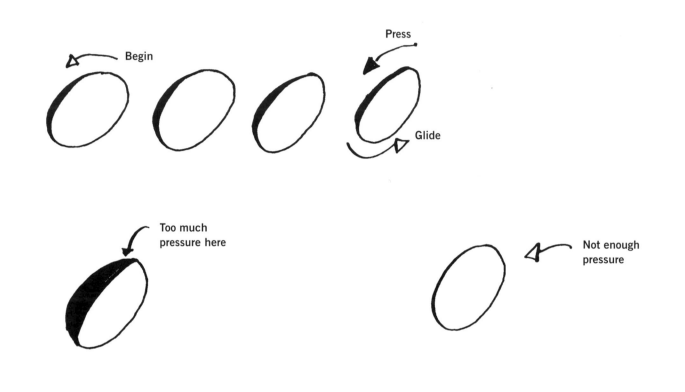

CREATING LETTERS

Now that you've practiced shapes and strokes, we can dive into the fun part—the letters! We'll practice making minuscules (lowercase letters) and majuscules (capital letters) at a slant, giving them a formal look loosely based off the Copperplate/Engrosser's Script lettering style. Once you're familiar with that style, we'll work on more casual, upright scripts. Let's get started!

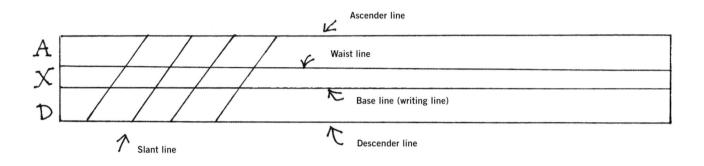

We'll use a lined writing sheet to create the letters. Each set of lines is divided into three sections. The middle section is where the letters sit. The ascenders on tall letters like "d" and "b" stretch up to the very top line. The descenders on letters like "p" and "y" reach to the very bottom line.

> Take your time when writing calligraphy, and be sure to leave plenty of space between each letter.

SLANT LINE

The slant line is the angle at which the letters are created. As discussed earlier, aim to keep the pen nib aligned with the slant line. Try to keep the slant line pointed roughly in your direction.

Warm up!

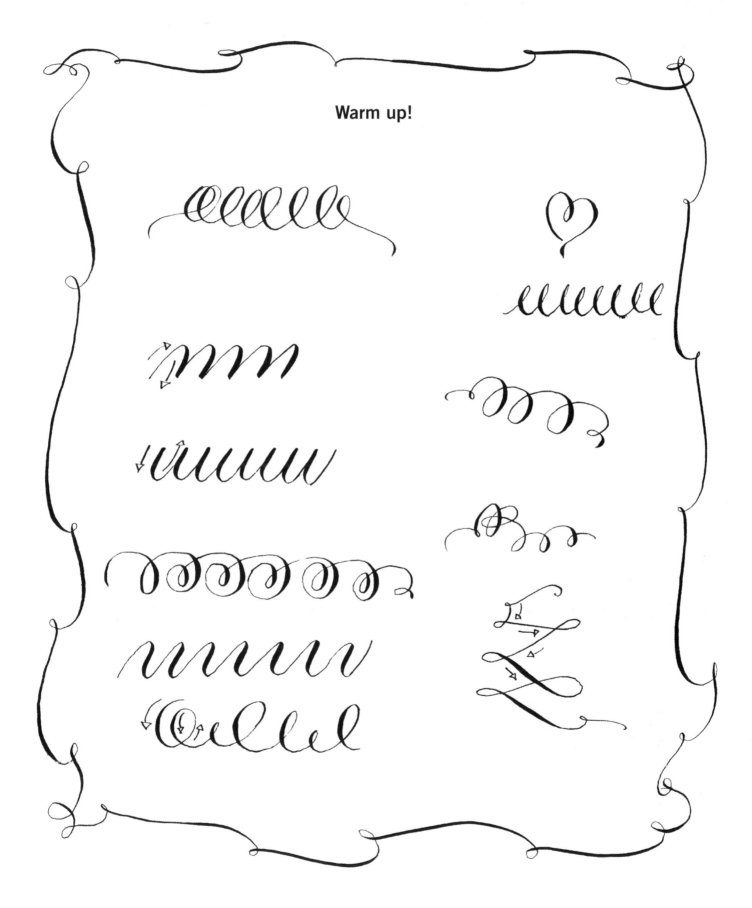

TAKING IT UP A NOTCH

Yes—it's time to take your lettering to the next level! Now that you've practiced the basic strokes and put them together, first in shapes and then words, let's expand your repertoire with an upright script. Then we'll start embellishing!

This upright script is loose and free—have fun with it! Notice that the letter shapes and strokes are the same as the slanted script you have already learned, but they are drawn upright. As with slanted script, it's still very important to maintain even spacing between and inside the letters. Each letter should take up roughly the same amount of space.

a b c d e
f g h i j
k l m n o
p q r s t
u v w x
y *and* z

NUMBERS & BORDERS

Don't forget numbers and punctuation marks! These characters benefit from pretty flourishes and strokes too.

Keep your embellishments small, as these kinds of characters generally need to stay close to other letters and numbers.

You can craft pretty borders, boxes, and other small embellishments to bring even more dimension to your lettering. Here are just a few examples to inspire you.

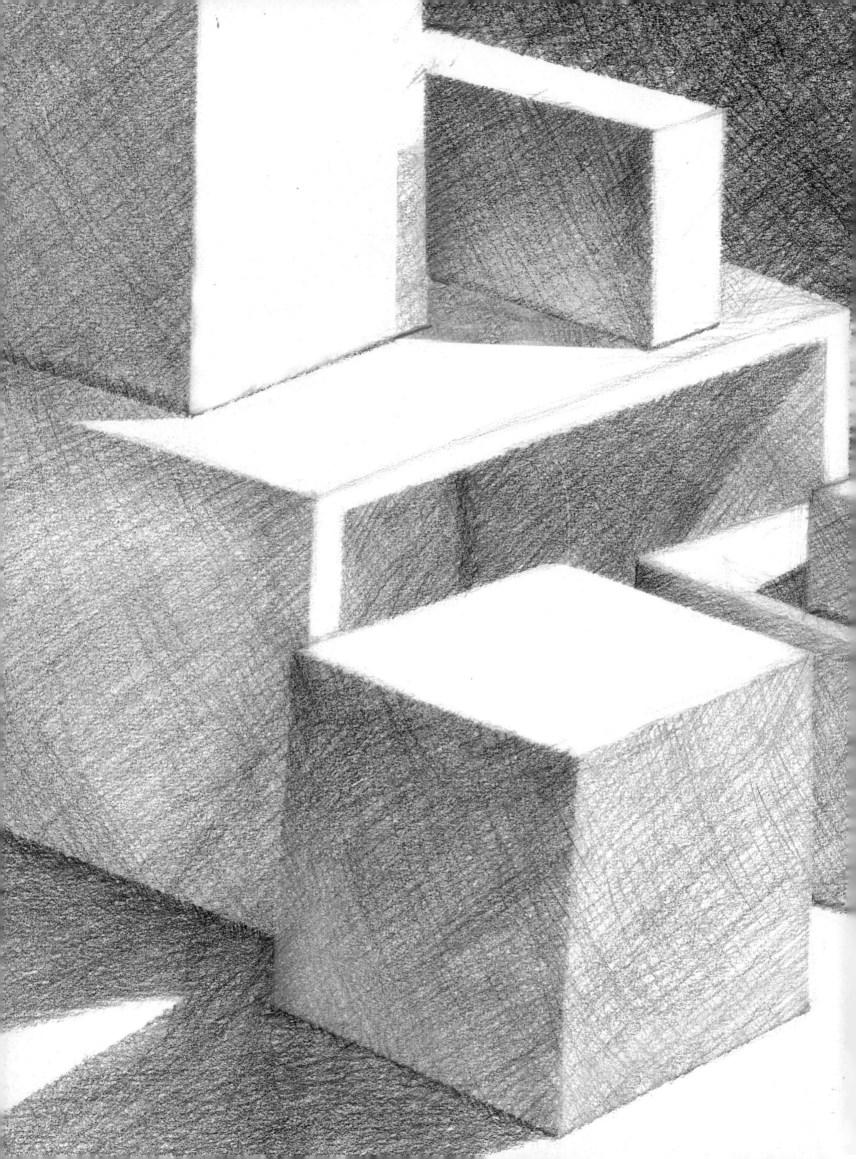

FUNDAMENTALS

The most important aspects of successful drawing are sensitivity, focus, and passion. We are all born with the ability to create; in some children this ability is nurtured, while in others it may be repressed. As adults, we still have the ability to "tap into" our creative side, but it takes practice, patience, and guidance.

As you prepare to transition to more difficult and complex subjects, such as still life and architecture, you need to understand and analyze what exactly you see, and how best to apply that scene to the drawing surface. This section demonstrates some simple, yet effective, techniques that artists have employed for hundreds of years that can help the artist organize and understand a complex scene in a logical way.

VALUE & LIGHT

We perceive the visible world around us because of light on form, or illumination. When the artist adds value, or tone, to an object in a line drawing, its volume, texture, surface, direction, and depth become more apparent, and the object takes on a reality that is immediately apparent to the viewer.

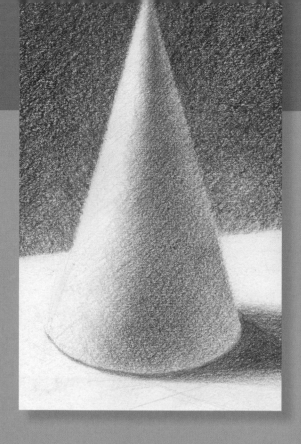

VALUE SCALE

Value represents the visual range of light to dark, with successive gradients of gray between. Creating a value scale is a great exercise to help the beginning artist understand value perception. A value scale typically includes less than 10 gradients, from white to black.

In this still life drawing, a nine-value range is identified, with a true 50 percent gray at the center of the scale and four light values and four dark values on either side of it. These basic forms are a helpful example of how light affects the surfaces and forms without influences of texture, surface irregularity, or surface complexity. There is a certain predictability to this type of lighting situation, which we call *light logic.*

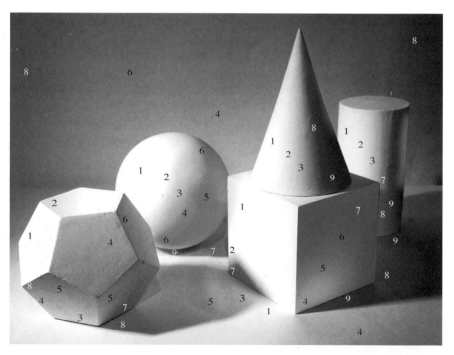

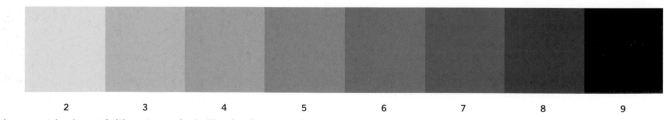

These simple geometric shapes (with a strong single illumination source) present a good example of the range of values inherent in a still life. Each form presents generalized rules of light logic, as well as specific light characterizations. Notice how the numbers in different areas correspond to the numerical value range.

LIGHT LOGIC

In the drawings here, the effect of the light on the forms is called *chiaroscuro*—an Italian word that essentially means "light and shade." This type of lighting situation uses a full tonal range and gradual transitions from very light to very dark. It produces dramatic value changes and promotes strong three-dimensionality. Just as we tend to simplify a value scale into gradual but understandable units, there is a system of terminology that describes the effects of light on a form (see below).

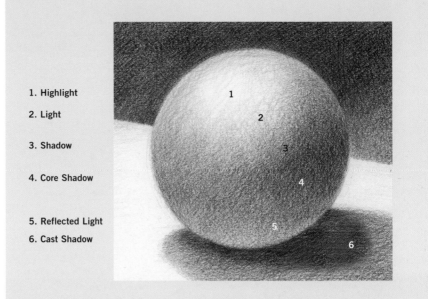

1. Highlight
2. Light
3. Shadow
4. Core Shadow
5. Reflected Light
6. Cast Shadow

Light Direction/Light Source It is vital to understand where the light that shines on an object is coming from, as well as the importance of keeping that light source separate and singular. The artist should understand how the light source direction, proximity, height, and intensity affect the appearance of the objects.

Highlight is the area of a form that receives the most direct effect of the singular light source.

Light describes the overall area of a form that receives generalized directional lighting from a single light source. On flat planes, the light is uniform; on curved surfaces, the light diffuses as the rounded form curves away from the light source. These subtle differences are evident in value transitions on spheres, cones, and cylinders.

Shadow describes the area of a form that does not receive any light. On rounded forms, the transitional change that separates light from shadow is very soft and gradual. On a hard-edged surface, such as a square, the definition is sharp and clear.

Core Shadow is the darkest area of the shadow; it receives no effects of light from the transition zone between light and shadow or from reflected light on the side of the form that faces away from the light source.

Reflected Light bounces off another lit form or surface into the form's shadow area. On a curved surface, reflected light usually appears on the shadowed edge of the form—the side opposite the form's lit side.

Cast Shadow is the shadow an object casts onto the surrounding surface, ground plane, or other object. Cast shadow is diffused, and it softens as it moves away from the form.

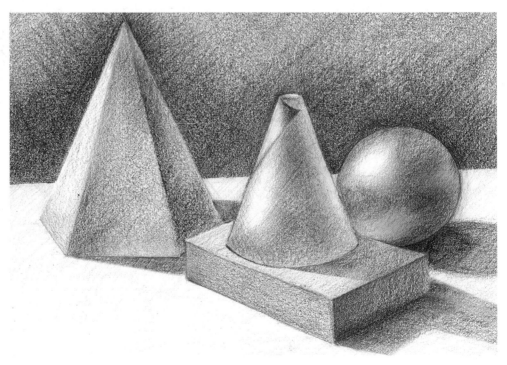

Student example of this value exercise, with simple forms in strong, single-light illumination.

TONAL APPLICATION

In this project, one pencil grade is layered, or *glazed*, over another, from lightest to darkest, with hatching and crosshatching. The graphite is never purposely smeared or blended with a stump, cloth, or finger, as blending tends to give the drawing a muddy or dirty look. While this method can be more time consuming, the process is more logical and produces tangible, visible results.

1

STEP 1 After making an overall gesture drawing of the shell, refine the sketch to a contour line drawing.

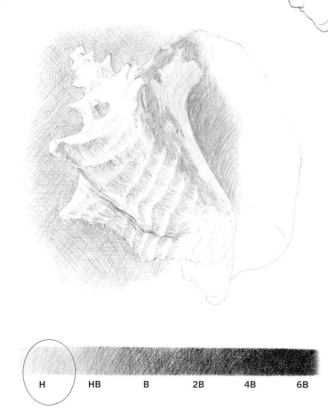

2

3

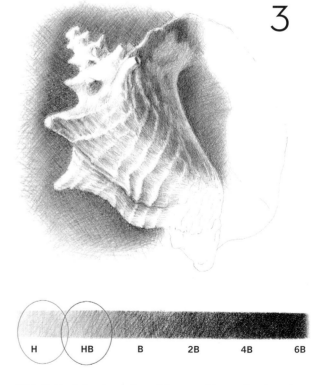

STEP 2 Lay a foundation with a "wash" of H graphite over the entire area, except for the lightest or completely white areas.

STEP 3 Next develop value with a specific application of the next darkest pencil—an HB.

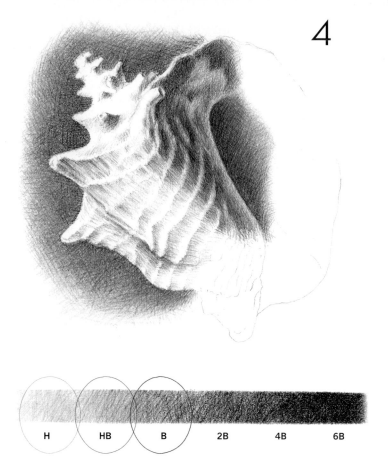

4

The process of layering graphite—light to dark—involves little guesswork as to what grade (or darkness) of pencil should be used. It doesn't require excessive pressure on the pencil point or blending to attain the appropriate tonal range. Switch to the next darkest pencil when the tone of the current pencil does not get appreciably darker without applying lots of pressure.

| H | HB | B | 2B | 4B | 6B |

STEP 4 Next apply a layer of B pencil over the two previous tonal applications. It's important to note that a large portion of the overall time spent on this type of drawing is in laying a foundation of tone with the lightest pencils. As you progress through the range of light to dark pencils, you'll spend a significantly smaller portion of time on each successive darker layer.

5

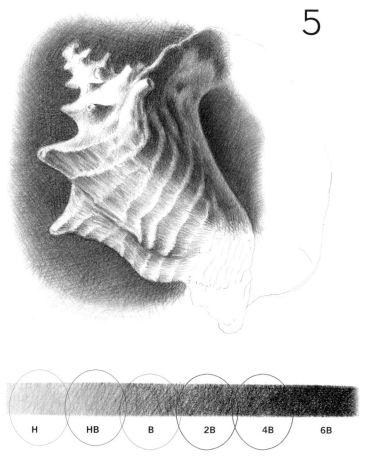

There is usually a distinct difference between H pencils (hard) and B pencils (black). You can also use an F pencil, instead of an HB, between the hard and soft pencils.

| H | HB | B | 2B | 4B | 6B |

STEP 5 Add darker values of 2B and 4B pencil over the deeper areas of shadow and the background. Use a 6B pencil to accent a few of the deepest darks.

PROPORTION & SIZE

This section demonstrates some simple, yet effective, techniques that artists have employed for hundreds of years that can help the artist organize and understand a complex scene in a logical way.

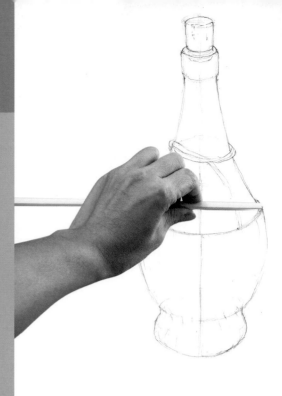

THE PICTURE PLANE

In considering the way we see and re-interpret objects in space, the first concept to understand involves the *picture plane*. The picture plane is an imaginary glass window that stands parallel to the viewer (the artist) and between the viewer and the subject. This imaginary plane is meant to represent the flat surface that the artist is drawing on (the paper surface). In an ideal theoretical situation, the artist would be able to trace the subject directly onto the glass window. In reality, there are ways for the artist to make use of this imaginary window to transfer the subjects seen through it onto the paper surface.

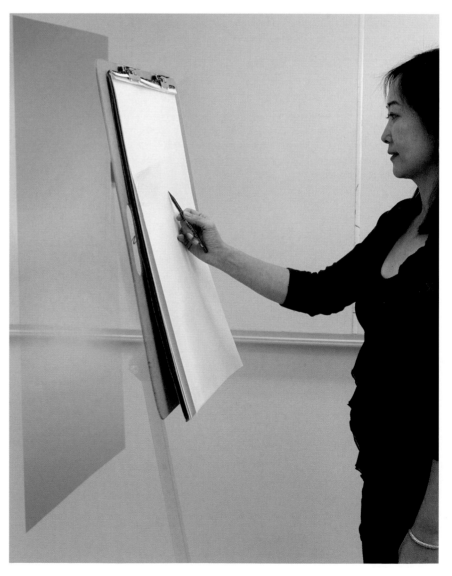

 Consider the picture plane (blue rectangle) as an imaginary "window" parallel to the drawing surface. We see what we are drawing through this imaginary window.

SPACE AND DEPTH

When viewing objects sitting on a flat ground plane in close proximity to each other, such as the coffeepots at left, we can easily see that the objects are of similar size. When the far left pot is moved toward the picture plane and the center pot is moved toward the back of the ground plane, there is the illusion of a change in the size of the pots.

TOP These coffeepots are very close to each other, sitting on the ground plane at about the same horizontal depth, approximately midway from the picture plane to the back of the ground plane.

BOTTOM The left pot is now the largest in relation to the other two and is near the bottom of the picture plane. The center pot's base is now the highest of all three within the picture plane. The top rims of all three pots are still relatively level with each other, when viewed horizontally across the picture plane. This relates to how we perceive cylindrical tops that are close to eye level.

DIMINUTION

As we move the objects around the ground plane, we can see the "changes" that occur in their relative size—though we know that the objects are all physically the same size. This illusion is the result of a visual interpretation called *diminution*, a hierarchy or size relationship caused by an increase in space between the objects, making objects of similar size look smaller as they move away from the picture plane.

Most people recognize this intuitively, but it is important to note how size diminution appears to the artist through the picture plane. The three coffeepots above are at the artist's eye level. We know this because we can still see the tops of the pots, and even just a bit down into them. As the pots advance toward the viewer, the tops appear lower on the picture plane, but the overall heights appear taller, and the widths seem wider. The pot closest to the viewer is the largest, and its base is the lowest on the picture plane. This consistently happens when objects are viewed from above or below eye level.

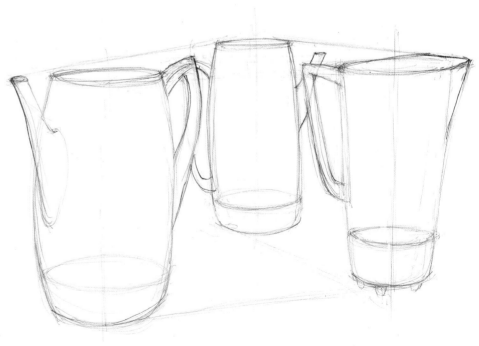

EYE LEVEL

Eye level, also called the "horizon line," is an imaginary horizontal line that corresponds to the precise location of the viewer's eyes and what is seen when the viewer looks directly ahead, without tilting the head up or down. It's important to realize that the artist may move their head up or down to view an object or objects; this is called "line of vision." Even as the artist's head moves up and down, however, the eye level stays the same.

Imagine being at the ocean, where the horizon line (eye level) is easily seen. If there is an airplane traveling from the horizon toward us, we watch it get closer by raising our line of vision until it is directly above us. We have not brought the ocean edge (horizon line) up to where the plane is flying—it stays at the eye level, where it belongs. This is how the eye level and picture plane work together.

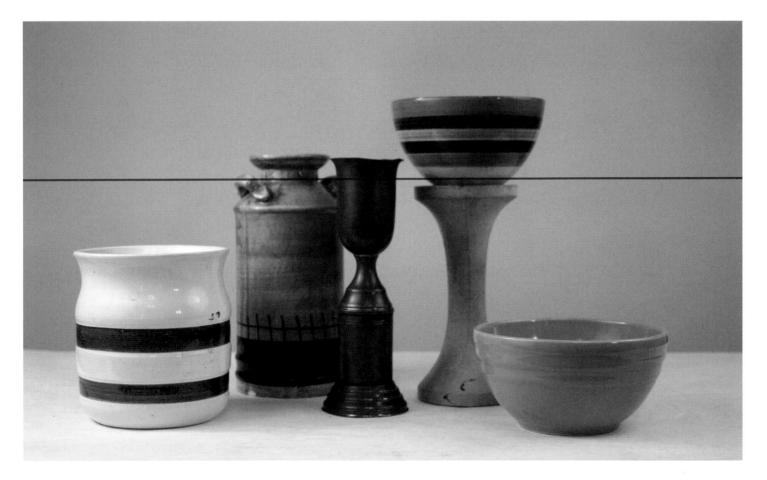

For a visual explanation of eye level we'll use this set of pots, of different shapes and sizes. Eye level is located somewhere between and within the height range of the objects, as the viewer is able to see the inside top of the objects that are below eye level, but not of those above eye level. Notice that the bases of all the objects seem to be in similar locations across the ground plane.

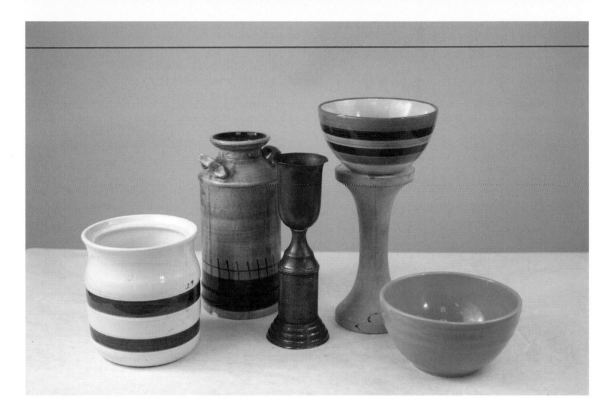

Now the viewer's eye level is above the level of the pots, and it is much easier to see inside all of them. The differences in orientation across the ground plane are more apparent, as is the space that each pot's "footprint" occupies.

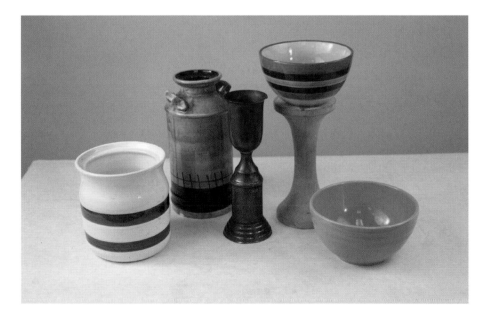

In this third picture, the eye level is higher and completely out of the image. The given space between each object is more apparent. Note that the objects nearest to the bottom of the picture plane are the closest to the viewer.

This type of overhead view for a group of objects makes it easier to understand the objects' hierarchy of sizes through diminution, as well as the phenomena of overlapping forms, which also helps us understand which form is in front of another.

OTHER USES FOR THE PICTURE PLANE

When attempting to compose a still life on the drawing surface, it is helpful to use a straight tool, such as another pencil or, in this case, a long chopstick. A good starting point is to use the chopstick to gauge overall implied angles that the objects present to each other within the context of the composition.

As you view these angles, it's imperative to keep the chopstick parallel with the picture plane (A). The chopstick can be easily rotated around the imaginary plane, as long as this rule is followed. This way any angles of coincidence can be seen in the still life and applied to the drawing surface, as long as that surface is parallel with the picture plane (B, C).

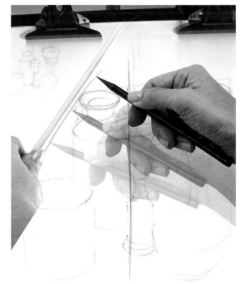

STEP A Rotate the chopstick to observe the imaginary angles that objects have in relation to each other when viewed through the picture plane.

STEP B These imaginary angular relationships can be recorded as lightly sketched lines in an overall preliminary, gestural blocked-in sketch.

STEP C Lightly sketch the same angles seen in the still life on the drawing surface in order to check the accuracy of the objects' placement in relation to their location on the picture plane.

A chopstick is helpful, when used as a viewing tool against the picture plane, in understanding how objects are perceived in relation to one another. Remember to keep the chopstick parallel to the imaginary picture plane.

SYMMETRY OF FORM

Symmetry refers to the similarity of form across a midline, also called an "axis." In a symmetrical object like this bottle, this means that each side of the bottle is the same, separated by a common midline (the axis), here called a major axis.

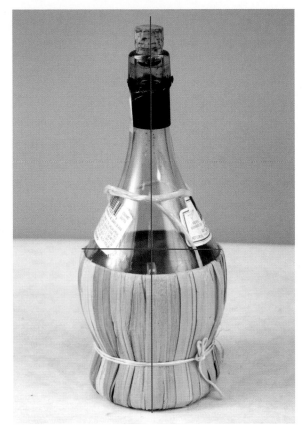

> 👍 The axis is an invisible vertical line that runs directly through the object from top to base. Seeing the axis makes it much easier to draw any kind of symmetrical object.

After finishing the light gesture drawing, and before moving on to a stronger, more refined drawing, use the chopstick to gauge the accuracy and spacing on both sides of the midline axis (A). Do this at several points along the vertical length of the axis until you are satisfied that the entire object is symmetrical (B, C). If there are any instances where the symmetry is wrong, it's easy to make corrections to the light drawing.

This bottle has an identical structure on both sides of its midline (blue), and is therefore a symmetrical object.

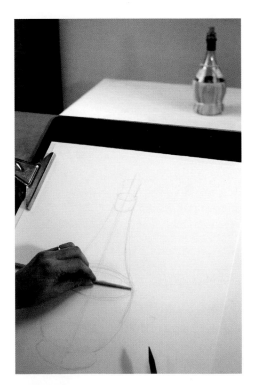

STEP A Use a chopstick to check the accuracy of the drawing on both sides of the midline.

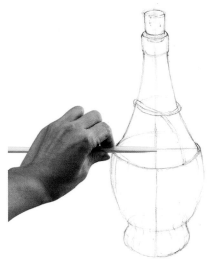

STEP B To measure the object, place the end of the chopstick at the object's midline axis and hold the chopstick with thumb and forefinger placed at the left edge of the object. This constitutes one unit of measurement.

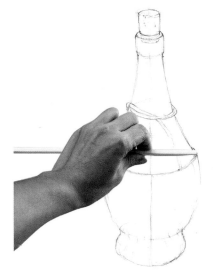

STEP C Without changing your finger placement, move the chopstick laterally so that your thumb and forefinger are at the midline; the end of the chopstick is now on the object's right side. If both measurements are the same, the object is symmetrical across this dimension.

UNITS OF MEASUREMENT

The chopstick can be very useful in finding accurate measurements of objects and proportional relationships between objects in a still life. It's important to remember that the arm must always be straight and parallel to the picture plane when measuring an object. This way any object's height or width can be used in comparison to any other height, width, or distance in the still life.

In this still life, we're focusing on the pot with the blue stripes in order to find a unit of measurement to use as a baseline proportion. The thumb and forefinger are placed on the chopstick at the base of the object, while the tip of the chopstick is placed at top of the object (A, B). This is the unit of measurement that can be used to ascertain the objects' relative sizes or the relative distance from one object to another (C). This should be done after the objects are lightly blocked in during the overall gesture sketch, before any refinement or detail is added. At this stage, any necessary corrections to size and placement can still be easily made.

STEP A The chopstick can be used to obtain a unit of measurement that the artist can use against other objects and spaces between objects. A good object to use for this unit of measurement is something simple and close to a squared form.

STEP B After an initial, light blocked-in gesture sketch of the entire still life, the artist uses the chopstick to find the unit of measurement.

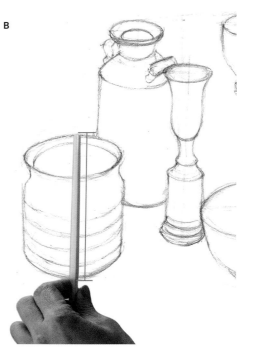

Use the unit of measurement to find distances between objects, first in the measurement of the still life and then applied to the sketch. If the unit of measurement between objects is found to be inaccurate in your drawing, corrections are still easy to make at this light stage of the sketch.

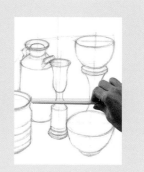

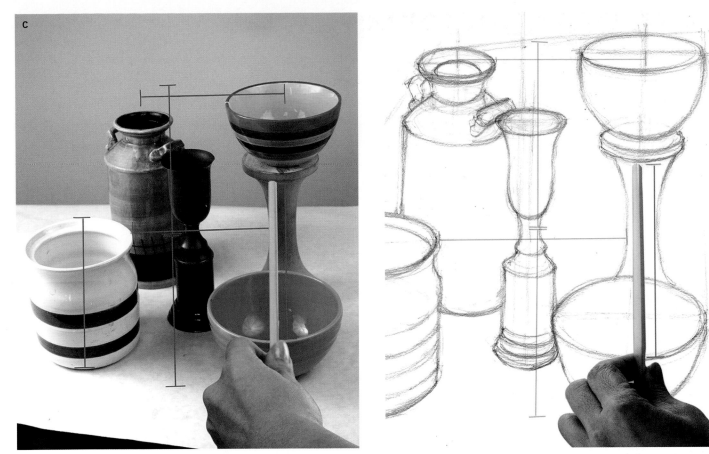

STEP C Within this still life there are several objects that are similar to the basic unit of measurement and some that are double the unit of measurement. The same can be said for the spaces between objects.

Bringing It All Together

In this still life, the angles corresponding to the heights and locations of each object are determined with the aid of a chopstick kept parallel to the picture plane. The angles are then sketched onto the light, blocked-in gesture drawing of the still life.

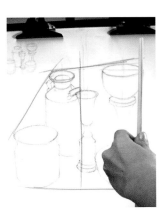

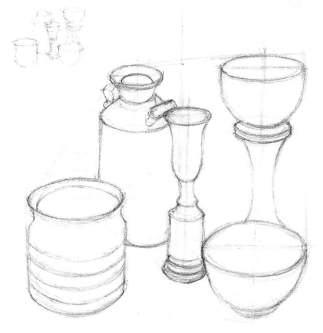

The unit of measurement for the striped pot is applied to several objects and distances for comparison, and the midline of each symmetrical object is sketched and used to verify the accuracy and integrity of each form.

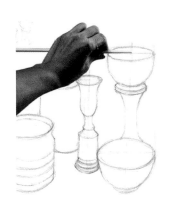

The final sketch is shown here with a small initial thumbnail sketch at top left that can be created prior to starting the large sketch. The thumbnail sketch is normally accomplished in 5 to 10 minutes and can aid in the initial placement of objects within the still life in the larger drawing.

DRAWING ELLIPSES

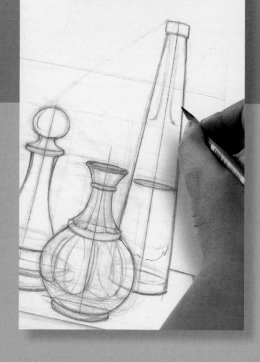

Nothing gives away an artist's deficiencies more quickly than a drawing with poorly constructed ellipses; even to the untrained eye, lack of accuracy in drawn ellipses can usually be spotted, although the viewer may not quite understand what is wrong with the picture or how to fix the problem.

ELLIPSES: FORESHORTENED CIRCLES

An *ellipse* is a circle in perspective. It sounds simple, yet many artists find it challenging to accurately draw them. Once you learn some simple rules and properties of ellipses, the mysteries will be revealed, and you can successfully and easily render them.

We see ellipses in objects all around us—rims of cups, bowls, and other cylindrical objects; wheels on cars, bicycles, and roller skates, etc. Observed straight on, these forms are circular, but it is much more common to see them at angles. Therefore, it is in the artist's best interest to learn as much as possible about ellipses.

In this still life, notice the gradual change in length of the blue minor axes of the ellipses as they rise toward eye level. The relative width of the major axes (red) stays the same, however.

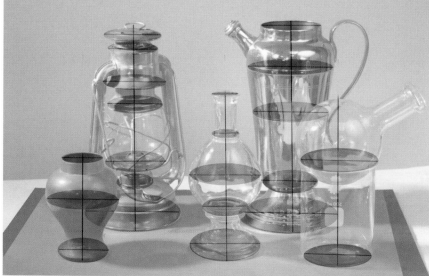

One of the most important elements that dictates how we see the shape of an ellipse is its relationship to eye level. Knowledge of eye level and its location is a key component in almost every drawing, but especially in regard to ellipses.

ATTRIBUTES OF ELLIPSES

All circles fit into a square. When drawing an ellipse, first visualize a circle within a square and then project it into perspective to observe the foreshortening that occurs. The circle is divided into equal quadrants by a horizontal axis and vertical axis. Notice what happens when the square and circle are projected into perspective space: The horizontal axis shortens in width, and the vertical axis shortens in height.

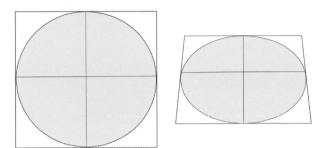

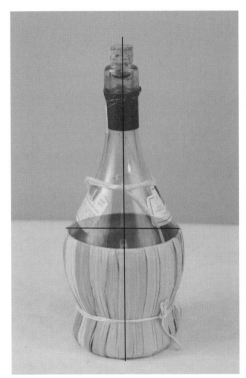

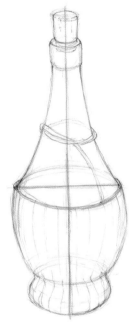

On this bottle, the horizontal axis is the major axis of the ellipse (red line). The vertical axis is the major axis of the bottle, but it is the minor axis of the ellipse (blue line). These axes are always at right angles to each other when a symmetrical object stands up straight on the ground plane. The major axis, or midline, of the bottle coincides with the ellipse's minor axis and is perpendicular to the ellipse's major axis. This is the rule when any symmetrical object's base rests on the ground plane.

Demonstrated are a few illustrations of the wrong ways to draw ellipses. The first example shows the classic "football" shape of an incorrectly drawn ellipse; the edges of an ellipse should always be rounded and never pointed. In the second example, the edges of the ellipse are too rounded, with the top and bottom edges too straight across their length. Ellipses should always curve continuously and have no straight edges. In the third example, the ratio of closed-to-open ellipses is wrong. The nearer the ellipse is to the viewer's eye level, the tighter that ellipse appears; conversely, the farther from eye level, the more rounded the ellipse appears.

Wrong Ways to Draw Ellipses

SIZE RATIO OF ELLIPSES

Ellipses can be explained in degrees of angle to the viewer's eye level, with 90 degrees equal to a true circle and 0 degrees when the ellipse is viewed at eye level. As an ellipse moves toward eye level, the length of the minor (vertical) axis is reduced. As an ellipse moves away from eye level, the length of the minor axis increases. Ellipses that are parallel to each other, or in similar locations horizontally, will have very similar size ratios (see image below).

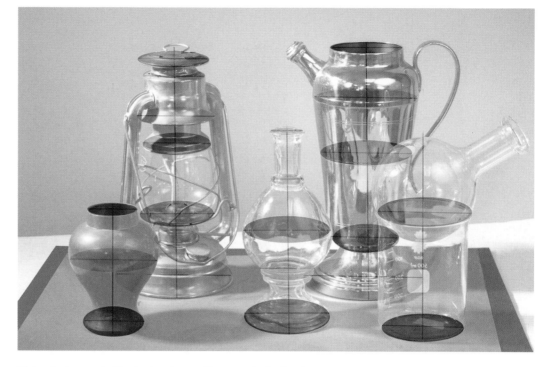

This photograph illustrates how ellipses relatively close to each other across a horizontal location are similar in their ratio of roundness. For instance, all of the ellipses at the objects' bases (magenta) have similar ratios of roundness; let's say 50 degrees. The middle, tan-colored ellipses are all around 30 to 35 degrees, and the very tops of the objects (purple) are about 10 to 15 degrees, as they are the closest to eye level.

ELLIPSES NOT PARALLEL TO THE GROUND PLANE

As a circular object moves away from standing vertically on the ground plane, there are similarities and differences to the ellipses that we have already discussed.

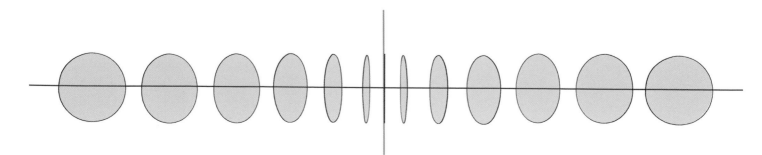

Study this photograph of four pots resting horizontally on the ground. Notice that the pot farthest from the viewer has an ellipse for its rim that is almost a straight line; as the pots rotate around the ground plane toward the viewer, the ellipse of the rim rounds out more with each successive rotation toward the viewer.

Also note that the pots tend to shift away from eye level and farther down on the picture plane. The center midline axes of the pots also present more of a perspective angle to the viewer. These midline axes are directly related to the perspective angle of the side of each pot, bisecting its symmetry.

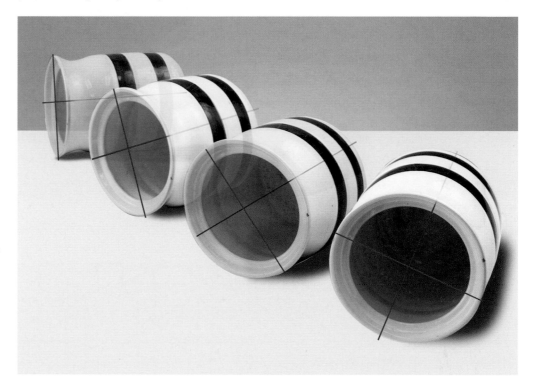

As the pots rotate toward the viewer from left to right, the ellipses become rounder, the blue midline (minor axis) becomes more of an acute angle to the picture plane, and the red major axis always stays at a right angle to the minor axis. The angle of the major axis of the pot (the minor axis of the ellipse) is dictated by the perspective construction angles of the sides of the pot.

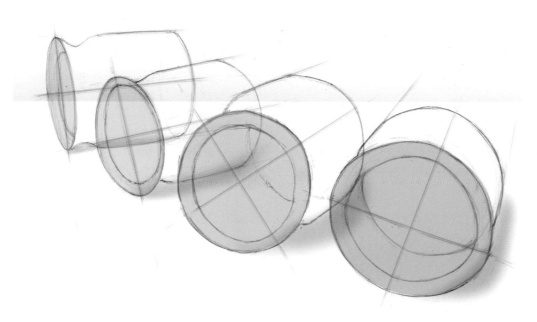

Here is what the sketch of these pots would look like, with the major axis of the pot (also the minor axis of the ellipse) and the major axis of the ellipse sketched in lightly.

PERSPECTIVE

Perspective is the representation of three-dimensional space on a two-dimensional surface. It's responsible for creating the illusion of depth and distance. Many artists try to make perspective into something more difficult than it is. The truth is, you've already seen perspective in action—you just didn't know what to call it. The rules of perspective simply explain the reasons behind what you're seeing.

UNDERSTANDING LINEAR PERSPECTIVE

Linear perspective is the most commonly recognized form of perspective. According to its rules, objects appear smaller as they recede into the distance. When learning about linear perspective, the horizon line—a horizontal line that bisects any given scene—is an important concept. It can be the actual horizon, or it can be a line that falls at eye level—meaning at the height of your eyes, not where your eyes are looking. The vanishing point (VP)— or the spot at which all parallel lines in a scene seem to converge—is always located on the horizon line.

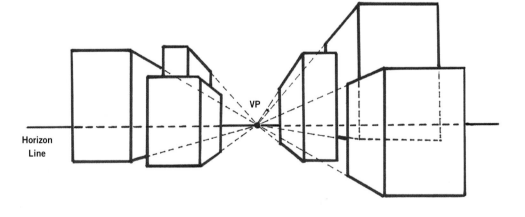

With one-point perspective, objects appear to shrink proportionately to one another as they recede into space. When applying one-point linear perspective, all the horizontal lines converge at one vanishing point in the distance. The vertical lines all remain at the same 90 degree angle.

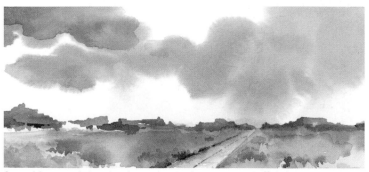

A road is one of the simplest ways to demonstrate one-point perspective at work—the lines converge at a distant point.

ONE-POINT PERSPECTIVE

When lines are all on one plane—such as with railroad tracks—the receding lines converge at one vanishing point. Think again of the railroad tracks—parallel stripes receding into the distance, with the space between them growing smaller until the lines merge on the horizon. Establishing the vanishing point will help you determine the correct angle for any lines coming toward (or moving away from) the viewer; but the angle of vertical or horizontal lines won't be affected. (See diagram above.)

TWO-POINT PERSPECTIVE

If a scene has more than one plane—for instance, if you are looking at the corner of an object rather than the flat face of it—then you should follow the rules of two-point perspective. With two-point perspective, there are two vanishing points. To find the vanishing points, first find your horizon line. Next draw a line that follows one of the object's angled horizontal lines, extending the line until it meets the horizon line. This establishes one vanishing point. Now repeat this process for the opposite side of the object to establish the remaining vanishing point. (Note: Sometimes a line will extend to a vanishing point that isn't contained on the page!) Each vanishing point applies to the angle of all parallel planes that are receding in the same direction. As with one-point perspective, vertical lines will all remain at the same 90 degree angle—only their size (in terms of length) will be affected by perspective.

Don't get bogged down by perspective and spend hours working on angles, when all you want to do is paint. Just hold the pencil at arm's length, line it up with the angle you see, bring the pencil to paper and record it.

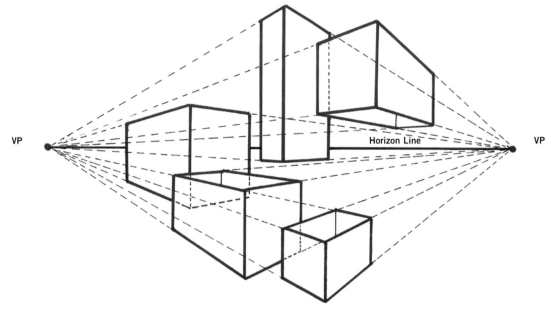

VP Horizon Line VP

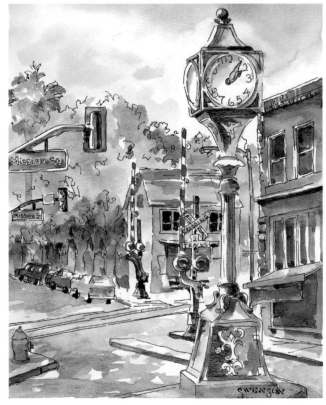

◀ Applying the principles of perspective to your subjects will help you achieve realistic-looking sketches, but you don't have to follow the rules rigidly. When drawings are too tight or stiff, they lose their human quality; if you bind yourself to exact lines and angles, you might turn your lively street scene into an architectural drawing. Apply your artistic interpretation to a scene to create a more natural look.

▲ This painting is an example of two-point perspective.

ATMOSPHERIC PERSPECTIVE BASICS

Atmospheric perspective is critical to creating the illusion of depth and dimension in your work. Atmospheric (sometimes called "aerial") perspective is responsible for the way objects in our field of vision appear to change in size, color, texture, focus, and even brightness as they recede into the distance.

When applying atmospheric perspective, remember to paint distant objects with less detail using cooler, more muted colors, and remember to paint foreground objects with more detail using warmer, brighter colors.

Using Atmospheric Perspective
In this painting, the artist gives the elements in the foreground the brightest, warmest colors, keeping them sharp in focus and highly detailed. She uses increasingly less detail for objects in the distance, also applying subtle, cooler colors as she moves into the middleground. The objects in the background are the most muted with blurred, unfocused edges.

Using Muted Colors
Here the artist rendered the background elements (the mountains and the foliage in front of them) with cooler, bluer colors, which pushes them back into the picture plane and creates the illusion of distance. Note that the green foliage in the foreground is much brighter and more detailed; also, the red flowers in the foreground are quite distinct, but become blurred and muted as they recede into the distance.

Recognizing Atmospheric Perspective
Although the foreground of this painting is in shadow (and therefore the objects closest to the viewer are muted), the artist still employs atmospheric perspective to create the illusion of distance between the middleground and the background. When placed against the cool, vague mountain in the distance, the warm, reddish hills and well-defined crevices of the middleground seem to "pop" forward.

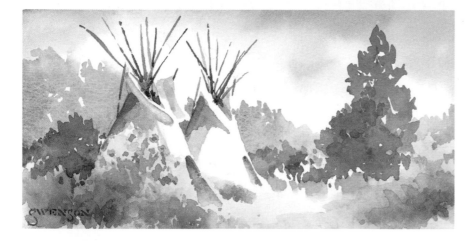

Distinguishing the Planes

The foreground shrubs boast the most vibrant foliage color and detail in this scene. In the middle ground, the trees have a softer, more out-of-focus look. And the trees in the distant background are grayed and indistinct.

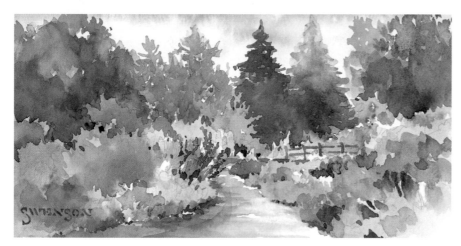

Pairing Perspectives

Linear perspective is responsible for the way the path narrows as it leads into the distance. But atmospheric perspective accounts for the blurring of forms and dulling of colors in the distance.

Sizing and Overlapping Elements

The house pictured here would be taller than the fence if the two elements were placed side by side—but enlarging the posts makes them appear nearer. Similarly, overlapping the house with the tree pushes the house into the distance, creating a more realistic sense of depth.

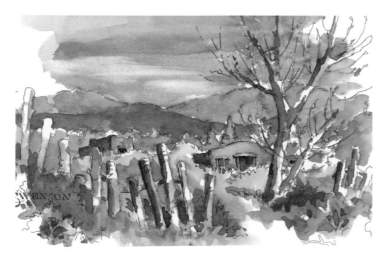

Implementing Color Distinctions

The contrast between the bright warm flower shapes in the foreground and the hazy, gray trees of the background help explain why Leonardo da Vinci called atmospheric perspective "the perspective of disappearance!"

PEOPLE IN PERSPECTIVE

Knowing the principles of perspective (the representation of objects on a two-dimensional surface that creates the illusion of three-dimensional depth and distance) allows you to draw more than one person in a scene realistically. Eye level changes as your elevation of view changes. In perspective, eye level is indicated by the horizon line. Imaginary lines receding into space meet on the horizon line at what are known as "vanishing points." Any figures drawn along these lines will be in proper perspective. Study the diagrams below to help you.

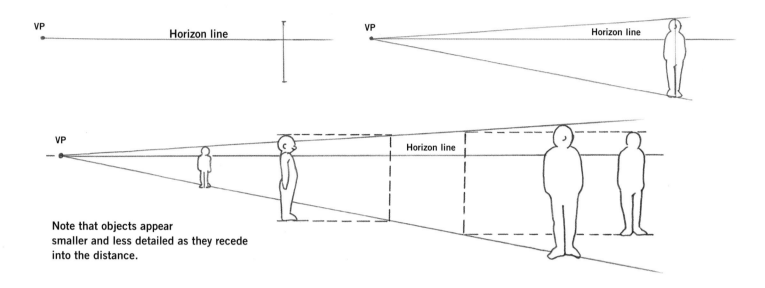

Note that objects appear smaller and less detailed as they recede into the distance.

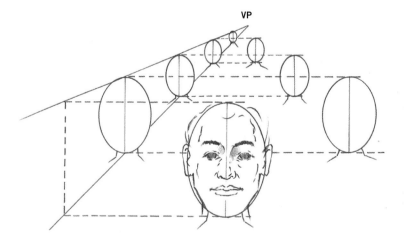

Try drawing a frontal view of many heads as if they were in a theater. Start by establishing your vanishing point at eye level. Draw one large head representing the person closest to you, and use it as a reference for determining the sizes of the other figures in the drawing. The technique illustrated above can be applied when drawing entire figures, shown in the diagram below. Although all of these examples include just one vanishing point, a composition can even have two or three vanishing points.

If you're a beginner, you may want to begin with basic one-point perspective. As you progress, attempt to incorporate two- or three-point perspective.

FORESHORTENING

Foreshortening causes the closest part of an object to appear larger than parts that are farther away. Technically, foreshortening pertains only to objects that are not parallel to the picture plane. Because of your viewing angle, you must shorten the lines on the sides of the nearest object to show that it recedes into the distance. For example, if you look at someone holding his arm straight down against the side of his body, the arm is perfectly vertical (and parallel to the picture plane), so it appears to be in proportion with the rest of his body. But if he raises his arm and points it directly at you, the arm is now angled (and no longer parallel to the picture plane), so it appears disproportionate to the rest of his body. (The hand looks bigger and the arm looks shorter.) So you would draw a large hand and an arm with shortened sides.

This drawing is an excellent example of foreshortening. Notice the difference in size between the boy's foot (closest to the viewer) and his head (farthest from the viewer).

SIMPLIFYING FORESHORTENING

You can use this simple exercise to better understand the logic of foreshortening. All you'll need is your own hand and a mirror!

FINGERS STRAIGHT UP Hold your hand in front of a mirror, palm forward. Notice that your fingers are the correct length in relation to your palm. Nothing is foreshortened here.

FINGERS ANGLED TOWARD YOU Now tip your hand forward a little, and see how the lengths of the fingers and the palm appear shortened. This is subtle foreshortening.

FINGERS ANGLED DOWN When you turn your fingers so they're angled down, they appear longer but still not full length, though the fingertips are visible. This pose shows some foreshortening; the fingers seem too long and thick in relation to the back of the hand.

FINGERS POINTING FORWARD Now point your fingers straight at you. This is the most extreme foreshortened view; the fingers appear to be mere stubs.

FINGERS POINTING STRAIGHT DOWN No foreshortening is at work in this frontal view. The tips of the fingers cannot be seen, and the lengths of the fingers and hand are not at all distorted.

UNDERSTANDING BODY ANATOMY

Figure drawing is easier when you have an understanding of the basic structure of the body. The muscles and bones give the body three-dimensional form, with the muscles filling out the skeletal foundation. Together they give the figure correct proportion—the relationship of the individual body parts to one another and to the body as a whole. Knowing what is beneath the skin of the figure will make your drawings more realistic and true to the form of your subject.

Front

Back

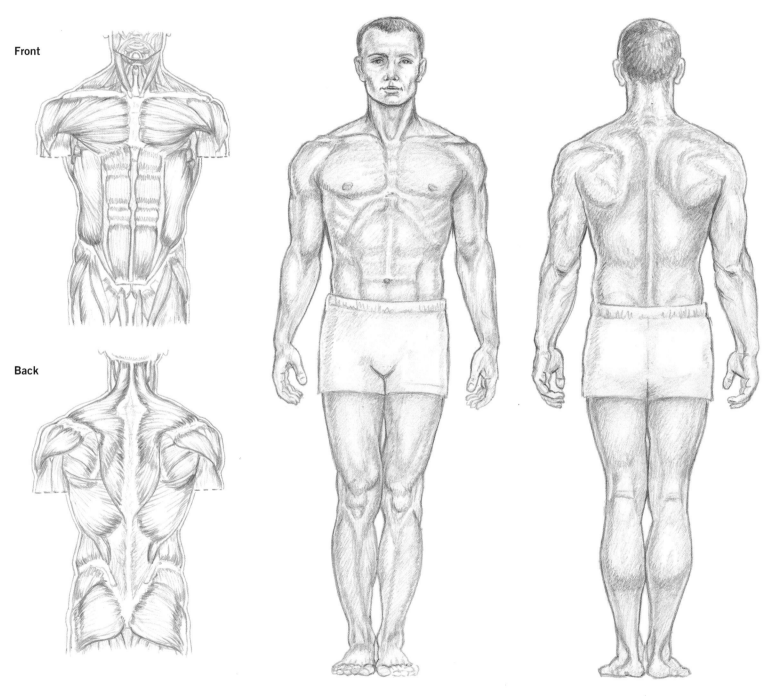

MUSCLES AFFECT FORM

The musculature of different individuals can vary depending on their level of physical fitness, but we all have the same muscles underneath. It's a good idea to become familiar with the placement of the structures shown in the front view (above) and back view (below) so you can better envision the way the skin lays over the muscles to create the human form.

TORSO MUSCULATURE (FRONT)

The torso muscles—from the neck to the shoulders, across the chest, down and around the rib cage, and then from the hips to the legs—control the movement of the body and give form to the skeleton. Compare this with the drawing at top left.

TORSO MUSCULATURE (BACK)

The muscles in the back of the torso generally extend across the body, rather than up and down as in the front. They hold the body erect, stretching tightly across the back when the limbs move forward. Compare this with the drawing at far left.

ADULT BODY PROPORTIONS

The proportional measurements of the parts of the human body vary slightly for every person, making them unique; paying attention to these variations will help you render accurate likenesses. But first it's important to understand how we're all the same by studying the average proportions of the human body, which are more apparent when we look at the skeletal and muscular views of the body. When drawing a figure, we measure in "heads," the vertical distance from the top of the head to the chin. Use rough measurements to help place the parts of your figure.

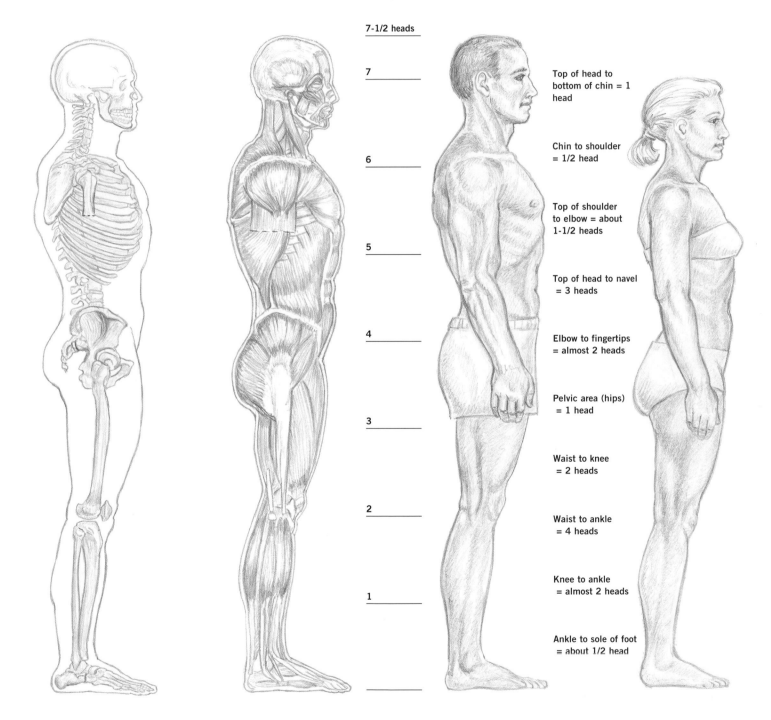

7-1/2 heads

7
6
5
4
3
2
1

Top of head to bottom of chin = 1 head

Chin to shoulder = 1/2 head

Top of shoulder to elbow = about 1-1/2 heads

Top of head to navel = 3 heads

Elbow to fingertips = almost 2 heads

Pelvic area (hips) = 1 head

Waist to knee = 2 heads

Waist to ankle = 4 heads

Knee to ankle = almost 2 heads

Ankle to sole of foot = about 1/2 head

SKELETAL STRUCTURE
By studying bone structure, we can clearly see the relationship of the length of each part of the body to the whole.

BODY MUSCULATURE
Proportion doesn't apply to length alone—the thickness of the body also must be proportionate. This aspect of proportion varies depending on the fitness of the individual.

MALE PROPORTIONS
The average male is approximately 7-1/2 heads high; of course, these proportions vary with different body types. Often artists use an 8-head-high figure for the male as an ideal proportion.

FEMALE PROPORTIONS
The average female is about half a head shorter than the male, or 7 heads high. Generally the female has narrower shoulders and a smaller waist than a male, but proportionally wider hips.

PROPORTIONS OF THE HEAD

Using a standard set of measurements helps the artist create accurate proportions when constructing a head drawing. In this section, you'll find measurements that can serve as general guidelines for your head drawings. These proportions are created from averages of the human population at large; however, remember that all people are not the same—they are individuals with varying proportions, and it is these variations that make us different from one another.

STEP 1 Begin with simple shapes first. A) Frontal: Start with a vertical rectangle. Inside, draw a single oval that includes the cranial and facial mass. B) Profile: Begin with a square. Then use two separate ovals connected at the forehead to draw the facial and cranial mass.

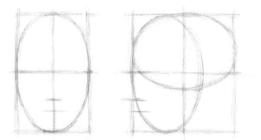

STEP 2 A) Frontal: Draw the major axis (vertical) to indicate the centerline of the face. Then add the minor axis (horizontal) to place the eyes. Draw a line halfway from the eye line to the chin to mark the base of the nose. The mouth is usually one-third of the way from the base of the nose to the chin. B) Profile: Divide the square into four by drawing a cross in its center. Mark nose and mouth measurements as in the frontal view (A).

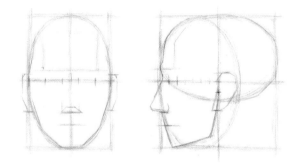

STEP 3 A) Frontal: A head is roughly five eyes wide. The tops of the ears are slightly higher than the eye line. The bases of the ears correspond to the base of the nose. Starting with the line for the brow ridge above the eye line, block in the forehead and base of the nose. B) Profile: Indicate the center of the ear in profile with a dark cross slightly below the center of the square. Place the eye approximately two eyes in from the front arch of the face. Now draw the angles of the nose and jawbone.

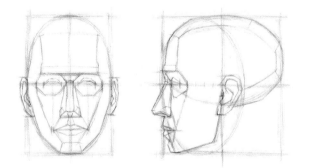

STEP 4 Everything on the face has a front, top, and bottom. When drawing the eyes, start with the eye socket first, using straight lines to create the overall shape. Then move to the upper lid. Articulate the nose with a bridge, sides, and base; then draw the planes of the face. Add the philtrum, which connects the base of the nose to the upper lip. Chisel out the cranial mass further. Develop the ear shapes, making them more organic and specific.

STEP 5 Now fluctuate the contour line to reveal the organic qualities of the face. Add the iris and pupil. Articulate the eyebrows with simple shapes, and place the nostrils at the base of the nose. Reveal the protuberance of the mouth using lines from the nostrils to the corners of the mouth. Then add the contours of the neck and the hairline to separate the face from the rest of the head.

FORESHORTENING HEAD MEASUREMENTS

Applying the rules of perspective and foreshortening helps create the illusion of volume and space. Mastering these principles results in more dynamic poses and compositions. Poses and perspectives that involve foreshortening can be more challenging than others. The obstacle is to overcome drawing *what you think you know* and instead draw *what you observe and truly see.*

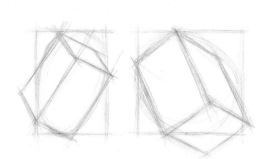

STEP 1 Starting with a simple box for the head allows you to see the major planes, indicate whether the model is looking up or down, and establish which side of the head we see. First, lightly draw a rectangle or square—whichever shape best fits your model's head.

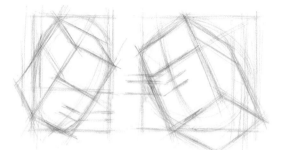

STEP 2 Mark the positions of the eyes, nose, mouth, and ears. Notice how foreshortening changes the marks from the frontal and profile views. When the model is looking down, it is important to know where the forehead becomes the top of the head. When the model is looking up, foreshortening appears more extreme. The eyes are high on the front of the face, reducing the amount of forehead seen. Foreshortening changes the ear line in relation to the other measurements and reduces the distances between the eyes, nose, and mouth.

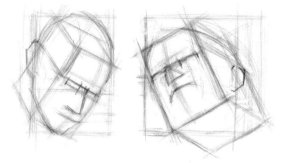

STEP 3 Begin chiseling out the shape of the head from the box using straight-line segments. When the model is looking down, we do not see the base of the nose. But when the model is looking up, we see plenty of the base. The arc of the mouth wraps with the curvature of the face and depends on the position of the head. Begin drawing the ears using straight lines that show where the curves change direction. Block in the eyes using rectangles.

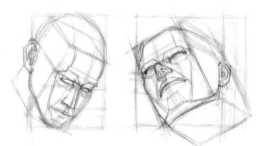

STEP 4 Further develop the planes of the head. Build the eye sockets before refining the eyes; this allows you to analyze the shapes around the eye for proper construction. Determine the shapes contained in the ears. When the model is looking down, focus on the bridge of the nose; when the model is looking up, focus on the nostrils.

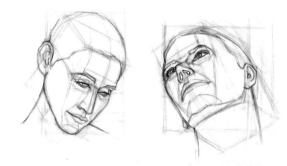

Foreshortening occurs when parts of an object nearest the viewer appear larger than parts that are farther away. For example, have someone stand in front of you with arms at his or her side. Take note of the size relationship of the hand and the head. Now have the person hold out a hand toward you, palm facing you. Notice that the hand now appears much larger in proportion to the head. This illusion is foreshortening in action.

STEP 5 In this step, increase your line weight to suggest value and create focal points or areas of interest, such as the eyes. Use more defined contour lines to articulate the organic qualities of the human head and define the major forms. Separate the hair shapes from the "mask" of the face, and add the eyebrows. Draw the contours of the neck as they relate to the gesture of the head.

COMPOSITION

A good composition will appear balanced and harmonious, with the various elements working together to create an eye-catching scene. Over the next few pages, you'll discover how to establish a center of interest, or focal point; create a visual path that leads the viewer's eye through the painting; organize the elements in your painting; and choose a format—horizontal, vertical, or panorama—that complements your subject.

POSITIVE AND NEGATIVE SPACE

The interplay of positive and negative space in a work of art is an important dynamic often brushed aside by beginners. Paying close attention to how they work together to influence the shape, balance, and energy of the work can help you improve and refine your compositions.

Positive space is the area in your work occupied by the subject, whereas negative space refers to the area between and around the subject. Think of negative space as a support system for your positive space; it should not take attention away from the positive space but instead should complement it. For example, negative space can echo the shapes of the subject to create rhythm within the work.

Sometimes a beginner's tendency is to fill a picture plane with as much subject matter as possible, cramming the scene with forms and utilizing every inch of empty space. However, the eye relies on areas of inactivity to rest and digest the scene as a whole. Many artists suggest aiming for a balance of positive and negative space, as too much of one can create a sense of excessive "fullness" or "emptiness." Others argue that using equal parts of positive and negative space creates confusion; the eye doesn't know where to focus. So, what to do? My advice is to let either the positive or negative space subtly dominate the composition. Play with ratios until you feel the dynamic best communicates your message.

CREATING A FOCAL POINT

A key element in creating a successful composition is including more than one area of interest, without generating confusion about the subject of the drawing. Compositions are often based on one large object, which is balanced by the grouping, placement, and values of smaller objects. Directing the viewer's eye with secondary focal points helps move the viewer through a scene, so that it can be enjoyed in its entirety.

The primary focal point should immediately capture the viewer's attention through size, line quality, value, placement on the picture plane, and the proximity of other points of interest which call attention to it. The secondary focal point is the area that the eye naturally moves to after seeing the primary focal point; usually this element is a smaller object or objects with less detail. Another secondary focal point may be at some distance from the viewer's eye, appearing much smaller, and showing only minor detailing, so that it occupies a much less important space in the drawing. This distant focal point serves to give the viewer's eye another stop on the journey around the composition before returning to the primary focal point.

Primary, Secondary, and Distant Focal Points

The size and detail on the pelican designates it as the primary focal point, and it immediately catches the viewer's eye. The pelican's gaze and the point of its bill shifts the attention to the small birds in the foreground (the secondary focal point). By keeping the texture and value changes subtle in the middle ground, the eye moves freely to this point. These three small birds are shaded fairly evenly so they don't detract from the primary focal point. The triangle created by the birds, along with the water's edge and the point of land, leads the viewer's eye to another, more distant focal point—the lighthouse. Here the two subtle rays of light against the shaded background suggest a visual path. The rays of light, the point of land, and the horizon line all work together to bring the viewer's eye back to the pelican, and the visual journey begins again.

LEADING THE VIEWER'S EYE

Once you've determined the focal point of your painting, you need to decide its position. You don't want your viewers to ignore the rest of the painting, so your focal point should be placed in such a way that the viewer's eye is led into and around the entire painting, rather than focusing only on the center of interest. You can lead the eye using a number of techniques: incorporating diagonal and curving lines, avoiding symmetry, overlapping elements, and composing with light and color.

In this landscape, the curving road creates an inviting path that guides the viewer's eye from the cool, bluish shadows to the warm, glowing fields and sunlit buildings.

Using Diagonal and Curving Lines

Even if the focal point of your painting is fairly obvious, you should emphasize the center of interest by using visual "signposts" to direct the viewer's eye toward it. Diagonal and curving lines often lead the eye from one of the corners of a painting to the center of interest. (For example, a diagonal street or a curving stream.) Curving and diagonal lines also can be formed by the placement of elements within the painting.

Avoiding Symmetry

One of the most basic rules of composition is to avoid too much symmetry in your paintings. Placing your focal point in the middle of the scene, for example, divides the painting in half and results in a static, dull composition. Placing the center of interest slightly off center, however, creates a much more dynamic, pleasing composition. This leads the eye around the entire painting, rather than inviting it to focus solely on the center of the composition. Try working out asymmetrical designs on scrap paper with thumbnail sketches— small compositional studies—before committing to a design.

POOR DESIGN In this thumbnail sketch, the elements are crowded into the center and are all on the same plane. The shapes are too symmetrical and uniform, and the eye is led out of the picture.

GOOD DESIGN Here the center of interest is placed farther to the left; the elements are staggered on different planes and are overlapped; and the curving path directs the eye into the scene.

THE RULE OF THIRDS

Determining the Focus

Determining the subject of your painting is only the first step; the next is to design the composition. To do so, ask yourself, "What do I wish to say?" The answer to this question will establish the center of interest—or focal point—of the painting. Surprisingly many artists don't know what or where their center of interest is; and if they don't know, neither will the viewer!

Once you've determined the focal point, you need to decide on its placement. You can always create a well-balanced composition if you follow the rule of thirds, also called the "intersection of thirds"; to follow this principle, divide the paper into thirds horizontally and vertically. Then place your center of interest at or near one of the points where the lines intersect. It's as simple as that! The rule of thirds keeps your center of interest away from the extremes—corners, dead center, or the very top or bottom of the composition—all recipes for design disaster. The result is a piece that holds the viewer's interest!

The rule of thirds helped locate the focal point of this painting. Note that the area containing my focal point has the greatest amount of detail and contrast; it features the lightest lights and the darkest darks.

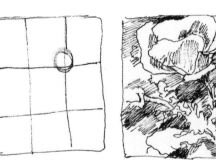

Testing Your Designs

Even when applying the rule of thirds, you'll usually find that you have a selection of designs to choose from. Thumbnail sketches—or small compositional studies—are the insurance policy of smart artists! They allow us to quickly work out a composition before committing time and effort to a sketch or painting. These sketches are small—2 to 3 inches at most—but they contain the necessary information about a scene's arrangements and values. It's always wise to make a few thumbnails before committing to a design.

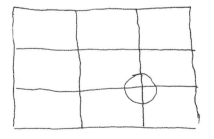

THE GOLDEN MEAN

The composition of most classical art is based on the Golden Mean, also known as the Golden Ratio, Golden Section, or the Divine Proportion. In ancient Egypt and Greece, design used a constant factor in a geometric progression, and that ratio was first calculated by a mathematician known as Fibonacci in the 13th century. The Golden Mean, or 1.618, is the constant factor in his continued proportion series: 1, 1, 2, 3, 5, 8, 13, 21, 34, 55, 89, 144, and so on. By adding the last number to the previous number, we arrive at the next number in the series; for example, 21 + 34 = 55, 55 + 34 = 89, and so on. By dividing any number by the previous, we get a result close to 1.618. In a continued proportion, the closest pair of numbers to the Golden Mean of 1.618 is 55 and 89—these two numbers are used most frequently in fine design to establish proportionate space.

FINDING THE GOLDEN MEAN IN NATURE

Examples of the Golden Mean are all around us in nature: the structure of sea shells, leaf and petal groupings, pinecones, pine-apples, and sunflowers, for instance.

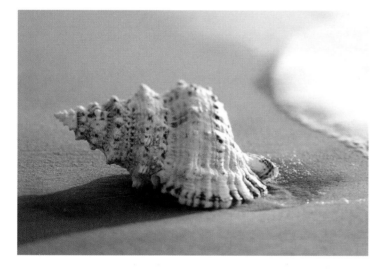

CONSTANT OR GEOMETRIC SPIRAL The conch shell shown here demonstrates the Golden Mean—as each section of the spiral naturally increases in size by 1.618 as it moves outward. This is called the "constant spiral" or "geometrical spiral."

THE "PERFECT" RATIO OF 89:55 The center of the daisy, like the sunflower and other plants with large seed heads, shows the geometric pattern formed by the Golden Ratio. As the seeds or pistils move out from the center of the flower, they create spiral patterns that curve to the right and left at an 89:55 ratio.

NATURALLY OCCURRING RATIO The Golden Mean ratio and spiral pattern also can be seen in the structure of most pinecones. Note how the individual pieces spiral up from the bottom of the cone. There actually are two spiral patterns: one to the left and one to the right. Different types of conifers generate different spiral patterns. The pineapple spirals in this same manner.

FINDING THE GOLDEN MEAN OF A LINE

The 1:1.618 ratio is used by designers and artists in all media, such as architects, engineers, cabinet makers, and many other creative people. In this exercise, we concentrate on dividing a line into what is commonly accepted as the most aesthetic division.

You can find the Golden Mean of any line by measuring it and using a calculator to divide that number by 1.618 (Method 1). Mark a point at that measurement on the line to divide it into two segments of the perfect proportions. You can continue to divide each smaller section of the line by 1.618 to create more divisions in the Golden Mean ratio. You also can use simple geometry to achieve the same results that the Greeks used in their design (Method 2). Just follow the steps below that illustrate each method.

Method 1: Calculator

STEP 1 Begin by drawing a line of any length and label the two endpoints as A and B. This particular line is 4 cm long.

STEP 2 Divide the length (4 cm) by 1.618. The number you get (in this case, 2.47 cm) is the distance between A and C above.

Method 2: Geometry

STEP 1 Begin by drawing a line of any length and label the two endpoints as A and B. Divide the line length in half and mark the center point.

STEP 2 Draw a perpendicular line at point B that is equal in length to half of line AB (the measurement from the center point to A or B). Label the end of the new line point C (BC = 1/2 AB).

STEP 3 Draw a circle with the center at point C and BC as the radius.

STEP 4 Draw a line from A to C. Label the point where line AC passes through the circle as point D.

STEP 5 Using point A as the center and AD as the radius, draw a partial circle which intersects line AB; that intersection is at point E (EA = AD). You should find that line AE equals a division of 144/89 and line EB equals a division of 89/55, where 144 is the original line length (AB). Contrast is created by the differing sizes of lines AE and EB, and unity is created by the correlation of line EB to the entire line AB (the Golden Mean).

PAINTING

The earthiness of working with pigments, liquids, and oils makes paint an ideal vehicle for expression. Whether carefully building up luminous glazes of watercolor or laying on thick strokes of oil paint, artists can work subtly or boldly, pulling from a wide variety of tools and techniques to most effectively communicate their subject, message, and emotion.

SURFACES & SUPPORTS

Also called a "support," your painting surface helps determine the qualities of your work—from texture, brightness, and color to longevity. Paper, canvas, and wood panels are the most common painting supports, but don't feel pressured into a traditional approach. However, the more you understand why and how artists work with particular surfaces, the more likely you will find success with your own artistic experiments and decisions.

WATERCOLOR PAPER TEXTURES

Watercolor paper is available in three textures: hot-pressed, cold-pressed, and rough. The surface you choose depends on your painting style and the visual effects you want to achieve.

Hot-pressed paper
this paper has been pressed with heat, which creates a smooth surface. Hot-pressed paper is ideal for fine detail, even washes, and a controlled style. This paper is not especially absorbent, which results in bright colors.

Cold-pressed paper
Also referred to as "Not" or "medium" paper, cold-pressed sheets are not treated with heat, leaving an irregular surface. This versatile paper is ideal for granular textures and a more painterly style.

Rough paper
This paper is even rougher than a cold-pressed surface. The deep tooth can leave quite a bit of the paper showing along the edges and within each stroke. It complements an expressive style and dry-brush techniques.

WATERCOLOR PAPER

Watercolor paper is the perfect surface for the fluid washes of watercolor. However, many artists like using this durable surface for other wet and dry media such as gouache, acrylic, pastel, pen and ink, and even graphite.

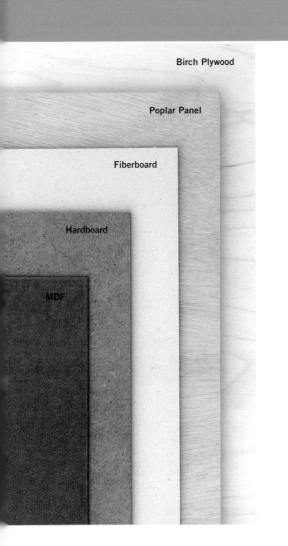

Birch Plywood

Poplar Panel

Fiberboard

Hardboard

MDF

PANELS

Wood panels have been used for painting for centuries. While canvas offers more portability, wood panels are still widely used today, along with wood-based composite panels. When prepared properly, panels offer artists a firm, sturdy, and durable support for oil, acrylic, tempera, and encaustic painting.

CANVAS

Canvas is lightweight, portable, and affordable. It also allows great freedom with artwork size. Canvas is considered the most popular painting surface for oil and acrylic.

CANVAS FORMATS

Canvas Paper	Sheets of pre-primed canvas
Canvas Board or Panel	Canvas mounted on board and pre-primed
Gallery-Wrapped Canvas	Canvas pre-stretched around wooden stretcher bars; available pre-primed and unprimed

Canvas is pulled taught over a wooden frame and secured with thick staples.

ALTERNATIVE SUPPORTS

Aside from traditional paper, canvas, and panels, you can paint on a variety of surfaces—including metal and stone. Try experimenting with these unusual supports.

Below are the most common supports used for the most common media.

- **Watercolor** Watercolor paper, rice paper
- **Gouache** Watercolor paper, illustration board
- **Acrylic** Watercolor paper, canvas paper, canvas panel, pre-primed and stretched canvas, wood panel
- **Oil Canvas** paper, canvas panel, pre-primed and stretched canvas, wood panel

BRUSHES

A wide range of brush types and sizes is available. Choosing the right brush for the right task makes a difference in your painting experience. Remember that skimping on brush quality can leave unintended marks from frayed, unwieldy bristles or stray hairs that get stuck in the painting.

BRUSHES

Brushes come in three basic hair types: soft natural-hair, soft synthetic-hair, and bristle brushes. Choosing the right brush for the right task makes a difference in your painting experience.

Natural-Hair Brush

Synthetic-Hair Brush

Soft natural-hair brushes are made up of the hair of an animal such as a weasel, badger, or squirrel. High-quality naturals hold a good amount of moisture and are an excellent choice for watercolor. Some oil artists use natural-hair brushes for detail work, but most acrylic artists avoid them because they are delicate and damage easily.

Soft synthetic-hair brushes are made of man-made fibers such as nylon and polyester filaments. They are ideal for acrylics and serve as an excellent alternative for watercolorists when natural-hair brushes are cost prohibitive.

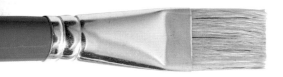

Bristle Brush

Bristle brushes are coarse and sturdy fro working with thick oil and acrylic paint. Made of hog hair, they produce visible, painterly brushstrokes.

Bristle brushes are ideal for using heavy-bodied paint (A), whereas soft-haired brushes work well for feathery strokes, details, and blending (B).

Brushes also vary in handle length. Long-handled brushes are intended for use with oil or acrylic; short-handled brushes are intended for use with watercolor, ink, and other fluid media.

Round Brush

Round brushes have round ferrules and hairs or bristles that taper to a soft point, allowing for varying stoke widths.

👍 **GOOD FOR WATERCOLOR** 👎 **NOT GOOD FOR STRAIGHT EDGES**

Flat Brush

Sometimes referred to as "shaders" or "one-stroke" brushes, flats are ideal for creating straight edges.

👍 **GOOD FOR EDGING** 👎 **NOT GOOD FOR DETAIL WORK**

Bright Brush

A bright brush is a flat brush with short bristles or hairs, offering greater control over strokes.

👍 **GOOD FOR SHORT, CHUNKY STROKES** 👎 **NOT GOOD FOR DETAIL WORK**

Wash Brush

A wash brush is a wide flat brush with soft hairs and a thin edge.

👍 **GOOD FOR WASHES** 👎 **NOT GOOD FOR DETAIL WORK**

Filbert Brush

The filbert brush acts as a hybrid of round and flat brushes.

👍 **GOOD FOR SOFT BLENDS** 👎 **NOT GOOD FOR HARD EDGES**

Chisel-Edge Brush

Also called "angular" or "slanted"—a chisel-edge brush is a flat brush with bristles or hairs trimmed diagonally.

👍 **GOOD FOR SHARP, ANGLED STROKES** 👎 **NOT GOOD FOR SOFT BLENDS**

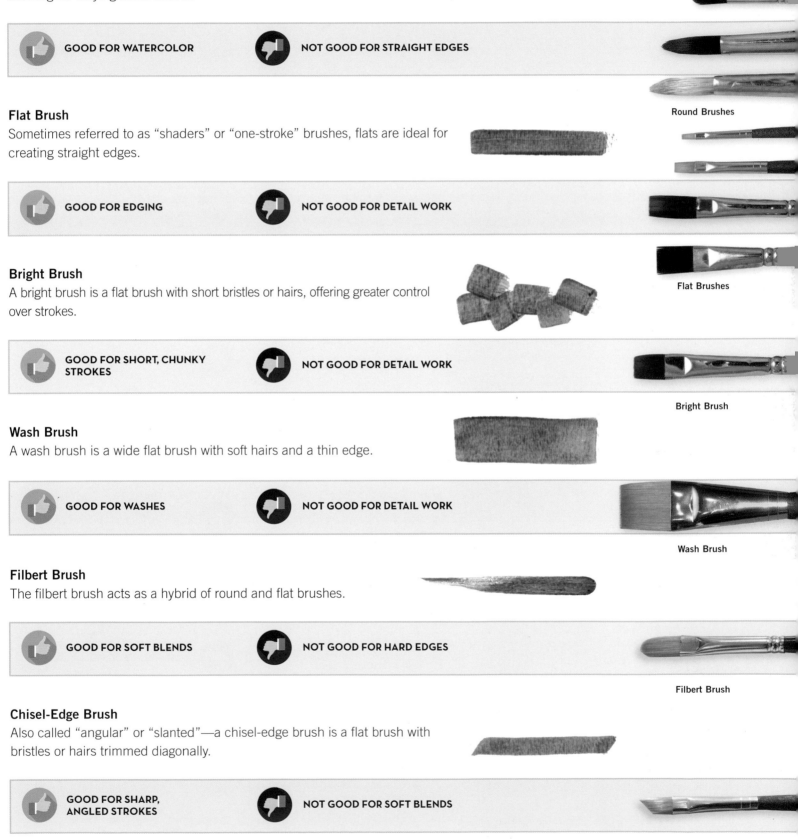

Round Brushes

Flat Brushes

Bright Brush

Wash Brush

Filbert Brush

Chisel-Edge Brush

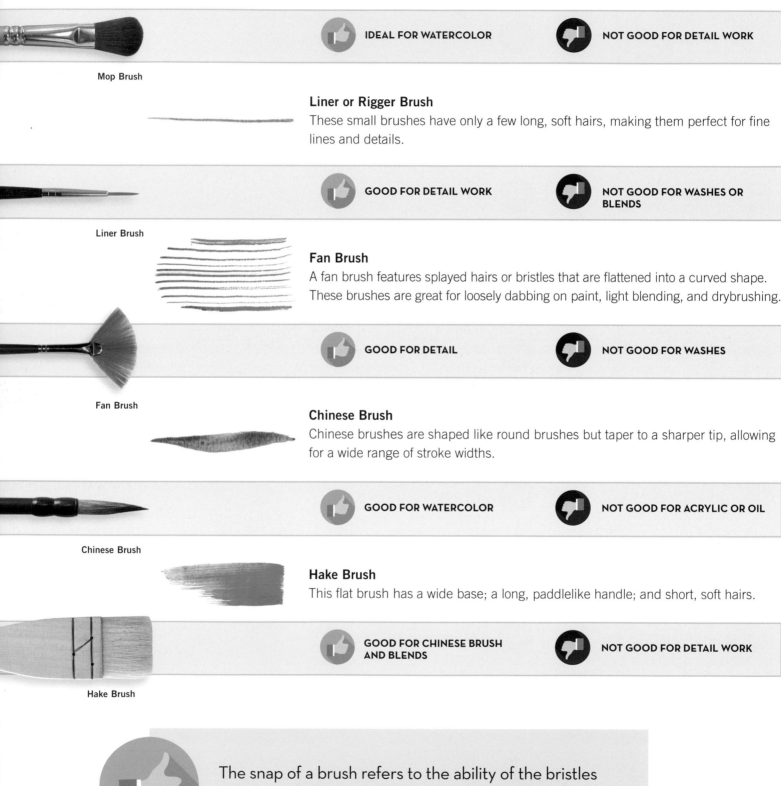

Mop Brush

Resembling a makeup brush, the mop brush is a thick bunch of soft hair that tapers subtly for a rounded tip.

Mop Brush

👍 IDEAL FOR WATERCOLOR 👎 NOT GOOD FOR DETAIL WORK

Liner or Rigger Brush

These small brushes have only a few long, soft hairs, making them perfect for fine lines and details.

Liner Brush

👍 GOOD FOR DETAIL WORK 👎 NOT GOOD FOR WASHES OR BLENDS

Fan Brush

A fan brush features splayed hairs or bristles that are flattened into a curved shape. These brushes are great for loosely dabbing on paint, light blending, and drybrushing.

Fan Brush

👍 GOOD FOR DETAIL 👎 NOT GOOD FOR WASHES

Chinese Brush

Chinese brushes are shaped like round brushes but taper to a sharper tip, allowing for a wide range of stroke widths.

Chinese Brush

👍 GOOD FOR WATERCOLOR 👎 NOT GOOD FOR ACRYLIC OR OIL

Hake Brush

This flat brush has a wide base; a long, paddlelike handle; and short, soft hairs.

Hake Brush

👍 GOOD FOR CHINESE BRUSH AND BLENDS 👎 NOT GOOD FOR DETAIL WORK

👍 The snap of a brush refers to the ability of the bristles or hairs to spring back into their original position.

PALETTE & PAINTING KNIVES

Palette and painting knives are handheld tools for handling oil and acrylic paint. They feature wooden handles connected to thin, flexible metal blades. Although the terms are often used interchangeably, the tools are not exactly the same. A palette knife is for mixing paint, whereas a painting knife is for applying paint to the canvas.

PALETTE KNIVES

The blade of a palette knife can either be flush with the handle or slightly bent away. The blade tapers to a rounded tip, and its edges are long and straight. Use a palette knife to mix paints on your palette by scooping and spreading the paint repeatedly. You can also use a palette knife to apply and spread oil primer across a canvas.

PAINTING KNIVES

Generally diamond- or trowel-shaped with a pointed tip, blades come in a variety of sizes and proportions. You can apply the paint thickly or scrape it across the surface for thin, irregular marks.

Painting Knives

Avoid overmixing your paint before applying it to your surface with a painting knife. Leaving mixes loose results in striations and gradations that give your strokes extra texture, depth, and spontaneity.

A B

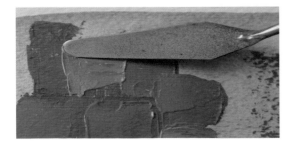

PAINTING TECHNIQUES

Holding the blade at an angle to the palette, scrape the paint toward you so it collects on the back of the blade. Spread the paint on your surface, pulling or pushing the knife perpendicular to the length of the blade. Then rotate the knife and apply horizontal strokes.

MIXING PALETTES

Mixing palettes are surfaces for preparing and mixing paints. The palette you choose depends on your medium and personal preferences.

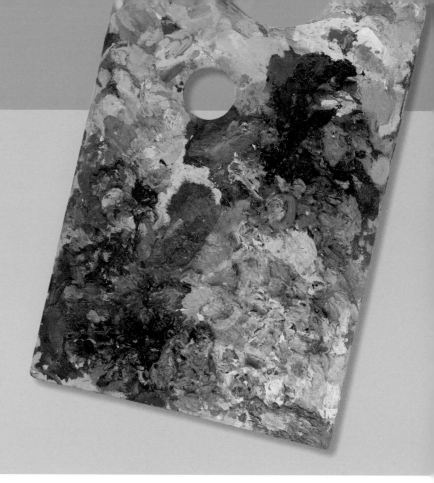

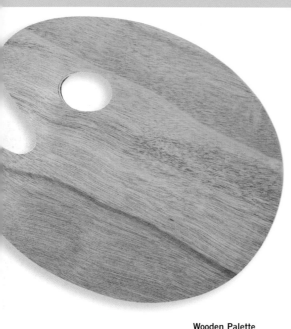

Wooden Palette

PALETTES FOR OIL & ACRYLIC

Wooden Palettes

Traditional wooden palettes offer a flat, lightweight mixing surface for oil paints. The wood color provides a warm middle value so you can better judge your paint values as you mix. Wooden pallets are not the best choice for acrylic paint, which dries quickly and adheres to the wood.

Plastic Palettes

White plastic palettes are smooth, lightweight, and inexpensive mixing surfaces. Many are simple and flat, whereas others feature shallow wells to keep paint colors separate. If using acrylic, you can easily clean the plastic using soap and warm water; if using oil, you can clean the surface using a cloth and solvent.

SETTING UP A PALETTE
Artists often organize the colors on their palettes to maintain consistency and order as they paint. Consider placing your colors in "rainbow order" followed by earth tones, black, and white. Place the colors along the edges of your palette, leaving plenty of room for mixing in the middle.

Plastic Palette

Clear Palettes

Sheets of plexiglass or tempered glass make excellent tabletop mixing surfaces for oil and acrylic.

Palette Paper

Palette paper comes in pads and disposable sheets. The paper is poly-coated for a smooth, moisture-resistant finish.

Palette Paper

Sealed Trays

Many artists use shallow, airtight containers for storing their palettes. You can use the plastic bottom directly for mixing paint, but most artists use the containers to store disposable or handheld palettes.

Sealed Tray

PALETTES FOR WATERCOLOR

Simple Welled Palettes

The fluid nature of watercolor and gouache calls for palettes with wells for containing mixes. White plastic palettes are an economical choice, as they are lightweight and easy to clean, but some artists opt for uncoated aluminum, which offers a bright, reflective surface that is durable and resistant to rust.

Travel Palettes

Sometimes referred to as portable palettes, compact palettes, or watercolor boxes, these convenient folding palettes snap shut for painting on the go.

Potted Palettes

These palettes come with a number of lidded pots that line mixing wells. The pots keep water-based paints—such as watercolor, gouache, and acrylic—moist and ready to mix.

Simple Welled
Watercolor Palettes

Potted Palettes

ACRYLIC

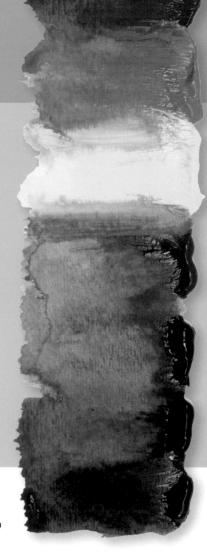

Acrylic is a uniquely distinctive medium, with unparalleled versatility. While it has its own look and feel, it also beautifully mimics other media, such as watercolor, oil, and even pastel. Acrylic paint dries quickly like watercolor but is as permanent as oil and as vibrant as pastel. You can thin acrylic paint with water to create luminous washes, or you can use it straight from the tube to build up thick layers. And because acrylics are water-based, cleanup is as simple as soap and water.

ADDITIONAL SUPPLIES
Before you begin painting, consider gathering the basic tools below to simplify and enhance your painting experience:
- Spray bottle
- Artist tape and binder clips
- Rags and paper towels
- Glass jars
- Sponges

ACRYLIC PAINT

Acrylic paint, which is made up of pigment and acrylic polymer, boasts a number of positive qualities that make it a viable competitor to oil and watercolor. First, you can dilute the paint with plain water (no harsh solvents needed), but once it's dry, the paint is waterproof. Second, you can apply the paint in thick or thin layers, imitating either oil or watercolor, respectively. Third, acrylic is resistant to cracking and fading. Fourth, unlike oil, acrylic dries quickly so you don't have to wait long between applying layers.

TYPES OF ACRYLIC

Acrylic paint comes in tubes, tubs, jars, and squeeze bottles. Tubs and squeeze bottles typically hold thinner paints, whereas traditional tubes contain thicker paint with more body. There are several distinct consistencies (or viscosities) of paint available, from thick and heavily bodied to thin and fluid. Manufacturers also produce paints with sheens that vary depending on the light and your viewing angle.

Whether your acrylics come in flip-top or screw-top tubes, jars, or squeeze bottles, be sure to keep the openings and lids clear of dried paint. Allowing paint to build up prevents the lid from sealing properly and will dry up the paint in the tube.

Basic Acrylics

The most common acrylic for fine artists has less body than oil paint but much more than watercolor washes. The gel-like consistency forms soft peaks and offers a great middle ground for artists who desire more control than fluid paints without the bulk of thick, heavy paints.

Heavy Body Acrylics

This thick, buttery paint with a high viscosity retains brushstrokes and allows artists to form stiffer peaks of paint. It is a great choice for highly textured work that uses painting knives, coarse brushwork, and impasto techniques.

Fluid Acrylics

Fluid paint has a low viscosity, with a consistency that lies between ink and basic acrylic paint. Fluids settle to a smooth finish and do not retain brushstrokes or peaks. You can achieve wonderful flowing, drippy effects and expressive spattering with this paint.

Acrylic Inks

Also called "liquid acrylics," these extremely fluid inks are the thinnest acrylics available. They work well with watercolor techniques such as spattering and glazing. Because they are waterproof, you don't have to worry about disturbing previous layers once dry.

Iridescent Acrylics

These paints contain mica, which gives them a metallic shimmer. Iridescent paints are very reflective and can provide exciting accents that add depth and variation to a work.

Interference Acrylics

Interference paints are transparent paints that, depending on the light and your viewing angle, shift between a bright, reflective sheen and its color's complement. This paint works best mixed with or glazed over black or dark colors.

ACRYLIC MEDIUMS & ADDITIVES

A vast array of acrylic mediums and additives allows you to experiment endlessly with the consistency, sheen, and behavior of your paint. These liquids, gels, and pastes are sure to breathe new life into your painting sessions and encourage creativity. Below are the most common types of additives and mediums, followed by the most common products available to artists today. Note that it's best to add paint to a medium, rather than medium to paint.

Liquid additives change the behavior of paint without adding binder to the mix. Often just a small amount of additive is needed.

Gel mediums are colorless substances made from the same emulsion as acrylic, so they mix into the paint seamlessly. They are excellent tools for extending and diluting paint colors, and you can also use them as collage adhesives. Manufacturers offer them in a range of viscosities and sheens to suit your needs.

Pastes are opaque mediums with fillers that allow for interesting textures. They do not dry clear as gels do, so consider this when using the pastes as a mix-in.

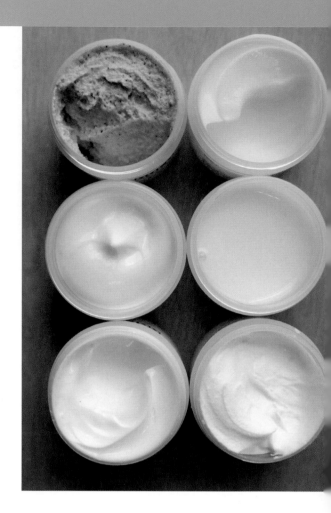

The best way to handle gels and pastes is with a palette or painting knife. Use the knife to scoop the mediums out of containers, mix them with paint, or spread them over your painting surface.

Flow Improver
This liquid additive increases the fluidity of paint by breaking the surface tension. Unlike plain water, flow improver helps preserve the strength of a paint color.

Retarder
Retarder is a liquid additive that slows the drying time of acrylic paint. Because acrylic paint dries quickly, artists use retarders to extend their working time, minimizing wasted paint on the palette and allowing for more blending on canvas.

ACRYLIC GELS & PASTES

Gels and pastes are the "secret" ingredients that will allow you to take your creative ideas and explorations to new heights. There are many gels, pastes, and grounds that can be used alone, together, or layered in any combination and mixed with any of the paints; therefore, the opportunity to explore countless avenues for personal expression is right at your fingertips. Finding "your voice," artistically speaking, has never been so easy and so much fun.

These materials are all made of the same ingredients: water and acrylic polymer solids. For you, this means creative freedom. You can mix, layer, and combine them in any way you wish to create endless variations and spectacular effects. The fast dry time lets you "layer up" to your heart's delight. Unlike oils, which have oppressive rules and dry times, acrylics allow you to follow your musings without fear of improper application techniques.

Gels can be thought of as colorless paint—they are made from binder but contain an added swelling agent to give them a heavier viscosity. They are offered in gloss, semi-gloss, and matte sheens and in viscosities ranging from light and (almost) pourable (like yogurt) to extra heavy (like peanut butter). Pastes are gels with solids added (marble dust, calcium carbonate, glass beads, etc.). This gives them body, which results in interesting textures and sculptural effects. Mediums are a low-viscosity polymer that you can use to thin paint for a better flow and to create glazes.

Light Molding Paste

Clear Tar Gel

High Solid Gel (Matte)

Coarse Pumice Gel

Regular Gel (Matte)

Crackle Paste

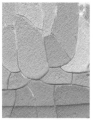
Coarse Molding Paste

Extra Heavy Gel (Gloss)

Clear Granular Gel

Fiber Paste

Coarse Pumice Gel

Fiber Paste

Molding Paste

Coarse Molding Paste

Light Molding Paste

Glass Bead Gel

Heavy Gel (Gloss)

Extra Heavy Gel (Matte)

Soft Gel (Matte)

Clear Granular Gel

Clear Tar Gel

Self Leveling Clear Gel

When tinted with color, the unique qualities of the gels and pastes become more apparent. You can use all gels and pastes in the following ways:

- As a surface texture on which to paint (called a ground)
- Mixed with paint for added body and sheen (called a medium)
- Applied on top of your painting for a covering effect

ACRYLIC TECHNIQUES

There are myriad techniques and tools that can be used to create a variety of textures and effects. By employing some of these different techniques, you can spice up your art and keep the painting process fresh, exciting, and fun! The examples on these pages were completed using acrylic paint.

FLAT WASH This thin mixture of acrylic paint has been diluted with water (use solvents to dilute oil paint). Lightly sweep overlapping, horizontal strokes across the support.

GRADED WASH Add more water or solvent and less pigment as you work your way down. Graded washes are great for creating interesting backgrounds.

DRYBRUSH Use a worn flat or fan brush loaded with thick paint, wipe it on a paper towel to remove moisture, then apply it to the surface using quick, light, irregular strokes.

SETTING UP A PALETTE
A good beginner's palette of colors consists of one warm and one cool version of each of the primary colors: yellow, red, and blue. You'll also want to include white, black, and a few browns, such as burnt sienna or raw umber. From these basics, you should be able to mix just about any color you'll need.

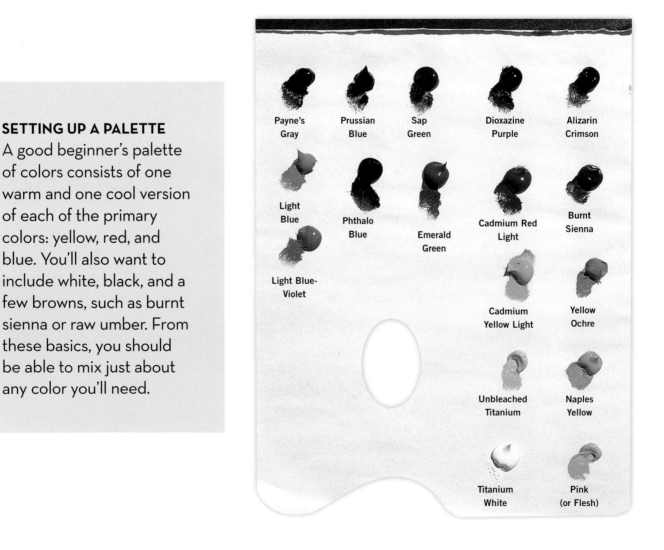

Payne's Gray — Prussian Blue — Sap Green — Dioxazine Purple — Alizarin Crimson

Light Blue — Phthalo Blue — Emerald Green — Cadmium Red Light — Burnt Sienna

Light Blue-Violet — Cadmium Yellow Light — Yellow Ochre

Unbleached Titanium — Naples Yellow

Titanium White — Pink (or Flesh)

THICK ON THIN Stroking a thick application of paint over a thin wash, letting the undercolor peek through, produces textured color variances perfect for rough or worn surfaces.

SCUMBLE With a dry brush, lightly scrub semi-opaque color over dry paint, allowing the underlying colors to show through. This is excellent for conveying depth.

STIPPLE Take a stiff brush and hold it very straight, with the bristle-side down. Then dab on the color quickly, in short, circular motions. Stipple to create the illusion of reflections.

MASK WITH TAPE Masking tape can be placed onto and removed from dried acrylic paint without causing damage. Don't paint too thickly on the edges—you won't get a clean lift.

SCRAPE Using the side of a palette knife or painting knife, create grooves and indentations of various shapes and sizes in wet paint. This works well for creating rough textures.

LIFTING OUT Use a moistened brush or a tissue to press down on a support and lift colors out of a wet wash. If the wash is dry, wet the desired area and lift out with a paper towel.

DRY ON WET Create a heavily diluted wash of paint; then, before the paint has dried, dip a dry brush in a second color and stroke quickly over it to produce a grainy look.

IMPASTO Use a paintbrush or a painting knife to apply thick, varied strokes, creating ridges of paint. This technique can be used to punctuate highlights in a painting.

GLAZING

Glazes are thin mixes of paint and water or acrylic medium applied over a layer of existing dry color. An important technique in acrylic painting, glazing can be used to darken or alter colors in a painting. Glazes are transparent, so the previous color shows through to create rich blends. They can be used to accent or mute the base color, add the appearance of sunlight or mist, or even alter the perceived color temperature of the painting. When you start glazing, create a mix of about 15 parts water and 1 part paint. It's better to begin with glazes that are too weak than ones that are too overpowering, as you can always add more glazes after the paint dries.

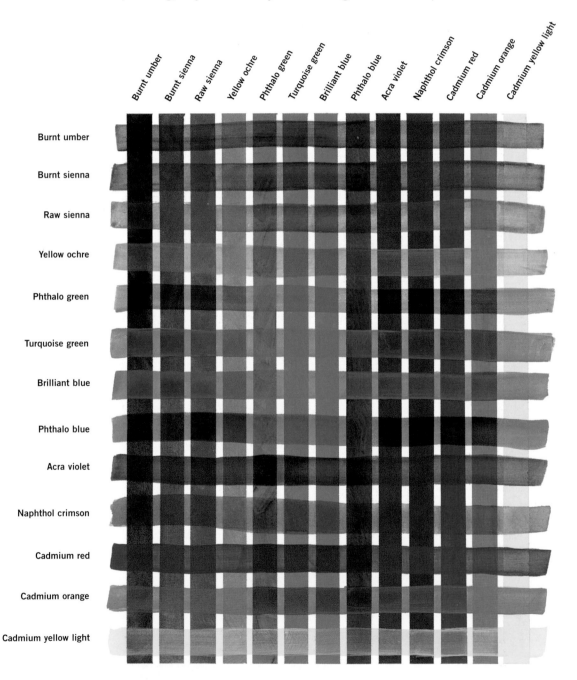

GLAZING GRID In this chart, transparent glazes of 13 different colors are layered over opaque strokes of the same colors. Notice how the vertical opaque strokes are altered by the horizontal translucent strokes.

APPLYING AN UNDERPAINTING

An underpainting is a thin wash of color that is applied to the support at the beginning of the painting process. An underpainting can be used to simply tone the support with a wash of color to help maintain a desired temperature in a final painting—for example, a burnt sienna wash would establish a warm base for your painting; a blue wash would create a cool base. An underpainting can also provide a base color that will "marry with" subsequent colors to create a unified color scheme. You can also use an underpainting to create a visual color and value "map," giving you a guideline for applying future layers. An underpainting can help provide harmony and depth in your paintings. Experiment with various underpaintings to discover which colors you prefer.

Magenta **Burnt sienna**

Purple **Phthalo violet**

Underpainting for Temperature

In the example at left, the flower has been painted over two different underpaintings: magenta (left) and light blue (right). Although the final flower is painted with identical colors on both sides of the canvas, the underpainting color greatly affects the appearance of the later layers of color. Notice that the left half of the flower appears significantly warmer in temperature, whereas the right half has a cool blue undertone.

Frisket is a masking material that is used to protect specific areas of a painting from subsequent layers of color. Liquid frisket is a type of rubber cement that is applied with a brush or sponge. When applied with a brush, it can be used for saving areas of fine detail. When you're done painting, simply rub off the dried frisket with your finger.

PAINTING THINLY AND THICKLY

PAINTING THINLY

Acrylic paint is generally described as an opaque medium, but you also can use acrylic as you would watercolor—in thin, diluted layers of color, or glazes. You can lighten the value of an acrylic wash by adding more water to the pigment, which in turn allows more of the support to show through the color. This gives the paint a luminous quality. You also can layer thin washes of acrylic paint to build up rich color. Because acrylic is waterproof when dry, you can layer new glazes over previous ones without lifting the initial pigment.

PAINTING THICKLY

To create a rich, buttery texture like frosting on a cake, apply thick layers of paint to your support using your paintbrush or a palette knife. Use the paint straight from the tube, or consider adding a paint-thickening medium, such as gel. Called "impasto," this technique allows you to create ridges and peaks of paint with quick, short strokes from varying angles and directions, adding physical dimension and texture to your painting. Don't overwork the paint—just keep your strokes loose and fresh.

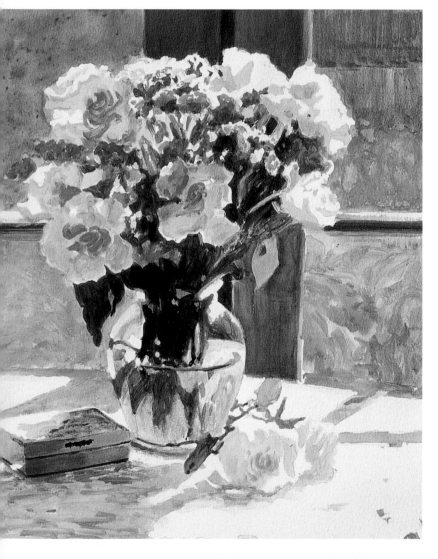

USING IMPASTO This technique is ideal for creating foamy water, as shown.

DILUTING ACRYLIC PAINT The transparent properties of thinned acrylic paint are perfect for depicting delicate, colorful subjects, such as the clear and reflective surfaces of glass and the fragile, soft curves of flower petals shown here. By thinning acrylic with generous amounts of water, you can achieve the airy quality of watercolor with a greater degree of control over your washes, as demonstrated in this light-filled painting of a vase of roses.

EMPHASIZING HIGHLIGHTS Punctuate the highlights in your painting (such as the white areas of rippled water shown here) by layering thick applications of paint over the highlighted areas.

DABBING AND TEXTURING

DABBING

To build up color in soft dabs, load the tip of your brush with paint and dot on color in a jabbing motion. This technique builds up layers of paint to create the illusion of depth and dimension, also adding an airy, impressionistic look to your painting. It's best to work from dark to light when using this technique, as you'll want to apply the lightest areas and highlights last.

BUILDING UP LAYERS
Layering dabs of several different shades of green and yellow gives fullness and dimension to foliage, as shown in this example.

TEXTURING

Because acrylic dries quickly, this medium lends itself to a variety of physical texturing techniques. Besides applying thick impasto applications to your support, you can mix in additives, such as painting mediums, sand, or eggshells. Or you can press bubble wrap, plastic wrap, coins, or fabric into wet paint to create interesting patterns and textures.

BUILDING UP TEXTURE Add interesting textures to your paintings by randomly pressing a balled-up piece of plastic wrap into the wet paint. The mottled texture that results (shown here in the beginning stages of a painting) will create visual interest wherever it shows in the finished painting.

SHAPING WITH SHADOW

Pastry chefs can create frosting flourishes with a flip of the wrist. With just a little practice, you'll be able to paint them with the same ease. The trick is to focus on the shadows. When you learn to place highlights and shadows appropriately, subjects take on dimension and a lifelike appeal!

PALETTE
- Alizarin crimson
- Burnt sienna
- Cadmium yellow medium
- Titanium white
- Ultramarine blue
- Yellow ochre

STEP 1 Work out this fairly simple composition directly on a 8" x 10" canvas using a ¼" flat brush. To establish the color scheme, use yellow ochre for the cakes, mix in burnt sienna for the cup, and apply alizarin crimson and ultramarine blue for the frosting.

STEP 2 For the background, work from top to bottom, starting with a mix of ultramarine blue and titanium white. Transition to burnt sienna with a bit of alizarin crimson for the lower half.

STEP 3 Using the same brush, paint the cakes—including what will be the liner—starting with mostly yellow ochre on the left, facing the light, and gradually adding more burnt sienna on the right as the cakes move into shadow.

Hold on to old brushes, like this small round brush. It's lost its shape, making the bristles perfect for applying specks of yellow ochre and white that look like dappled light.

STEP 4 Next add highlights to the top of the cake on the left (see detail). Define the paper liners with the ¼" flat brush. At the top of each paper ridge, I apply a mix of yellow ochre and titanium white.

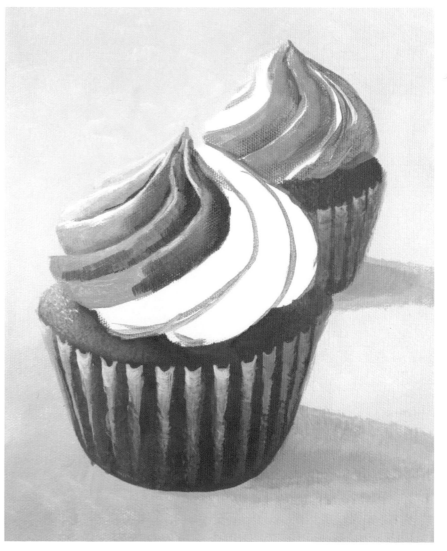

STEP 5 You have two options for the frosting. (See page 150 for an alternative approach.) Here, with the ¼" flat brush, each swirl is painted individually. Begin with a medium-tone mix of ultramarine blue, alizarin crimson, and titanium white. On top of this, apply shadows, using less white in the mix. Then define highlights, using white with a touch of ultramarine blue.

FROSTING DETAIL

STEP 1 You also can approach the frosting as one shape. Mix a medium tone of ultramarine blue, alizarin crimson, and titanium white to add guidelines showing the direction of the swirls. Then paint from left to right, using less white as you move into shadow.

STEP 2 Next add more dimension to the swirls with shading. I use the same mixture from the previous step, but with more white. I also add more alizarin crimson for a pinkish tone in the lighter areas on the left and more blue for the darker shadows at right.

STEP 3 The last step is to add highlights along the ridges of the swirls where the light hits the frosting. I use pure titanium white for the spots where the light hits directly, but I add ultramarine blue to tone down the white for highlights in the areas of heavier shadow.

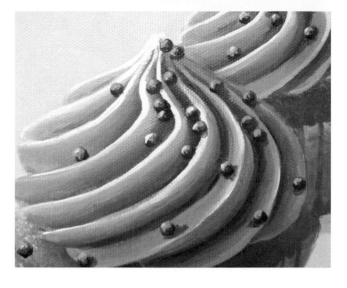

STEP 7 Dot each sprinkle into place with a medium-tone mixture of alizarin crimson and titanium white, using a small, round brush. To give the dots shape, add shadows and highlights.

STEP 6 When you've finished frosting one cake, move on to the next. Try approaching the frosting on the cupcake in the foreground with individual swirls and the frosting on the cupcake in the background as a whole. Both methods yield frosting that looks good enough to eat. All we need now is sprinkles!

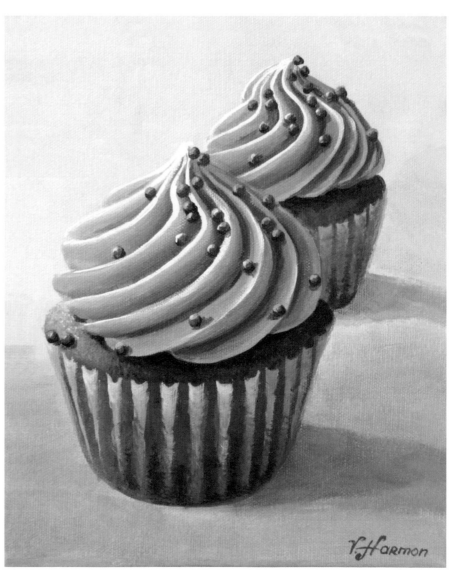

STEP 8 The sprinkles aren't the only decorations that cast shadows; the frosting also casts a shadow on the top of each cake. Return with a little yellow ochre mixed with burnt sienna to add these. To finish, emphasize the shadows cast from the cupcakes on the table, layering on alizarin crimson mixed with burnt sienna and a little titanium white.

GRADUAL TRANSITIONS

Ocean waves are dynamic, full of motion, light, and beautiful color transitions. You need to be able to paint wet-on-wet to create gradual transitions from one color to the next. In order to do so, be sure to mix enough paint on your palette. If you do not have enough paint and need to mix more during the process, the paint on your paper will dry too fast.

PALETTE
- Titanium white
- Cadmium yellow
- Hooker's green
- Cerulean blue
- Ultramarine blue

STEP 1 First create a composition drawing. You can do this on any drawing paper, and then transfer it onto your watercolor paper or canvas.

STEP 2 Next emphasize the most important compositional lines with very thin mixtures of cerulean blue and Hooker's green.

STEP 3 Start painting the background waves, using Hooker's green and ultramarine blue for the water and titanium white and cerulean blue for the lighter reflections on the waves.

STEP 4 Next use a very light mixture of titanium white, cadmium yellow, and Hooker's green on the bottom of the falling part of the wave, making this mixture darker as you move up toward the top of the wave.

STEP 5 Mix titanium white, cadmium yellow, and Hooker's green to paint the top of the rising part of the wave. As you work closer to the bottom of the wave, darken the color by adding more ultramarine blue to the mix.

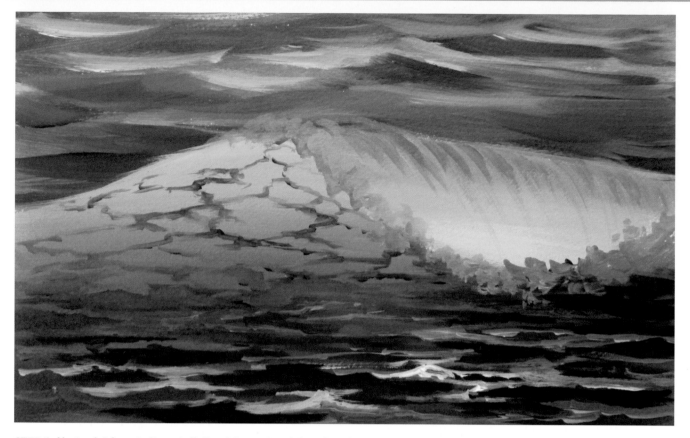

STEP 6 Next paint foam trails on both the rising part and the edge of the crashing part of the wave. For this step use mostly midtone and darker mixtures of blues and greens. Remember that the foam in the shadow of the falling wave should be much darker than the foam on the top of the wave or in the foreground.

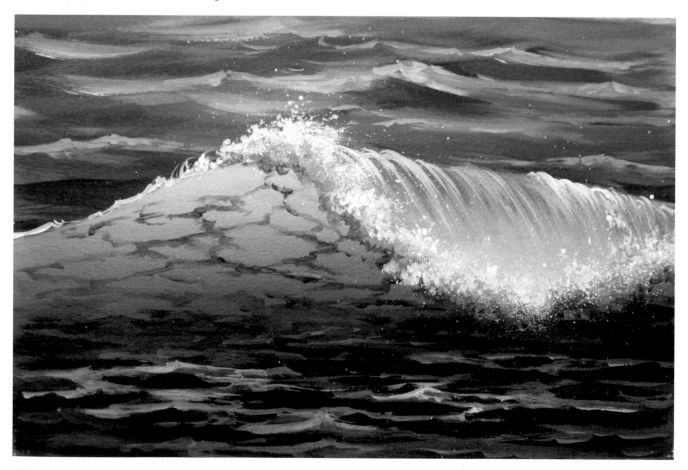

STEP 7 Mix titanium white with a little cadmium yellow. Then follow the spattering technique, using a toothbrush to create the foam splashes on the crashing wave.

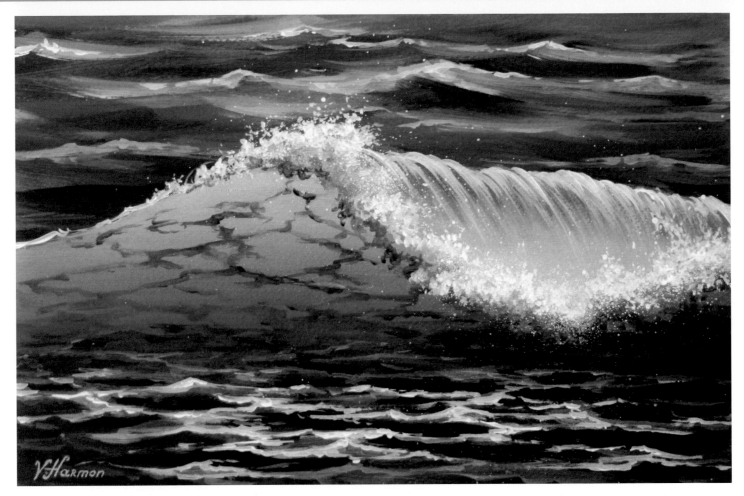

STEP 8 For the final step, use the same mixture from step 7 to emphasize the highlights on the tops of the waves and the sunlit foam. Try not to overdo in this step; otherwise you may lose your focal point, which is the crashing wave.

DETAIL

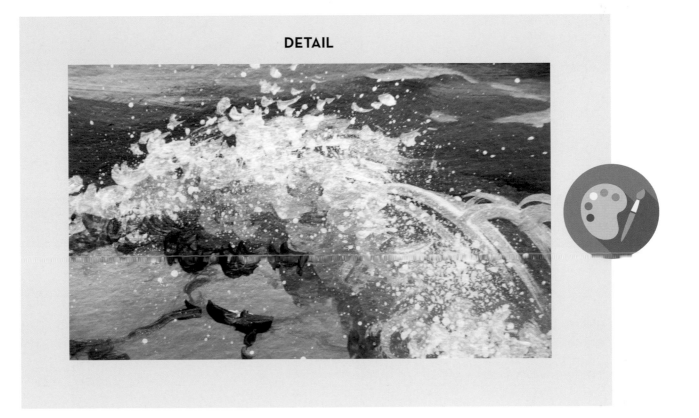

POP ART

Zebras are fun to paint, with the pattern of stripes and the play of light-and-dark values. You can choose to put variations of color in the darks and keep the lights white or you can create flat, dark-valued stripes and put color in the lights. You might even want to try painting the zebra stripes in multiple colors in chromatic order!

PALETTE
- Bright aqua green
- Cadmium yellow deep
- Cadmium yellow light
- Cobalt turquoise
- Dioxazine purple
- Powder blue
 (ultramarine blue +
 titanium white)
- Titanium white

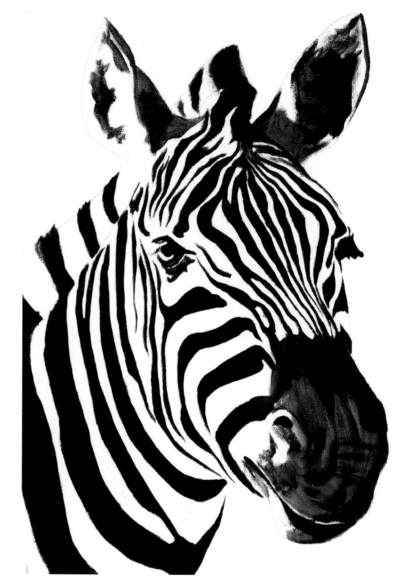

STEP 2 Block in the darks with dioxazine purple using #6 and #2 brights, depending on the size of the stripes. Purple will function as the black in the stripes. Paint it on thick for the dark stripes. Thin it with a little water around the muzzle and ears, where there is more variation, to denote texture and form. Highlights and shadows can be suggested with very little effort. A good value underpainting creates a helpful foundation for the rest of the project. Use paper towels to mop up any drips.

STEP 1 First sketch the subject, marking the black stripes. Note that if you fill the stripes with dark pencil on the canvas, your color might end up muddy as it picks up the graphite.

Edges are very important for this subject. Clean edges will help create eye-catching contrast between the black-and-white stripes. Make sure your brush is wet enough to keep your edges smooth. If you make a rough edge, use a brush filled with water (but not dripping) to smooth the wet paint or lift it away.

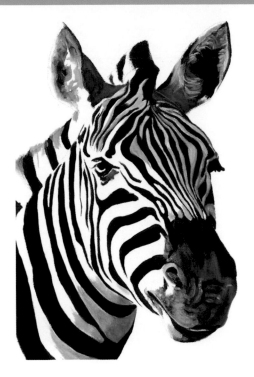

STEP 3 Use cobalt turquoise to block in the shadow side of the whites, as well as the reflected lights in the darkest darks. Start to fill in some of the white stripes with bright aqua green, and work on the next lightest darks by highlighting the nostril, blending the hair in the ears, adding creases in the velvety muzzle, and adding to the soft edge in the cobalt turquoise on the shadow side of the neck.

Add cadmium yellow deep to some of the white stripes on the shadow side of the face, the ears, and the edge of the mane, blending out to white on the neck. This creates a contrast of color between the green and orange.

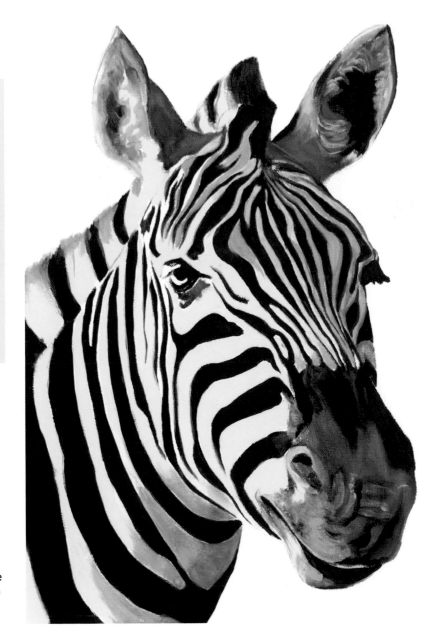

STEP 4 Use cadmium yellow light to fill in most of the rest of the white spaces, as well as the edges of the ears. Go over a few of the aqua stripes and in the ears to create a more vivid green.

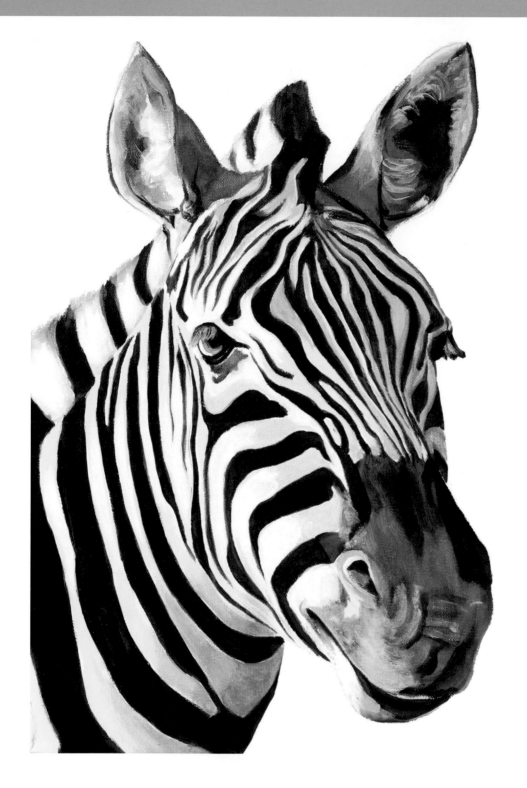

STEP 5 Use titanium white, thinned with water, to add highlights on the sunny side of the face and to create form. Add touches of white on the cheek, neck, and mane, as well as around the eye and the lip. Then warm or cool the stripes on the shadow side of the face. On the aqua stripes, apply a thin layer of yellow. On the yellow stripes, apply a thin layer of aqua. This creates both color variation and harmony in the face. Using a dry brush, use powder blue to lightly add dimension to the mane. Then touch a little more powder blue here and there around the face to relate it throughout the painting. Paint the eye aqua green with a white highlight. Then paint the lashes on the light side by drybrushing aqua with yellow on top; on the shadow side, highlight the lashes with aqua.

If you use a color in only one place on the painting, it stands out and becomes an eye trap. Make sure your color use is purposeful.

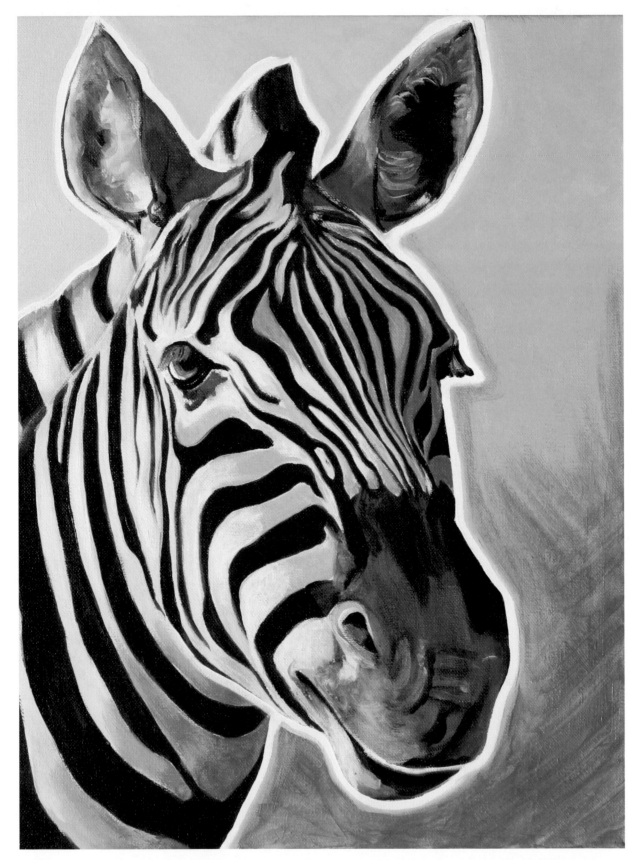

STEP 6 Add a background, using colors that you used in the zebra: powder blue, a mix of powder blue and aqua green, and aqua green with a bit of cobalt turquoise. Wet-brush over one corner for visual interest. Then paint a graphic white line around the zebra to punch the shape of the subject out from the background. Make sure all the details are complete, and then set the painting aside, coming back to it later to see if any additional finishing touches are needed.

OIL

Often described as "rich" and "buttery," this classic painting medium is a favorite among fine artists. The paint consists of ground pigment suspended in oil, which traps light and creates a luminous effect on the canvas. The slow-drying properties of oil allow artists to create smooth blends and rework their paintings over multiple sessions. This large window for manipulating and refining a work of art can result in an impressive degree of realism.

OIL ESSENTIALS
- Set of oil paints
- Solvents
- Drying oils
- Set of brushes
- Mixing palette
- Paper towels and soft rags
- Easel or painting board
- Vine charcoal for sketching
- Safety items

OIL PAINT

Oil painting is notoriously messy and calls for quite a few materials. Because it's not water-based, you'll need special liquids for thinning the paint and cleaning your brushes. You'll also need to take safety precautions such as working in a well-ventilated workspace. Most manufactured paints contain a linseed oil base, but other drying oils, such as walnut or poppy seed oil, can be used. You can use drying oils or resins mixed with solvent to change the properties of the paint, building up a lustrous painting from thin initial washes of color to thick, dimensional highlights.

SAFETY & OIL PAINTING Oil painting involves a number of hazardous materials, so it's important to know safe handling habits before you begin.

- Work in a well-ventilated area, particularly when using paint thinners and harsh solvents such as turpentine. They release toxic fumes during use and as they evaporate from the drying paint.
- When making paint or handling dry pigments, use a respirator mask, safety goggles, and rubber or vinyl gloves.
- Use rubber or vinyl gloves when handling solvents and paint. Consider using a barrier cream on your hands to reduce any potential absorption.
- Do not work near heat or flames. Solvents, especially turpentine, are highly flammable.
- Do not throw solvent-soaked rags into the trash, due to their flammability.
- Do not pour paints or solvents down the drain. Contact local disposal companies or environmental government agencies to determine the best course of disposal.
- Do not pile up or throw oil-soaked rags into the trash. As they oxidize in open air, drying oils (particularly linseed) pose a risk of spontaneous combustion.
- Do not put your hands, brush handles, or other art materials in your mouth during a painting session; also, avoid eating and drinking while painting.
- Know the ways toxins can enter the body: through ingestion, inhalation, and contact with the skin or eyes.

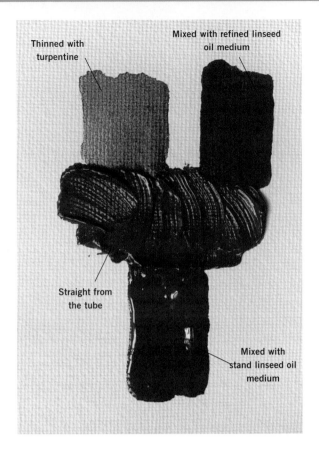

Thinned with turpentine

Mixed with refined linseed oil medium

Straight from the tube

Mixed with stand linseed oil medium

Oil paints are available in metal tubes in the following quantities: 12ml, 37ml, 150ml, and 200ml. It's a good idea to purchase a larger tube of white, as you will use this paint in mixes more than any other color.

PAINTS & DRYING TIMES

Unlike watercolor and acrylic paint, oil takes a very long time to dry. It can take several days for a layer of paint to feel dry to the touch, but for varnishing purposes, an oil painting needs to dry for six months to a year. Even after this long period, the oil continues to dry for many years. Be sure to keep a wet oil painting well protected as it dries by storing it in a dark room with very little risk of scuffing.

Colors dry at different rates. Avoid layering a fast-drying paint over a slow-drying paint; this can help prevent ripples and cracks in a painting. Listed in the chart below are common pigments, categorized according to their drying rates.

DRYING RATES OF OIL PAINT COLORS

FAST	• Cobalt blue (medium-fast)
	• Burnt sienna
	• Burnt umber
	• Flake white
	• Mars black
	• Naples yellow
	• Prussian blue
	• Raw sienna
	• Raw umber
MEDIUM	• Dioxazine purple
	• Perylenes
	• Phthalo blue (medium-fast)
	• Phthalo green (medium-fast)
	• Pyrroles
	• Ultramarine blue
	• Viridian
SLOW	• Alizarin crimson
	• Cadmium red
	• Cadmium yellow
	• Cerulean
	• Ivory black
	• Lamp black
	• Quinacridones
	• Terre verte
	• Titanium white
	• Yellow ochre

DRYING OILS & MEDIUMS

Drying oils and mediums allow artists to change the consistency and reflective qualities of the paint. Although you can technically paint straight from the tube, most artists add medium to extend the paint and to build an oil painting in the traditional "fat over lean" layering process. The drying oils and resins mentioned on the following pages can be used as mediums, but the term "medium" in oil painting generally refers to a mix of oil and solvent, with the solvent accelerating the drying process.

Linseed Oil

This oil is the most common choice for use in both oil-based paints and as a medium. Pressed from flaxseed, the oil is slightly yellow in hue and increases a paint's gloss, flow, and transparency. It also slows the drying time and creates a sturdy film when dry. There are several varieties of linseed oil available, each with its own properties (see "Types of Linseed Oil" below).

Poppy seed Oil

This thin oil pressed from poppy seeds does not yellow as much as linseed oil, keeping whites and lights pure and luminous. However, paints mixed with this oil have a longer drying time. When using poppy seed oil alongside other oils, use it in the upper layers to avoid cracking.

Artists traditionally begin an oil painting with thin layers of paint that have been diluted with solvent. They then build up their subjects slowly, using thicker, more oily paint as they progress. This method prevents a canvas from warping and upper layers from cracking during the drying process.

TYPES OF LINSEED OIL

Refined Linseed Oil	This thin, slow-drying oil is great for increasing the transparency of paint.
Cold-Pressed Linseed Oil	A yellow oil, this option increases gloss and flow, while drying faster than refined linseed oil.
Stand Linseed Oil	This viscous, slow-drying oil is the consistency of honey and settles to a smooth, glossy finish. Mixed with solvent, stand oil is great for glazing and detail work.
Sun-Thickened Linseed Oil	Adding body and gloss to paint, this syrupy option is a bit thinner and faster-drying than stand oil.
Sun-Bleached Linseed Oil	Bleached by the sun, this oil yellows less than its linseed counterparts.

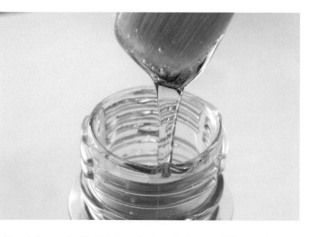

Stand linseed oil's thick and slow-drying qualities make it ideal for the upper layers of an oil painting. Use it for luminous glazes and finishing touches.

Linseed

Poppy Seeds

Walnuts

Safflower Seeds

Walnut Oil

Pressed from walnuts, this oil is a wetter and more expensive alternative to linseed oil. It yellows a bit less and has a wonderful glossy sheen. Walnut oil is a great choice for painters who do not want to work with harsh solvents; you can use it to both thin paint and clean brushes.

Safflower Oil

Safflower oil, pressed from safflower seeds, is a top choice for mixing with white paints because it yellows less than linseed oil. However, it dries very slowly, so avoid using it beneath faster-drying oil layers.

SOLVENTS

Because oil-based paints do not mix with water, artists traditionally use solvents for paint thinning and cleanup. If you choose to purchase a solvent, be sure it is intended for fine-art purposes. Note any instructions and cautions provided by the manufacturer.

ADDITIONAL MEDIUMS

Alkyd Medium	This medium contains resins that can halve the drying time of oil paint. Alkyds have been shown to dry to a very durable, flexible film, and many artists believe that alkyds are less likely to yellow than linseed oil.
Copal Medium	This resin speeds the drying time of paint while increasing flow and gloss; however, it is prone to darkening.
Damar Varnish Medium	This gloss-increasing medium is generally used in a ratio of one part damar varnish to one part turpentine to one part linseed oil.
Beeswax Medium	This soft medium adds body to paint while imparting a subtle matte quality.

WARNING Solvents are toxic and flammable. Use them only in a well-ventilated area away from any source of heat, and dispose of them properly. For more on oil painting safety, see page 160.

ADDITIONAL MEDIUMS

Turpentine	Made from pine resin, turpentine is a toxic, colorless, strong-smelling liquid that efficiently thins and dissolves oil-based paints and resins. Turpentine has a fast evaporation rate, which helps artists advance the painting process.
Mineral Spirits	This petroleum-based solvent is slightly less toxic, less flammable, and gentler on skin than turpentine. It evaporates more slowly from paint.
Odorless Mineral Spirits	In this solvent, the toxicity and potent odors of mineral spirits have been reduced.
Citrus-Based Solvents	This option is less toxic than the solvents listed above; however, its mild nature makes it less effective when working with resins.

If you don't like the idea of handling or storing harsh solvents, consider working with walnut oil. This drying oil can act as a binder, medium, thinner, and brush cleaner.

BASIC PAINTING TECHNIQUES

Most oil painters apply paint to their supports with brushes. The variety of effects you can achieve—depending on your brush selections and your techniques—is virtually limitless. Just keep experimenting to find out what works best for you. A few of the approaches to oil painting and brushwork techniques are outlined below.

APPROACHING YOUR PAINTING

There are three basic approaches to oil painting; you may want to try each approach to see which you prefer. In the first approach, you begin by toning the entire canvas with a layer of transparent color (an *imprimatura*) and then build up the painting with a series of thin layers of color (*glazes*) on top of the initial color. For the second approach, you build the painting from dark to light or light to dark; for example, you may start by blocking in the darkest values, then add the mid-values, and finish with the lightest values. The third approach is called *alla prima*, which is Italian for "at once." This means that you apply all the paint in a single painting session. In this approach, you are not applying a series of layers but laying in the opaque colors essentially the way they will appear in your final painting. Artists also refer to this method as a *direct approach*.

PAINTING THICKLY Load your brush or knife with thick, opaque paint and apply it liberally to create texture.

THIN PAINT Dilute your color with thinner, and use soft, even strokes to make transparent layers.

DRYBRUSH Load a brush, wipe off excess paint, and lightly drag it over the surface to make irregular effects.

BLENDING Use a clean, dry hake or fan brush to lightly stroke over wet colors to make soft, gradual blends.

GLAZING Apply a thin layer of transparent color over existing dry color. Let dry before applying another layer.

PULLING AND DRAGGING Using pressure, pull or drag dry color over a surface to texture or accent an area.

When you're learning a new technique, it's a good idea to practice on a separate sheet first. Once you're comfortable with the technique, you can apply it with confidence to your final work.

STIPPLING Using the tip of a brush or knife, apply thick paint in irregular masses of small dots to build color.

SCRAPING Use the tip of a knife to remove wet paint from your support and reveal the underlying color.

SPATTER Randomly apply specks of color on your canvas by flicking thin paint off the tip of your brush.

SPONGING Apply paint with a natural sponge to create mottled textures for subjects such as rocks or foliage.

WIPING AWAY Wipe away paint with a paper towel or blot with newspaper to create subtle highlights.

SCUMBLING Lightly brush semi-opaque color over dry paint, allowing the underlying colors to show through.

APPLYING AN UNDERPAINTING

An underpainting may consist of almost all of the colors in your project palette, offering a visual color reference, which proves extremely useful as you layer in more and more paint.

PALETTE

Oil Colors
- Blue violet
- Cadmium orange
- Emerald green
- Lemon yellow
- Phthalo violet
- Red deep
- Red medium
- Titanium white
- Yellow ochre

Oil Pastels (optional)
- Rose red
- Violet
- Yellow ochre

STEP 1 Draw a very rough sketch of the planned composition on a separate sheet of paper to use as a reference.

STEP 2 Begin by laying down the underpainting, consisting of lemon yellow, yellow ochre, cadmium orange, and phthalo violet. Load your brush with the darkest color first, plus medium. Using soft, broad brushstrokes, apply color to the support. Continue this process, working from dark to light, making sure to clean the brush between each new color. Once you have generously covered the canvas, let it dry for about 30 minutes. Then use a soft dry brush to gently blend the colors into each other.

STEP 3 Using quick, loose strokes, draw the dahlia petals using an oil pastel or the tip of a round paintbrush. Use yellow ochre for the petal outlines over the yellow areas of the underpainting, and use rose red or red deep for the outlines you draw over the reds, violets, and oranges. Keep your lines loose and free of detail, but strive to create the overall basic shape to help you form the general composition.

STEP 4 Following the outlines, begin filling in the dahlia. Use blue violet for the darkest, shaded areas. For the tips of the muted petals, apply a mix of phthalo violet and cadmium orange.

STEP 5 Next lay in the various reds. For the brighter red petals, mix a bit of quick-drying medium with phthalo rose red and apply it over the yellow underpainting. For the darker petal areas, including the shadows, add a bit of emerald green to the red mix. Begin applying the color to the petals, making sure to stop and blend them occasionally with a flat sable brush.

STEP 6 Continue layering in the reds, making sure that the brushstrokes curve with the shape of the petals. When finished applying the reds, go back over and fill in the deepest shadows with the emerald green/red mixture. Use phthalo violet to add shading in areas.

STEP 7 Mix a dab of red rose with titanium white and another dab of cadmium orange with white. Then add highlights to the petals in select areas. Softly blend the hues into the darker tones using a clean, dry brush and enhance any shadows, edges, or darker areas with strokes of red deep or phthalo violet.

STEP 8 Finish darkening the deepest shadows with red deep and phthalo violet.

CAPTURING LIGHT

There are many different ways to paint portraits, and there are no exact rules to follow for each style. However, there are some good guidelines in classical portraiture. This portrait captures the intense, sweet expression of this toddler before he matures into a little boy. The natural light bounces and falls beautifully across once side of his face, creating a Rembrandt effect.

PALETTE

- Alizarin crimson
- Burnt sienna
- Cadmium orange
- Cadmium red light
- Cadmium scarlet (or pyrrole red)
- Cerulean blue
- Perylene red
- Phthalo turquoise
- Raw sienna
- Raw umber
- Sap green
- Transparent red oxide
- Ultramarine blue
- Viridian green
- Titanium white
- Tellow ochre

STEP 1 When working from a photograph, begin with a pencil drawing on paper first.

STEP 2 Clean the surface with turpentine and a soft cloth to remove any extra residue. Then tone the canvas with a light yellow ochre wash. Begin working paint over the soft lines with a #4 filbert bristle brush and a light wash, using transparent red oxide with a touch of ultramarine blue to neutralize the color.

STEP 3 Start by carefully blocking in the darker areas of the face, using a mid-value flesh tone of cadmium red light, viridian green, very small amounts of phthalo turquoise and titanium white, and a touch of raw sienna. Next mix perylene red with viridian green to make a darker, richer flesh brown and add a bit of yellow ochre or raw sienna. Keep in mind that the more red you add, the warmer the flesh tone; likewise, the more viridian green or phthalo turquoise you add, the cooler the flesh tone. Turn your attention to his golden hair and begin blocking it in, using yellow ochre, raw sienna, burnt sienna, and titanium white. In the darker parts of the hair add ultramarine blue or a little cerulean blue to raw sienna or burnt sienna.

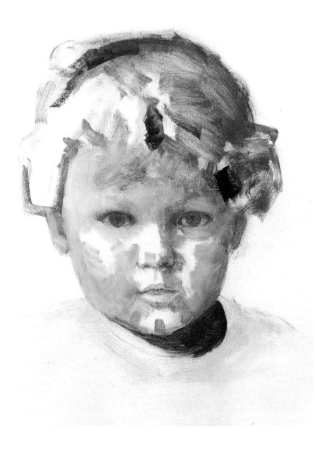

To achieve a luminous appearance, you can't lay down all your paint in one or two sessions. Instead, work each day until you feel you've come to a stopping point. Let it dry, and then come back and continue building one layer at a time. Each time you sit down at your easel look for ways to make a better painting.

STEP 4 Start painting the delicate pink undertone of the cheeks, using a dab of perylene red, pyrrole red or cadmium scarlet, and titanium white. Add more flesh tone across the face and darken the eyes with my flesh colors.

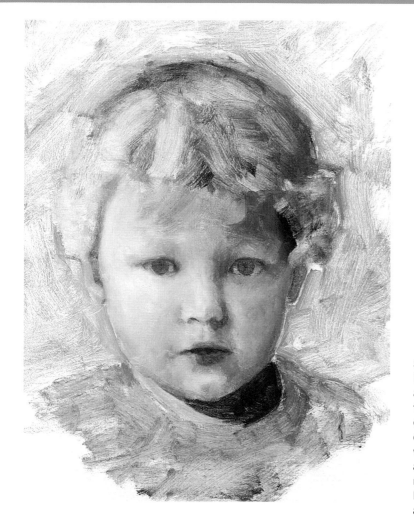

STEP 5 Softly blend the skin, using a flat natural-hair brush. Paint with basic brushstrokes and crosshatch strokes and, when needed, use your finger to soften or blend. Paint the lips with a darker mix of the same color you used on the cheeks. Then go back to the hair, painting the golden blond curls on the lighter side with yellow ochre and titanium white. Return to the darker hair and paint with raw sienna and a little white. Start to block in the orange shirt, with a mix of cadmium orange, yellow ochre, and titanium white. Block in the background with a little cerulean blue, white, and a few little paint strokes of my soft orangey color.

The "whites" of the eyes are never really white; they are yellow, grayish, or slightly orange in color. Each person's coloring is different.

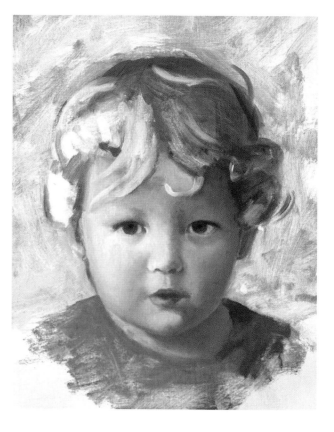

STEP 6 Next work on the eyes. Instead of using pure black, which can look flat, for the pupils, make a nearly black mix of ultramarine blue, alizarin crimson, and sap green. Work around the eyes and paint the lashes with a very dark brown mix of ultramarine blue, alizarin crimson, sap green, and a tiny drop of titanium white and raw umber. Using very small strokes, start to apply to the white of the eyes. Go back into the light parts of the hair with yellow ochre mixed with titanium white. Then go back to the darker parts of the hair with raw sienna and a little cerulean blue, burnt sienna, and ultramarine blue.

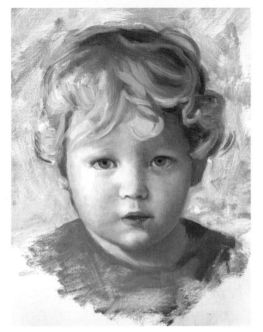

You can save your mixed colors for future sessions. Rake together similar mixes of flesh tones in the center of your paint box and store in the refrigerator or freezer. You can prevent the paint from drying out with a drop of clove oil.

STEP 7 Paint the blue irises with cerulean blue, ultramarine blue, titanium white, and a tiny drop each of cadmium red light and yellow ochre to tone the intensity. Add more highlights in the hair and start blending the dark and light shapes gently into each other for a soft appearance. Refine the shapes of the ears a bit.

STEP 8 Go over the eyes again, and then paint the catchlight in each the same color as the whites of the eyes. Use your finger to blend. Using the light and dark blond mixes, place various strokes in the hair to develop the soft curls. Use titanium white in some parts to add highlights. Also add some white highlights on the end of the nose and on the lips. Finish the background, drybrushing with the blond hair mixes. Make a final pass around the painting, looking for any hard edges that need to be blended.

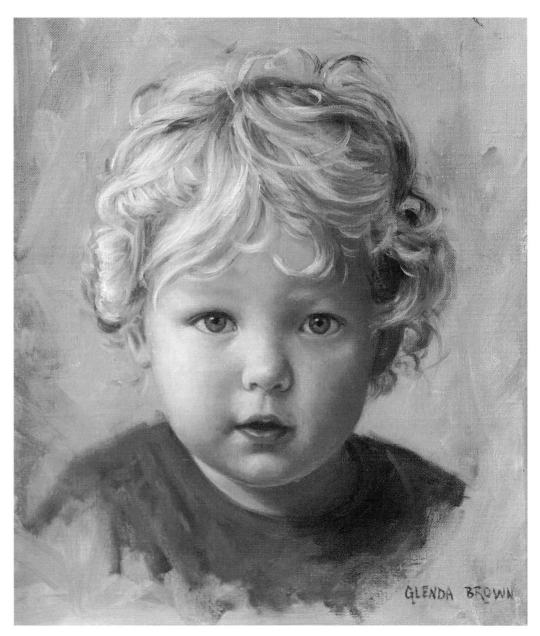

GLENDA BROWN

WATERCOLOR

The airy and atmospheric qualities of watercolor set it apart from all other painting media. Watercolor is a fluid medium that requires quite a bit of practice to master. However, if you devote enough time to this medium, you'll understand why it is praised for its ability to quickly capture an essence, suggesting form and color with just a few brushstrokes.

WATERCOLOR ESSENTIALS

- Set of watercolors
- Jars of water
- Set of brushes
- Mixing palette (with wells)
- Paper towels
- Watercolor paper
- Artist tape
- Drawing or painting board
- Sketching pencil and eraser

TYPES OF WATERCOLOR

Watercolor is pigment dispersed in a vehicle of gum arabic (a binder), glycerin (a plasticizer to prevent dry paint from cracking), corn syrup or honey (a humectant to keep the paint moist), and water. Fillers, extenders, and preservatives may also be present. Watercolor comes in four basic forms: tubes, pans, semi-moist pots, and pencils. What you choose should depend on your painting style and preferences.

Tubes

Tubes contain moist paint that is readily mixable. This format is great for studio artists who have room to store tubes and squirt out the amount needed for a painting session. Unlike oil and acrylic, you need only a small amount of tube paint to create large washes. Start with a pea-sized amount, add water, and then add more paint if necessary.

Pans

Pans, also called "cakes," are dry or semi-moist blocks of watercolor. Many lidded watercolor palettes are designed to hold pans, making them portable and convenient. They often contain more humectant than tube paints to prevent the paint from drying out. To activate the paint, stroke over the blocks with a wet brush. To create large washes or mixes, load the brush with paint and pull color into a nearby well.

Semi-Moist Pots

Semi-moist pots are the most economical option. The colors sit in round pots, often in a row with a lid that serves as a mixing tray. Like pans, these gummy-looking watercolors are formulated with more humectant to retain moisture. Activate the paint by stroking over the color with a wet brush.

Watercolor Pencils

These tools combine the fluid, colorful nature of watercolor with the control of pencil drawing. Available in both wood-encased and woodless forms, they feature leads of hard watercolor that you can sharpen like any graphite pencil. They are great for creating fine details or sketching a composition for traditional watercolor painting, or you can use them with a wet brush to develop entire works.

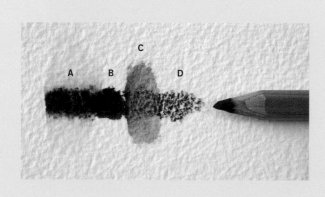

You can apply watercolor pencil in several ways. Shown here is pencil applied over wet paper (A), wet pencil tip over dry paper (B), pencil applied over dry paper followed by strokes of a wet brush (C), and pencil over dry paper (D).

WATERCOLOR MEDIUMS

Watercolor mediums and additives alter the characteristics of the paint. Whether you want more flow, gloss, sparkle, or texture, a number of products are available to help you achieve your desired results.

Gum Arabic

Made from the sap of an acacia tree, gum arabic is the binder of watercolor paint. When added to your jar of clean mixing water, it increases the gloss and transparency of watercolor.

You can alter the drying time of watercolor paint by using additives in your mixing water. Just a few drops of alcohol can help speed up the drying time, and a few drops of glycerin will slow it down. Both products are available at your local pharmacy. These additives can help counteract the unwanted effects of working in exceptionally moist or dry environments.

Ox Gall

Ox gall is made of alcohol and cow bile. The medium is a wetting agent that reduces the surface tension of water and increases the fluidity of watercolor. It is particularly useful when working in large washes on hard-sized watercolor paper, as it makes the paper more readily accept paint. Add just a few drops to your jar of clean mixing water to see the effects.

Iridescent Medium

Iridescent medium gives a metallic shimmer to watercolor paint. Mix a small amount into your washes, noting that a little bit goes a long way. For more dramatic results, stroke the medium directly over a dried wash.

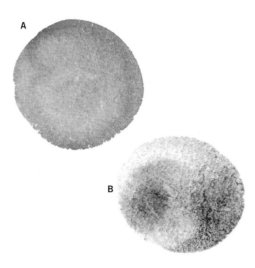

Granulation Medium

When used in place of water in a watercolor wash, this medium encourages granulation. It is most effective when used with nongranulating colors such as modern pigments. In these examples, view phthalo blue with (A) and without (B) granulation medium.

Lifting Preparation Medium

Lifting preparation medium allows you to easily lift watercolor from your paper—even staining pigments. Apply the medium to the paper with a brush and allow it to dry; then stroke over the area with watercolor. After the paint dries, use a wet brush to disturb the wash and lift the paint away by dabbing with tissue or paper towel. These swatches show attempts to lift permanent carmine on a surface prepped without (A) and with (B) lifting preparation.

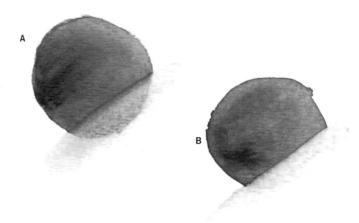

Masking Fluid

Masking fluid, also called "liquid frisket," is a drying liquid, such as latex, that preserves the white of the paper while you paint. This allows you to stroke freely without working around highlights. Fluids may be colored or colorless and rub-away or permanent.

A few new watercolor mediums on the market allow artists to incorporate textures into their watercolors. Some contain sandlike particles for coarse effects, and some add body to the paint to allow for thick, brushy strokes. Always be on the lookout for new mediums that inspire you to use paint in new ways.

WATERCOLOR TECHNIQUES

Unlike other painting media, watercolor relies on the white of the paper to tint the layers of color above it. Because of this, artists lighten watercolor washes by adding water—not by adding white paint. To maintain the luminous quality of your watercolors, minimize the layers of paint you apply so the white of the paper isn't dulled by too much pigment.

GRADATED WASH A gradated (or graduated) wash moves slowly from dark and to light. Apply a strong wash of color and stroke in horizontal bands as you move away, adding water to successive strokes.

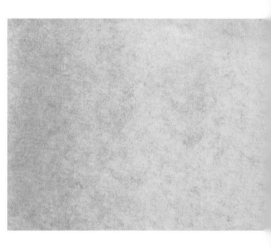

WET-INTO-WET Stroke water over your paper and allow it to soak in. Wet the surface again and wait for the paper to take on a matte sheen; then load your brush with rich color and stroke over your surface. The moisture will grab the pigments and pull them across the paper to create feathery soft blends.

FLAT WASH A flat wash is a thin layer of paint applied evenly to your paper. First wet the paper, and then load your brush with a mix of watercolor and water. Stroke horizontally across the paper and move from top to bottom, overlapping the strokes as you progress.

TILTING To pull colors into each other, apply two washes side by side and tilt the paper while wet so one flows into the next. This creates interesting drips and irregular edges.

BACKRUNS Backruns, or "blooms," create interest within washes by leaving behind flower-shaped edges where a wet wash meets a damp wash. First stroke a wash onto your paper. Let the wash settle for a minute or so, and then stroke another wash within (or add a drop of pure water).

USING SALT For a mottled texture, sprinkle salt over a wet or damp wash. The salt will absorb the wash to reveal the white of the paper in interesting starlike shapes. The finer the salt crystals, the finer the resulting texture. For a similar but less dramatic effect, simply squirt a spray bottle of water over a damp wash.

DRYBRUSHING Load your brush with a strong mix of paint, and then dab the hairs on a paper towel to remove excess moisture. Drag the bristles lightly over the paper so that tooth catches the paint and creates a coarse texture. The technique works best when used sparingly and with opaque pigments over transparents.

APPLYING WITH A SPONGE In addition to creating flat washes, sponges can help you create irregular, mottled areas of color.

USING ALCOHOL To create interesting circular formations within a wash, use an eyedropper to drop alcohol into a damp wash. Change the sizes of your drops for variation.

SPATTERING First cover any area you don't want to spatter with a sheet of paper. Load your brush with a wet wash and tap the brush over a finger to fling droplets of paint onto the paper. You can also load your brush and then run the tip of a finger over the bristles to create a spray.

MIXING WATERCOLORS

Painting with transparent watercolors is a unique and enjoyable experience because of the way the colors can be mixed. Other types of paint (especially oil) are usually mixed on a separate palette and then applied to the canvas. They are also mixed additively; in other words, white pigment is added to lighten the colors. In contrast, transparent watercolor relies on the white of the paper and the translucency of the pigment to communicate light and brightness. A well-painted watercolor seems to glow with an inner illumination that no other medium can capture.

The best way to make your paintings vibrant and full of energy is to mix most of your colors on the paper while you are painting the picture. Allowing the colors to mix together on the paper, with the help of gravity, can create dynamic results. It is accidental to a certain degree, but if your values and composition are under control, these unexpected color areas will be very exciting and successful.

WET-ON-DRY

This method involves applying different washes of color on dry watercolor paper and allowing the colors to intermingle, creating interesting edges and blends.

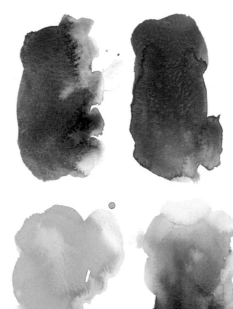

MIXING IN THE PALETTE VS. MIXING WET-ON-DRY To experience the difference between mixing in the palette and mixing on the paper, create two purple shadow samples. Mix ultramarine blue and alizarin crimson in your palette until you get a rich purple; then paint a swatch on dry watercolor paper (near right). Next paint a swatch of ultramarine blue on dry watercolor paper. While this is still wet, add alizarin crimson to the lower part of the blue wash, and watch the colors connect and blend (far right). Compare the two swatches. The second one (far right) is more exciting. It uses the same paints but has the added energy of the colors mixing and moving on the paper. Use this mix to create dynamic shadows.

MIXING A TREE COLOR Next create a tree color. First mix green in your palette using phthalo blue and new gamboge, and paint a swatch on your paper (near right). Now create a second swatch using a wash of phthalo blue; then quickly add burnt sienna to the bottom of this swatch. While this is still wet, add new gamboge to the top of the swatch. Watch these three colors combine to make a beautiful tree color that is full of depth (far right).

VARIEGATED WASH

A variegated wash differs from the wet-on-dry technique in that wet washes of color are applied to wet paper instead of dry paper. The results are similar, but using wet paper creates a smoother blend of color. Using clear water, stroke over the area you want to paint and let it begin to dry. When it is just damp, add washes of color and watch them mix, tilting your paper slightly to encourage the process.

APPLYING A VARIEGATED WASH After applying clear water to your paper, stroke on a wash of ultramarine blue (left). Immediately add some alizarin crimson to the wash (center), and then tilt to blend the colors further (right). Compare this with your wet-on-dry purple shadow to see the subtle differences caused by the initial wash of water on the paper.

WET-INTO-WET

This technique is like the variegated wash, but the paper must be thoroughly soaked with water before you apply any color. The saturated paper allows the color to spread quickly, easily, and softly across the paper. The delicate, feathery blends created by this technique are perfect for painting skies. Begin by generously stroking clear water over the area you want to paint, and wait for it to soak in. When the surface takes on a matte sheen, apply another layer of water. When the paper again takes on a matte sheen, apply washes of color and watch the colors spread.

PAINTING SKIES WET-INTO-WET Loosely wet the area you want to paint. After the water soaks in, follow up with another layer of water and wait again for the matte sheen. Then apply ultramarine blue to your paper, both to the wet and dry areas of the paper. Now add a different blue, such as cobalt or cerulean, and leave some paper areas white (left). Now add some raw sienna (center) and a touch of alizarin crimson (right). The wet areas of the paper will yield smooth, blended, light washes, while the dry areas will allow for a darker, hard-edged expression of paint.

GLAZING

Glazing is a traditional watercolor technique that involves two or more washes of color applied in layers to create a luminous, atmospheric effect. Glazing unifies the painting by providing an overall underpainting (or background wash) of consistent color.

CREATING A GLAZE To create a glazed wash, paint a layer of ultramarine blue on your paper (far left). Your paper can either be wet or dry. After this wash dries, apply a wash of alizarin crimson over it (near left). The subtly mottled purple that results is made up of individual glazes of transparent color.

Charging In Color

This technique involves adding pure, intense color to a more diluted wash that has just been applied. The moisture in the wash will grab the new color and pull it in, creating irregular edges and shapes of blended color. This is one of the most fun and exciting techniques to watch—anything can happen!

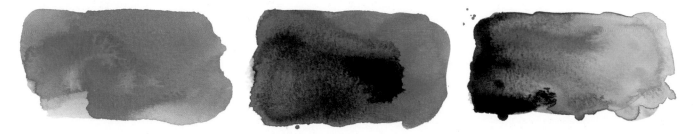

CREATING A CHARGED-IN TREE COLOR First apply a wash of phthalo blue (left); then load your brush with pure burnt sienna and apply it to the bottom of the swatch (center). Follow up with pure new gamboge on the opposite side, and watch the pigments react on the paper (right). Remember that pigments interact differently, so test this out using several color combinations.

WATERCOLOR PENCIL STROKES

Watercolor pencil is very versatile, allowing you to create everything from soft, even blends to rough textures and intricate patterns. There are four basic approaches to using watercolor pencil. The first is to apply it as you would regular colored pencil and then blend the colors with a paintbrush and water. Another method is to create a "palette" by applying the pigment to a piece of scratch paper and then scrubbing a wet brush over it to pick up the color. You can also break off the tip of a sharp pencil and place it in a small amount of water to create a pool of color. Or you can dip a pencil in water until the pigment softens, rub it over the bristles of a brush, and apply the color to the support. Below are a number of ways to make the most out of your watercolor pencils.

STROKES

When you choose a subject to render in watercolor pencil, you'll also need to determine the weight, direction, and intensity of the strokes you'll use to make the most accurate representation. Try making strokes in different directions, varying the pressure, and alternately using the point and side of your pencil. Then go a step further by blending the pigment with a damp brush—your strokes will still be apparent but softened and more diffuse.

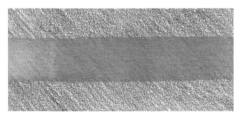

LEFT DIAGONAL STROKE You can fill in large areas with left-slanting diagonal strokes. Here they were blended in the middle with a wet flat brush.

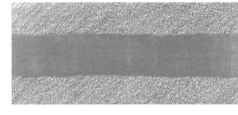

RIGHT DIAGONAL STROKE This is the same example as at left but with right-leaning strokes. You'll get better coverage with this stroke if you're right-handed.

VERTICAL STROKE This stroke can give you more even coverage, but it can be tedious. Be sure not to slant your strokes — your hand may get tired!

OVERLAPPING STROKES You can mix colors by overlapping two hues and blending them with water. Here right diagonal strokes of green were layered over vertical strokes of blue.

CIRCULAR STROKES Straight lines aren't the only way to fill in color. On the left above, color was applied in tiny, overlapping circles. On the right, larger circles created more texture.

BUNDLING To create interesting texture or patterns, "bundle" small groups of linear strokes together. Note that the closer together the lines are, the more intense the resulting color.

HATCHING Hatches are parallel lines used to suggest texture, create form, and build up color. Overlapped lines in opposite directions are crosshatches.

POINTILLISM You can also apply color with small dots made with the pencil point (called "pointillism"). The tighter the dots are, the deeper the hue.

STIPPLING Although stippling is often thought of as a brush technique, you can also stipple with a pencil;. use small dots and dashes to color small areas.

WATERCOLOR PENCIL TECHNIQUES

PRESSURE

The amount of pressure you use on the pencil determines the intensity of color you produce. The more pressure you apply, the more intense the color will be. Please note that very firm pressure is not generally recommended for water-soluble pencils, as the pigment tends to clump if applied too heavily.

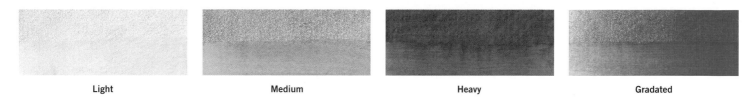

Light Medium Heavy Gradated

USING PRESSURE Here you can see the difference between light, medium, and heavy pressure, as well as a gradated example—varying the pressure from left to right. The bottom half of each example has been brushed with water.

BLENDING

Working with watercolor pencil gives you a unique opportunity to mix and blend colored pencil pigments—you don't need to restrict yourself to overlapping layers and layers of color, as water can mix the hues. Adding water also allows you to smooth your strokes or create special effects that wouldn't be possible with regular colored pencil. Below are just some of the ways you can blend and manipulate both dry and wet watercolor pencil pigments.

HAND BLENDING Here dry watercolor pencil was applied with varying amounts of pressure from left to right; then the bottom was blended by hand. Make sure your hands are warm, and then use your fingers and a circular motion to blend or smudge small areas.

TOOL BLENDING In addition to using your fingers, you can utilize tools to blend the pigment. The red lines above were blended slightly with a cotton swab (on the left) and with a paper blending stump (on the right). Both tools create smoother smudges than you'd get by hand.

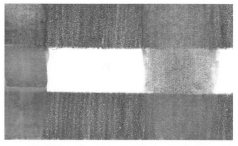

COLOR MIXING This example shows two wet methods for blending and mixing color: with water, as shown on the left, or with alcohol, as shown on the right. As you can see, the alcohol doesn't thoroughly dissolve all the pigment, so it produces a coarser-looking blend.

DRY PENCIL In the top section, dry watercolor pencil was applied to dry paper; it looks the same as regular colored pencil. In the bottom half, the paper was wet first, and then the dry pencil applied. Notice that the lines over the wet paper appear blurry.

WET PENCIL In this example, the tip of the water-soluble pencil was dipped in water before being applied to the dry paper; then clear water was brushed down the stripe just off-center. Notice how much more intense the pigment is when wet.

SHAVINGS This mottled texture was created by dropping pencil shavings onto the wet paper. Then, on the left side of the example, the pigment was rubbed into the paper by hand. The right side was spritzed with water to let the pigment dissolve naturally.

SPECIAL EFFECTS

Because watercolorists generally use the white of the paper for the lightest areas of their paintings (rather than using white paint), it's important to "save" these areas from color. There are several methods you can use either to protect your white areas from color or to lighten areas where color has been applied.

Painting Around White Areas

One way to save the white and light areas of your paper is to simply paint around those areas of your subject. It helps to wet the paper where you want to paint, keeping dry the area you're painting around. The dry area stops the bleed and flow of the wet paint, protecting the white and light areas from receiving paint.

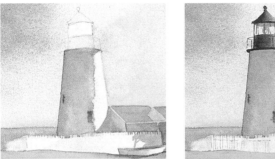

PAINTING AROUND WHITES Here you can see the progression of a painting where the artist employed the technique of painting around whites. At an earlier stage in her painting (shown at left), the artist decided that the white picket fence and the right side of the lighthouse should receive the lightest values, so she simply painted around those areas. The example at right shows the final result.

White Gouache

Gouache is similar to watercolor (it is water-based), but it contains an ingredient that makes it more opaque. Some artists use white gouache to create or restore white areas in their watercolor paintings, as it can give light areas a more vibrant look. Gouache is also great for adding small highlights, such as in the pupil of an eye, or fine details, such as animal whiskers. Use a brush to paint white elements of your painting or to cover small mistakes.

SOFTENING DETAILS To create soft white details such as these water ripples, dampen a brush and dip it into slightly diluted white gouache; then paint over an area of already dry paint. The white gouache will sink softly into the underlying color, creating a slightly blurred effect.

The white of the paper is very valuable to watercolorists. Below are some other ways to "save" and "retrieve" whites on paper.

MASKING FLUID This rubbery substance can mask whites. Apply the mask, paint over it, and then rub off the mask when the paint is dry.

LIFTING COLOR WITH MASKING Protect the surrounding color with artist's tape, then lightly scrub with a damp sponge to remove color.

LIFTING COLOR WITHOUT MASKING Using a stiff brush loaded with clean water, gently scrub the paper to remove color.

SCRAPING WITH A KNIFE When damp paper has just lost its shine, you can use a palette knife to scrape off color.

RENDERING EDGES

The most interesting paintings have varied edges. A painting done completely wet-into-wet will have all soft edges, resulting in a mushy look without any focus. And a painting with only hard edges will be busy and sharp, making it difficult to look at. Combining different kinds of edges gives depth, focus, and interest to the subject matter. Varying edges also produces a finished piece that is both more realistic and more interesting.

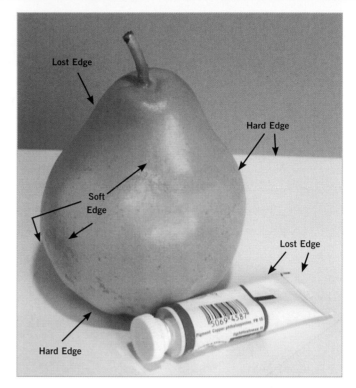

DISTINGUISHING EDGE TYPES Varied edges aren't limited to painting—they're a part of life. In this photo, you can pick out hard edges, soft edges, and even lost edges (where an edge merges with an adjacent edge).

HARD Hard edges suggest structural, angular, and mechanical subjects. To make a hard edge, apply wet paint to dry paper.

TEXTURED Broken edges define rough objects and can be used anywhere. Create them by dragging a lot of paint and minimal water across the paper with a brush.

SOFT Soft edges produce rounded, diffused areas. For soft edges, paint wet into wet, soften a freshly painted edge with clean water, or lift out color.

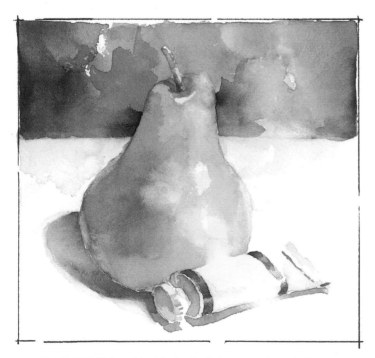

VARIED EDGES This subject looks lively because the painting includes a combination of hard edges, soft edges, and lost edges. Find the edges yourself. (They've changed a bit from the photo! Remember, the eye sees differently than the camera does.)

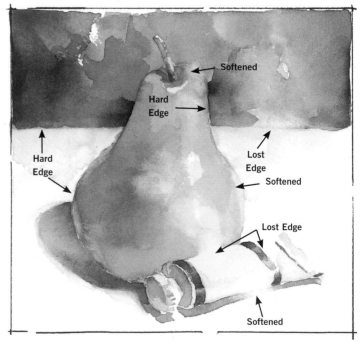

EDGES REVEALED How did you do? The white tube of paint is on a white surface, which allows for many lost edges. The pear is a little more difficult because you don't see the lost edges right away. When you have two areas that are close in value, squint and you'll see that the edge disappears. Once you can identify various types of edges, it will be easier for you to create them.

FILL THE SKY WITH ACTION

It often is an easy option to paint the sky with a simple flat or gradated wash, but what if you changed your approach and made the sky the most detailed part of the scene? As a general rule, keep the sky simple if there is a lot of detail in the land portion of the composition—but if the land isn't very detailed, try to introduce some tone, shape, and life into the sky. It's really all about balance, as you don't want to clutter your painting compositionally. Every once in awhile you'll find a sky that's exceptional, and you can make it the main focus of your painting.

PALETTE
• Burnt sienna
• Cobalt blue
• French ultramarine
• Hooker's green
• Light red
• Raw sienna
• White gouache

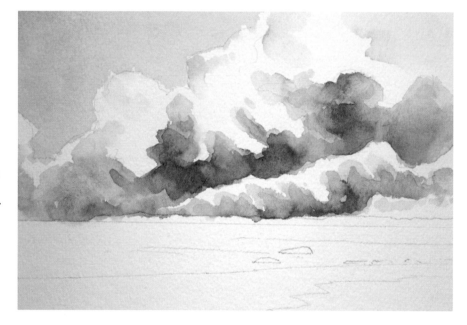

STEP 1 Faintly draw the cloud shapes, horizon, and tide line with a pencil. Using the side of a medium round brush, scrub in the blue portion of the sky with cobalt blue, leaving the edges around the clouds rough. Immediately afterward, use a mix of French ultramarine and light red to similarly map in the cloud shadows. As you paint, drop in a pale wash of raw sienna for the cloud shadows on the right and soften some areas with clean water.

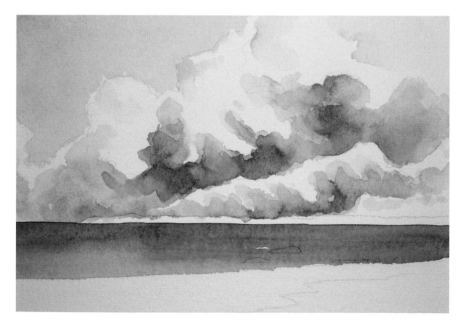

STEP 2 For the water, apply Hooker's green, French ultramarine, and raw sienna very loosely, letting them mix on the paper to suggest the varied colors in the sea. Then wait for the wash to dry.

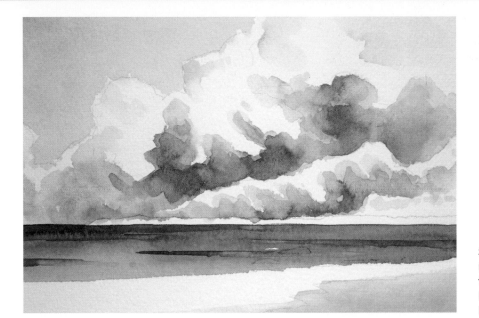

STEP 3 Next apply layers of Hooker's green mixed with French ultramarine to paint one or two of the harder-edged wave shadows. For the beach in the foreground, mix raw sienna with a bit of French ultramarine.

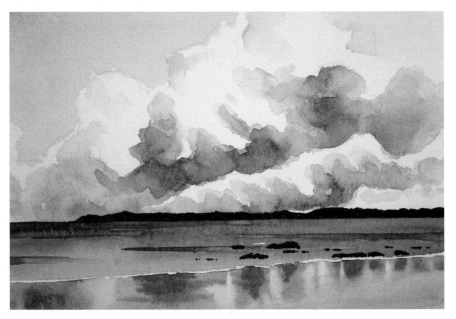

STEP 4 Using a very small round brush loaded with a very dark mixture of French ultramarine and burnt sienna, carefully lay in the rocks and the distant stretch of land below the clouds. Then wet the beach area with clean water and apply the reflections of the strongest tones and the shapes of the clouds above. To do this, simply use stronger mixes of the colors used to form the clouds in step 1. For the lighter reflections, lift out paint with a damp brush.

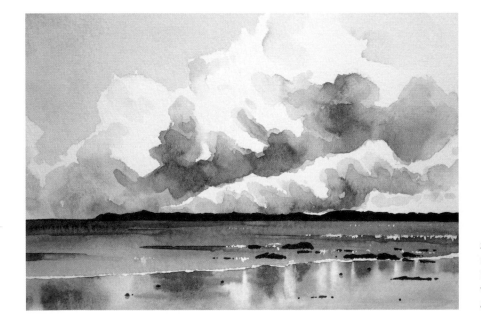

STEP 5 Once the foreground is dry, add a few more dark rocks using French ultramarine and burnt sienna. Then use a rigger brush loaded with white gouache straight from the tube to dab crests along the small ocean waves.

RENDERING SOFT EDGES

Flowers are one of the most exquisite subjects an artist can paint. With a little planning, you can transform any arrangement into a stunning work of art. Take a few minutes to work out the best composition, colors, and background. These templates will help you feel confident in achieving your finest work.

PALETTE
- Cerulean blue
- Lemon yellow
- Quinacridone rose
- Phthalo blue

STEP 1 Try to "audition" colors by painting samples onto scrap paper (see "Selecting Mixes" below). Then I paint several quick studies using the chosen colors with different backgrounds (see left). Once you've selected your color palette, create a line drawing of the subject above.

SELECTING MIXES

| cerulean + rose | cerulean + alizarin | cerulean + lemon | rose + phthalo | rose + cobalt |

STEP 2 Paint masking fluid around the outer edges before wetting the entire background. Then drop in diluted colors—rose and yellow at the top, rose and cerulean blue on the right, and cerulean blue and yellow at the bottom. Mix the colors, and allow them to blend by tilting the painting. If an area begins to dry, mist it with a spray bottle. Then spatter yellow with a toothbrush.

 Use a palette for mixing to avoid contaminating your colors.

STEP 3 Once dry, peel off the masking and work on the flowers. Keep each color—rose, yellow, and cerulean blue—separate, and use only clean water. Apply a light wash of color.

STEP 4 Wet the entire vase with clean water, drop in cerulean blue and a purple mixture on the left side, and tilt the painting to blend. After the vase area is dry, use a light green wash made from both the blues and yellow to cover the leaves. Mixing phthalo blue, yellow, and a bit of rose in varying proportions will create every shade of green needed for the leaves. Beginning with the shadowed areas, paint one leaf at a time. Work on dry paper, and paint the shadows with graded washes to achieve soft dark-to-light transitions.

 Eliminate hard edges on flowers and leaves by rewetting the hard edge with the tip of a small brush and then dabbing it with a paper towel to soften.

STEP 5 Give the vase another wash of cerulean blue and purple, again working wet-into-wet. Now finish the flowers. Work the values so that light flower edges are against dark leaves and dark flower edges are against light colors to create maximum visual impact. Keep your colors bright and pure by layering shadow colors and never mixing more than two primary colors at a time. For example, layer yellow tulip shadows with light washes of rose and yellow (orange), rose and cerulean (purple), or yellow and cerulean (green).

A gradated (or graduated) wash moves slowly from dark to light. Apply a strong wash of color and stroke in horizontal bands as you move away, adding water to successive strokes.

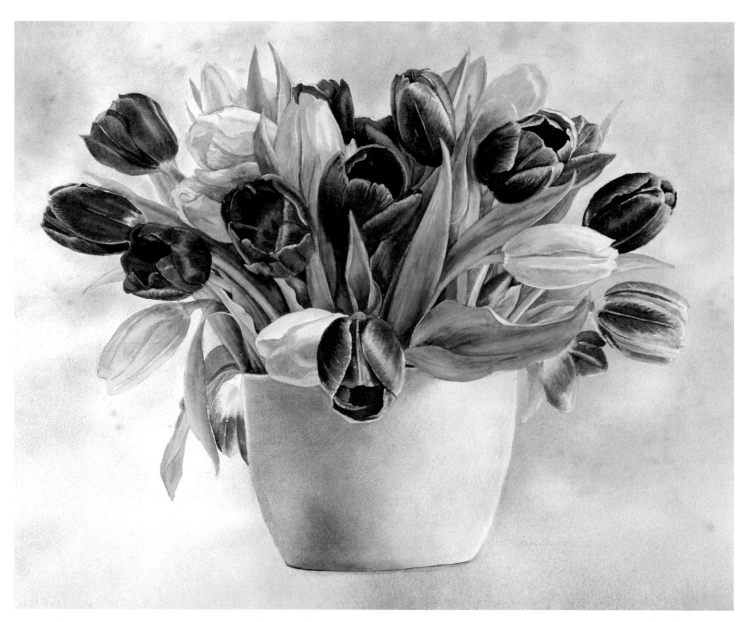

STEP 6 Wet the vase again before dropping in a final layer of blue and purple. Once dry, paint a small shadow under the edge (darker on the left side) so the vase doesn't appear to be floating. Use white ink to clean up ragged edges and add tiny highlights to a few leaf and flower edges.

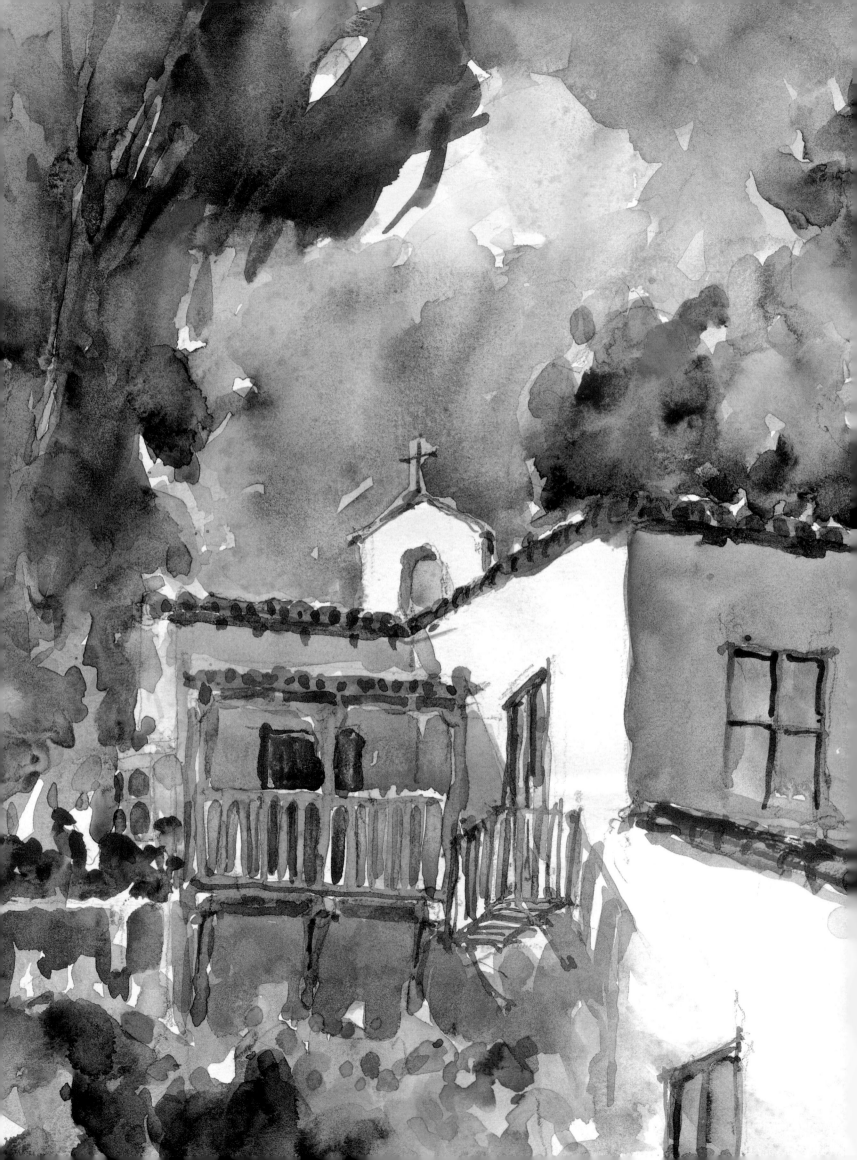

COLOR BASICS

Color is a universal gift of beauty. Because it requires no effort to perceive and enjoy it, we often take it for granted. However, its absence in our lives is unthinkable. But what exactly is color? More specifically, how do we understand it, organize it, and harness its power in a manner that helps us create, communicate, and express? The more you know about color organization and mixing, the more you will be equipped to achieve your unique artistic goals in any medium.

COLOR

A fundamental knowledge of color can assist you in clearly expressing yourself in your art. Color helps communicate feelings, mood, time of day, seasons, and emotions. Knowing how colors work, and how they work together, is key to refining your ability to communicate using color.

THE COLOR WHEEL

A color wheel is a visual representation of colors arranged according to their chromatic relationship. The basic color wheel consists of 12 colors that can be broken down into three different groups: primary colors, secondary colors, and tertiary colors.

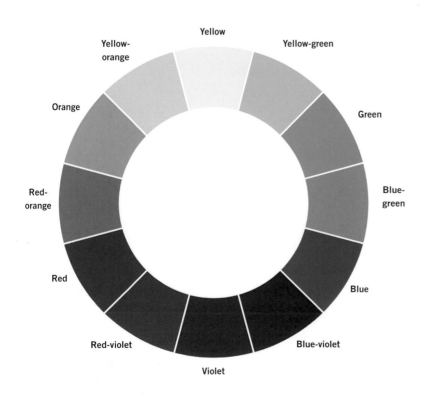

One of the easiest things to create is a 12-color color wheel with just the three primaries: red, yellow, and blue. All colors are derived from these three. Beginners should mix a color wheel with both the primaries and secondaries. This can help you understand how to create additional colors, see how colors interact, indicate if you have too many colors (do you really need five reds?), and see your palette of colors in spectrum order.

Color wheel made with three primaries

Color wheel made with primaries and secondaries

THE BASICS OF COLOR

PRIMARY COLORS

The primary colors are red, yellow, and blue. These colors cannot be created by mixing any other colors, but in theory, all other colors can be mixed from them.

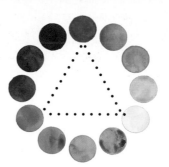

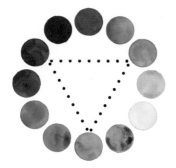

SECONDARY COLORS

Secondary colors are created by mixing any two primary colors; they are found in between the primary colors on the color wheel. Orange, green, and purple are secondary colors.

TERTIARY COLORS

If you mix a primary color with its adjacent secondary color, you get a tertiary color. These colors fill in the gaps and finish the color wheel. Tertiary colors are red-orange, red-violet, yellow-orange, yellow-green, blue-green, and blue-violet.

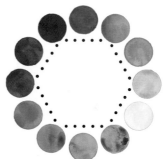

COLOR SCHEMES

Choosing and applying a *color scheme* (or a selection of related colors) in your painting can help you achieve unity, harmony, or dynamic contrasts. This page showcases a variety of common color combinations. Explore these different schemes to familiarize yourself with the nature of color relationships and to practice mixing colors.

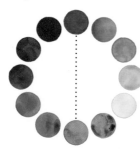

COMPLEMENTARY COLOR SCHEMES
Complementary colors are opposite each other on the color wheel. Red and green (shown above), orange and blue, and yellow and purple are examples of complementary colors. When placed adjacent to each other in a painting, complements make each other appear brighter. When mixed, they have the opposite effect, neutralizing (or graying) each other.

TRIADIC COLOR SCHEME This scheme consists of three colors that form an equilateral triangle on the color wheel. An example of this would be blue-violet, red-orange, and yellow-green (shown above).

TETRADIC COLOR SCHEMES Four colors that form a square or a rectangle on the color wheel create a tetradic color scheme. This color scheme includes two pairs of complementary colors, such as orange and blue and yellow-orange and blue-violet (shown above). This is also known as a "double-complementary" color scheme.

ANALOGOUS COLOR SCHEMES Analogous colors are adjacent (or close) to each other on the color wheel. Analogous color schemes are good for creating unity within a painting because the colors are already related. You can do a tight analogous scheme (a very small range of colors) or a loose analogous scheme (a larger range of related colors). Examples of tight analogous color schemes would be red, red-orange, and orange; or blue-violet, blue, and blue-green (shown at left). A loose analogous scheme would be blue, violet, and red.

SPLIT-COMPLEMENTARY COLOR SCHEMES This scheme includes a main color and a color on each side of its complementary color. An example of this (shown at left) would be red, yellow-green, and blue-green.

COLOR TEMPERATURE

Divide your color wheel in half by drawing a line from a point between red and red-violet to a point between yellow-green and green. You have now identified the warm colors (reds, oranges, and yellows) and the cool colors (greens, blues, and purples). Granted, red-violet is a bit warm and yellow-green is a bit cool, but the line needs to be drawn somewhere, and you'll get the general idea from this. In a painting, warm colors tend to advance and appear more active, whereas cool colors recede and provide a sense of calm. Remember these important points about color temperature as you plan your painting.

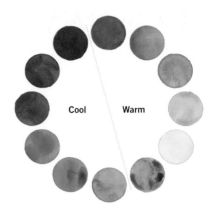

MOOD AND TEMPERATURE

We are all affected by color, regardless of whether we realize it. Studies show that color schemes make us feel certain ways. Warm colors, such as red, orange, yellow, and light green, are exciting and energetic. Cool colors, such as dark green, blue, and purple, are calming and soothing. Use these colors schemes as tools to express the mood of the painting. In fact, you'll find that you don't even need a subject in your painting to communicate a particular feeling; the abstract works below demonstrate how color is powerful enough to stand on its own.

WARM PALETTE What is this painting of? Who knows! It doesn't matter. The point here is to express a mood or a feeling. Here the mood is hot, vibrant passion. Energetic reds and oranges contrast the cool accents of blue and purple.

COOL PALETTE A much different feeling is expressed in this painting. It is one of calm and gentle inward thought. The red-orange accents create an exciting counterpoint to the overall palette of cool greens and blues.

Color isn't the only thing that affects mood. All parts of the painting contribute to the mood of the piece, including the brushstrokes and line work. Keep these points in mind as you aim for a specific feeling in your paintings.

UPWARD STROKES (heavier at the base and tapering as they move up) suggest a positive feeling.

VERTICAL STROKES communicate force, energy, and drama.

DOWNWARD STROKES (heavier at the top and tapering as they move down) suggest a more somber tone.

HORIZONTAL STROKES denote peace and tranquility.

CONVEYING MOOD WITH COLOR

In addition to warm and cool palettes, bright and dark palettes also work well for conveying a mood. A bright palette consists of light, pure colors with plenty of white paper showing through. This gives the effect of clean, positive, uplifting energy. Darker, saturated colors covering most of the paper suggest a more serious tone—a mood of quiet somberness and peace.

BRIGHT PALETTE The pure, warm colors with plenty of white paper showing through expresses the cheer of this light-hearted scene. Complementary colors (e.g., red against green or yellow against purple) also help enliven the story.

DARK PALETTE The darker colors in the cool range communicate a heavier mood. Here I used an analogous color scheme of cool, darker colors to indicate the quiet end of the day and the approaching night.

A painting should be primarily one temperature—either warm or cool. There should be a clear, simple message in each painting with a minimum of variables. Also, you don't want to confuse the viewer with uncertainty. However, warm accents in a cool painting (and vice versa) are certainly acceptable and encouraged. Remember, you want your statement to be exciting but clear.

ACCENTING WARM AND COOL PALETTES These two examples feature warm and cool colors almost exclusively. The warm painting (left) suggests a hot summer day with energy in the air, and the cool painting (right) recedes into quiet and suggests a winter afternoon. Notice that in each case, complementary accents emphasize the color theme with contrast.

COLOR PROPERTIES

The properties of color are hue, value, and intensity. When you look at a color, you will see all three properties. Hue is the name of the color, such as red, yellow, or blue. Value refers to how light or dark a color is. Intensity is the color's brightness or dullness.

HUE

Hue refers to the color name. Here are some examples of blue hues.

Phthalo blue:
a greenish blue

Cobalt turquoise light:
a bright, greenish blue

Cerulean blue:
a bright, grayish blue

Ultramarine blue:
a cool, reddish blue

Cobalt blue:
a pure blue

VALUE

Value refers to the lightness or darkness of a color (or of black). Variations of color values are an important tool for creating the illusion of form and depth in your paintings. Colors have their own inherent value; squint at a color wheel and you'll see light colors, such as yellow, and dark colors, such as purple. In addition, each color has its own range of values. With watercolor, add water to lighten the value (creating a tint of the color), or add black to darken the value (creating a shade of the color).

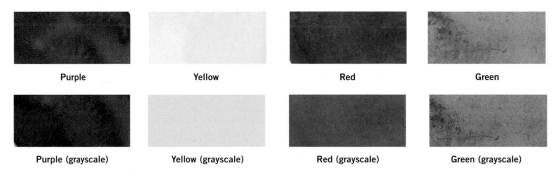

Purple **Yellow** **Red** **Green**

Purple (grayscale) **Yellow (grayscale)** **Red (grayscale)** **Green (grayscale)**

ASSESSING THE VALUE OF COLOR Above are colors from the color wheel (top row) and how they appear in grayscale (bottom row). Viewing them in this manner reveals the true value of each color without any visual distractions. As you can see, purple is very dark, yellow is very light, and red and green are similar medium values.

CREATING VALUE SCALES Get to know the range of lights your paint colors can produce by creating a few value scales. Working your way from left to right, start with a very strong wash of your color and add more water for successively lighter values.

INTENSITY

Intensity refers to the purity (or saturation) of the color. Colors right out of the tube (or as they appear on the color wheel) are at full intensity. To change the intensity of watercolor paint, you can dull the color (or gray it) by adding its complement, gray, black, white, or water. Although adding black or water changes the value of the color, it also neutralizes it, dulling it and making it less intense.

Ultramarine blue right out of the tube at full intensity

Ultramarine blue dulled with water

Ultramarine blue dulled with burnt umber

COLOR AND VALUE

For most paintings to be successful, there should be a good value pattern across the painting, which means a clear and definite arrangement of dark, middle, and light values. This will create an effective design, which is pleasing to the eye. It also helps communicate the point of your painting in a clear and uncluttered manner. Keep in mind that these values should not be equal in a painting but rather predominantly light or dark. Equal amounts of light and dark result in a static image that lacks movement, drama, and—most important—interest.

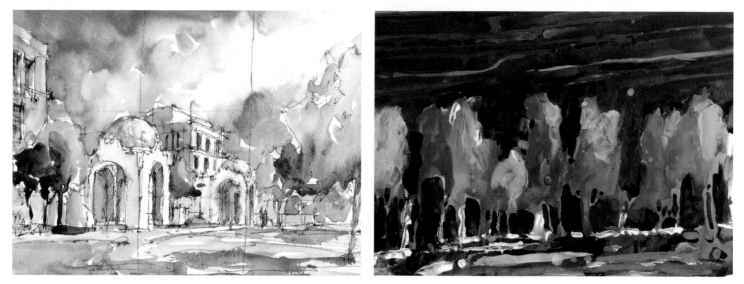

Predominantly light painting Predominantly dark painting

A good exercise is to make a black-and-white print of your painting. Does it read well? Can you see a separation of elements and objects without having to rely on the colors? If so, good job—your values are working for you. Too often we rely on the colors to get the point across, and we are disappointed when it doesn't happen.

To demonstrate the importance of value, the same painted scene appears three times (see below). The painting at the far left uses the appropriate colors and values. The middle painting uses the correct colors, but its values are similar to one another. The painting at the right uses the correct values, but all the wrong colors. Which of these makes a better painting—the image at center or the image at right? (Hint: The one with the correct values, at right).

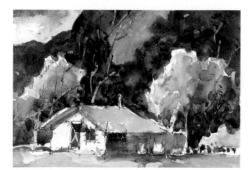

Correct colors, correct values

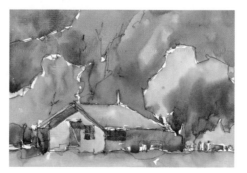

Correct colors, incorrect values

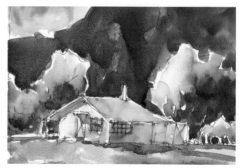

Incorrect colors, correct values

COMPLEMENTARY COLORS

When placed next to each other, complementary colors create lively, dramatic contrasts that can add interest and excitement to a painting. In contrast, you can also mix in a little of a color's complement to dull the color. For example, mute a bright red by adding a little of its complementary color, green.

PAIRING COMPLEMENTS When complementary colors appear together in nature, they create striking scenes—for example, red berries among green leaves, an orange sun against a blue sky, or the yellow center of a purple iris.

CONTRASTING COLORS

When light values are placed next to dark values, the effect can be strong and dramatic. Pairing contrasting complementary colors in a painting creates a visual vibration that excites the eye.

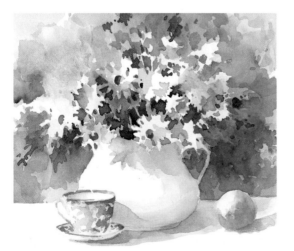

LIGHTING THE SUBJECT Another benefit to working indoors is lighting control. Artificial lighting lets you work at night or on rainy days. And with artificial light, you can manipulate the direction and strength of the light source for interesting shadows. You may want to use natural light—such as light from a window—when indoors; but natural light can interfere with artificial light, so it's best to use only one.

MAKING ELEMENTS "POP" In this floral painting, notice the way placing a yellow iris against a background of greens, blues, and purples gives the colors a jewel-like quality and adds vibrancy. The contrast between the complementary colors, yellow and purple (paired with harmonious blue and green), makes the irises "zoom" forward.

COLOR SCHEMES IN PAINTINGS

Color schemes are combinations of colors that create an appealing visual dynamic. There are many types of color schemes, several of which are shown below. Some schemes create contrast and excitement; others create harmony and peace. Keep in mind that each scheme affects the subject of a painting differently, so it's important to assess your goals and select a color scheme before you begin painting. Also, note that color schemes are a general way of categorizing the dominant colors used in a painting; not every single color used in a painting has to be straight from the selected color scheme.

COMPLEMENTARY COLOR SCHEME The dominant colors in this painting are yellow-orange and blue-violet, which lie opposite each other on the color wheel. The artist has placed these two colors adjacent to one another throughout the still life, which makes the complements appear especially vibrant.

TRIADIC COLOR SCHEME This scheme combines three colors that are evenly spaced apart on the color wheel. Using all three of these colors in equal weight can overwhelm the viewer, so it's best to allow one color to be more prominent (such as the green in this painting).

ANALOGOUS COLOR SCHEME This harmonious scheme combines colors that are adjacent to one another on the color wheel, so they are all similar in hue. In this particular instance, the artist has muted (or grayed) all of the colors to communicate the quiet and solitude of diffused, early morning light.

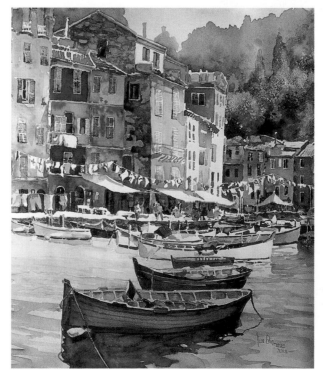

TETRADIC COLOR SCHEME This color scheme involves two pairs of complements (such as red-orange/green and yellow-orange/blue-violet), creating a square or rectangle within the color wheel. The complements vibrate against one another and produce a colorful scene full of life. Notice how this dynamic makes the flowers seem to "pop" from the background.

SPLIT-COMPLEMENTARY COLOR SCHEME This scheme combines a color (in this case, blue) with two colors adjacent to its complement (yellow-orange and red-orange). The scheme retains a hint of the vibrant interplay of a complementary scheme but includes more variety in hue.

PRIMARIES

Bold and basic, the primaries are the fundamental colors of the color wheel. Using predominantly primary colors to create a work of art yields dynamic and accessible results. Because they are equidistant on the color wheel, they create a triadic color scheme.

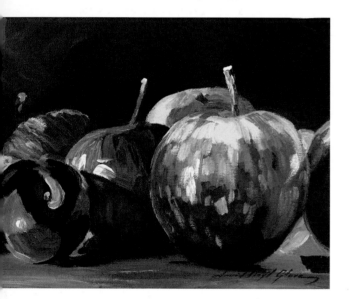

USING PRIMARIES TO CREATE SECONDARIES

You may know that red and yellow make orange, blue and yellow make green, and blue and red make purple, but the actual possibilities are a little more complex! You can blend them to create secondary colors, tertiary colors, and neutral colors, but you cannot create primaries using other colors. Below are a few basic guidelines for creating secondaries, along with a few sample mixes to get you started.

ORANGES Mixing cadmium yellow, cadmium red, and titanium white produces a wide range of basic oranges.

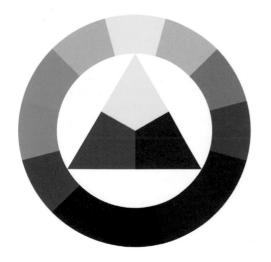

GREENS Blends of cadmium yellow and phthalo blue produce a range of bold and vibrant greens.

VIOLETS A mix of phthalo blue and cadmium red yields a beautiful variety of purples and mauves.

PAINTING WITH PRIMARIES

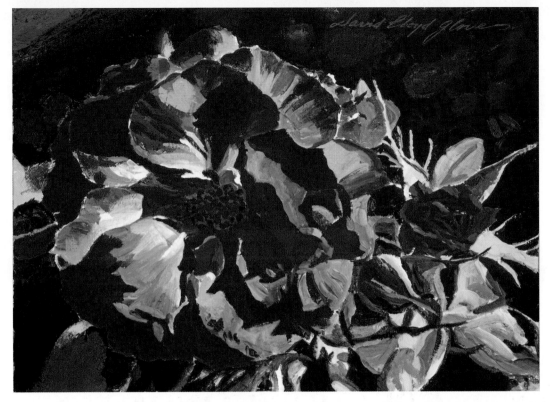

WORKING WITH REDS To create this bright rose, mix and apply several red shades to describe the dimension, shape, and lighting. Use cadmium red as the base, blending with titanium white for the lights and dioxazine purple for the shadows. The complementary green leaves make the red appear even more vibrant.

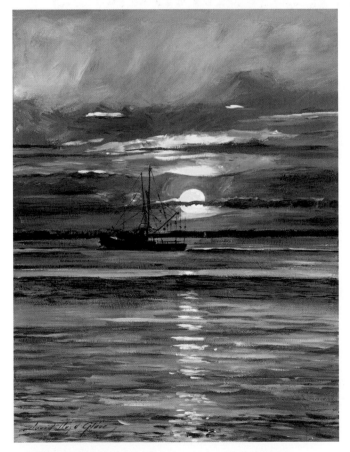

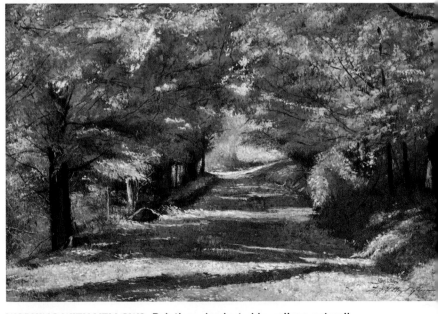

WORKING WITH YELLOWS Paintings dominated by yellows naturally result in warm paintings. Every color in this painting is in the warm hemisphere of the color wheel, with the exception of the cool blue sky peeking through the trees. Use only primary colors and titanium white, along with dioxazine purple to create the shadows.

WORKING WITH BLUES Blues create a sense of depth, serenity, and atmosphere. The complementary bright yellows and oranges of the sun and surrounding clouds make the warm blues appear even more intense to the eye.

SECONDARIES

Like primaries, secondaries form a triadic color scheme when used together in a painting. Lying equidistant on the color wheel, each color helps bring out the others, and together they allow for dusky tones that still retain impact.

WORKING WITH SECONDARIES

Secondary colors add dimension to the color wheel with three festive hue families—violet, green, and orange. Each of these colors is a mix of two primary colors. Violet is a combination of red and blue, green is a combination of blue and yellow, and orange is a combination of yellow and red. When mixing secondaries for a painting, consider the following: Mixing colors that lean toward each other on the color wheel will create vibrant results. Mixing colors that lean away from each other on the color wheel will create muted results. Both vibrant and muted colors have a place in painting, so it's best to master both styles of mixing to find color combinations that suit your subject and style.

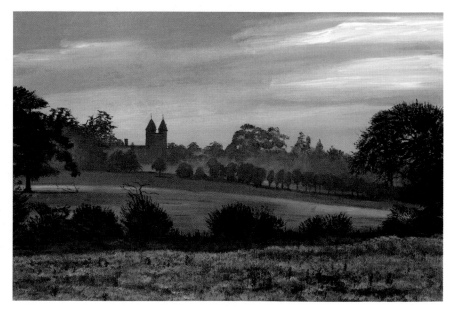

COMMON GREEN PIGMENTS

Green is a fresh, cool-leaning color that suggests fertility and nature, ranging from deep, earthy tones to the bright greens of spring. Below are a few common paint colors shown in masstone (with thickness), undertone (spread thinly), and mixed with white.

PHTHALO GREEN is a cool, blue-leaning green.

MOSS GREEN, which is similar to sap green, has a vibrant, orange-leaning undertone. This is a wonderful tool for painting foliage.

CHROMIUM OXIDE GREEN is cool, earthy, muted, and very opaque.

COBALT GREEN is a vibrant, blue-leaning green pigment.

For most colors, pushing a mix toward red warms the color, and pushing a mix toward blue cools it. Green, however, is the complement of red, so push warm greens toward yellow and cool greens toward blue.

Working with Greens

To make a primarily green painting appear colorful yet realistic, make sure your greens vary in temperature and tone. Use warm greens alongside cooler shades to establish dimension and visual interest.

COMMON VIOLET PIGMENTS

Violet is the darkest hue on the wheel and is quite versatile in its associations; its deepest, richest forms suggest royalty and strength, whereas its lightest tints and muted tones appear dreamy and feminine.

DIOXAZINE PURPLE is a cool, transparent, staining pigment that has a very dark masstone and an intensely vibrant undertone.

COBALT VIOLET Is a popular medium-violet pigment that creates soft, muted tints.

QUINACRIDONE MAGENTA is on the cusp of the purple family near red, resembling the hue of magenta ink.

Dioxazine purple is a versatile mixing tool often used to deepen colors in place of black. However, use this pigment with some restraint, as it can quickly overpower a mix.

Working with Violets

Create depth and dimension by incorporating a variety of purples. The warm and cool purples work together to excite the eye as they suggest light and shadow. Use dioxazine purple for the deepest colors, cobalt violet for the highlights, and ultramarine blue to deepen and shape the flower clusters.

COMMON ORANGE PIGMENTS

Orange is a bold, warm, and invigorating color often associated with fire and autumn. Its hues can be deep and fiery or pale and delicate, like apricots or light skin tones.

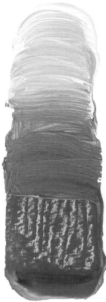

PERINONE ORANGE is an intense, red-leaning orange that thins to produce beautiful, transparent washes for florals or skin-tone mixes.

QUINACRIDONE BURNT ORANGE is a transparent, deep, rich orange that resembles a neutral reddish brown.

CADMIUM ORANGE is a premixed paint color of cadmium red and cadmium yellow pigments.

Working with Oranges

In this palette knife painting, a wide range of oranges is used to suggest the landscape. A complementary blue is used in the sky for a vibrant visual dynamic, and the tree is accented with dabs of bright green to complement the deep red-oranges of the tree.

NEUTRALS

Neutrals encompass browns, grays, and a range of muted tints, tones, and shades. Pure hues, such as blue or green, tend to receive more attention, but neutrals are in fact more prominent in our day-to-day lives. They are easy on the eyes—soft, soothing, and atmospheric—and they can serve to help pure hues appear more vibrant.

The muted colors of this classic landscape suggest a light, airy atmosphere. Although the mind still reads some areas as vivid color, such as the complementary reddish brown tree and green bushes, the colors are softened and neutralized for a unified, subtle appearance.

WORKING WITH BROWN

Browns are earthy mixes of the three primary colors in varying proportions. Tints, tones, and shades of brown can range from pale tans and ruddy terra-cottas to deep chocolates and rich skin tones. Although browns do not have a place on the traditional color wheel, they play an important role in painting.

MIXING NEUTRALS

Neutrals are blends of all three primaries: red, yellow, and blue—plus white when desired for softening and lightening. To create neutrals that lean warm or cool, simply adjust the proportions of your pigments. Red- and orange-leaning neutrals appear much warmer than blue- or green-leaning neutrals. Experiment with the pigments on your palette to discover the wide range of neutrals at your fingertips.

Cadmium red medium, cadmium yellow medium, and ultramarine blue combine to create a range of rich neutrals.

Using the same primary colors, add white for a range of softer tones. Add more blue for darker, cooler mixes, and add more yellow and white for lighter mixes.

For a warm brown, try mixing red and yellow with just a touch of blue in the bristles.

In this example, the top mix contains more yellow, whereas the bottom mix contains more red.

For cool browns and grays, blend yellow, blue, and white with just a touch of red in the bristles.

WORKING WITH BLACK

Not considered a hue on the color wheel, black is just black—right? Not exactly,
There are differences in appearance, consistency, and mixability among black
pigments. Some artists choose to avoid blacks and grays altogether by mixing them
for a more natural look (see below).

MIXING BLACKS

Black pigments tend to look unnatural and flat set
against the rest of a color palette. However, mixed
blacks (or deep, dark colors) often suit the overall
color balance of a painting. Mixed blacks have a subtle
sense of color and depth, which help create deep, lively
shadows with dimension.

Using black to deepen or neutralize a
color can overwhelm and deaden the
other pigments in a mix. Remember, a
little dab goes a long way.

Mixing equal parts burnt sienna and
ultramarine blue yields a dark, earthy
black with a slight hint of blue.

Blending cadmium red medium with
dioxazine purple yields a red-leaning
black, which can be used for tree
branches and trunks.

Cobalt violet and phthalo green
creates an effective cool black for the
deepest ocean colors in seascapes.

Mixing equal parts cerulean blue and
crimson red gives a deep, purple-leaning
black. As more red is added, the mix
becomes more of a dark brown.

MIXED MEDIA

Mixed media refers to the use of more than one medium to produce a work. Mixed media art is about trial and error, passion and purpose, imagining and discovering. This style of art allows artists of all ages to create, using tools and supplies they can find just about anywhere. Simply trying different techniques and mediums helps you discover what works and what doesn't. You have the freedom to create as you wish and to explore as you choose, and you will learn about the different mediums along the way.

TOOLS & MATERIALS

Each of the mixed media techniques in this section incorporates its own unique set of tools and materials; however, the following pages cover the traditional art supplies you'll need to complete each project. All of the other unique materials you'll need will be described within each mixed-media technique.

DRAWING SUPPLIES

Drawing Pencils

Artist's pencils contain a graphite center and are sorted by hardness (or grade) from very soft (9B) to very hard (9H). A good starter set includes a 6B, 4B, 2B, HB, B, 2H, 4H, and 6H.

Paper

Drawing paper is available in a range of surface textures: smooth grain (plate finish and hot pressed), medium grain (cold pressed), and rough to very rough. Rough paper is ideal when using charcoal; smooth paper is best for watercolor washes. The heavier the paper, the thicker its weight. Thick paper is better for graphite drawing because it can withstand erasing better than thin paper.

Colored Pencils

There are three types of colored pencils: wax based, oil based, and water soluble. Oil-based pencils complement wax pencils nicely. Water-soluble pencils have a gum binder that reacts to water in a manner similar to watercolor.

Art Pens

There are a number of ink, gel, indelible, and poster-paint art pens on the market that are useful for rendering fine details in your mixed-media projects. Experiment with a variety of pens to see which ones you like best for your particular projects.

Erasers

There are several types of art erasers. Plastic erasers are useful for removing hard pencil marks and large areas. Kneaded erasers can be molded into different shapes and used to dab an area, gently lifting tone from the paper.

Watercolors

Watercolors come in pans or tubes. Tubes contain moist, squeezable paint and are useful for creating large quantities of color. Artist-quality watercolors are made with a higher ratio of natural pigments to binders, so they are generally brighter in appearance. Student-quality watercolors use more synthetic pigments or mixes of several types of pigments.

Pastels

Pastels come in oil pastels; hard, clay-based pastels; and soft pastels, which are chalklike sticks. Soft pastels produce a beautiful, velvety texture and are easy to blend with your fingers or a soft cloth. Pastels are mixed on the paper as you paint; therefore, it's helpful to have a range of colors in various "values"—lights, mediums, and darks—readily available.

Brushes

The three basic brush styles are flats, rounds, and filberts. Large and medium flats are good for painting washes and filling in large areas. Smaller flats are essential for detail work; drybrushing; and making clean, sharp edges. Larger rounds and filberts are useful for sketching outlines and general painting, whereas the smaller sizes are essential for adding intricate details. Brushes are grouped by hair type (soft or stiff and natural or synthetic), style, and size. Always wash your brushes after using them; then reshape the bristles and lay them flat or hang them to dry. Never store brushes bristle-side down.

Acrylics

Acrylic paints come in jars, cans, and tubes. Most artists prefer tubes, as they make it easy to squeeze out the appropriate amount of paint onto your palette. Acrylic is a fun medium. It dries much faster than oil, making it easier to paint over mistakes, although it's less forgiving when blending. As with other types of paint, acrylics come in artist and student grade. Artist-grade paints contain more pigment and produce truer colors than student-grade paints, which contain more filler. Most mixed-media artists work with acrylic paints. In addition, there are a number of acrylic mediums, including glazing, thickening, dispersing, and texturing mediums, that can help you achieve a range of effects.

Other Art Essentials

Other tools you may want to have on hand include a ruler, artist tape, art markers and crayons, blending stumps, a pencil sharpener, and a utility knife for cutting drawing boards.

PAINTING BACKGROUNDS

In mixed media, backgrounds can be considered as works of art in themselves. Here are a few basic painting techniques that can be used to create backgrounds for your mixed media artwork.

SCUMBLING & STIPPLING

To scumble, use just a little bit of paint on an old, dry brush. Push and spread the paint around, creating a thin layer (left side of image). To stipple, use the same dry brush in a soft bouncing motion, again with a minimum of paint, splaying the bristles as you bounce the brush (right side of image).

Using scumbling and stippling techniques, mix two or more colors as you move around the surface. There is no need to change brushes, as this creates new and interesting colors as you go. Use white or black to lighten or darken areas as desired.

SCRAPING

Squeeze two or three colors of paint onto your surface and spread it around by scraping across the surface with a credit card or palette knife. You can also draw lines in your paint with the edge of the card, or push it more to create interesting designs.

ROLLING PAINT

Squeeze a little paint directly onto your surface. Spread the paint with a paint roller or brayer, moving in different directions. Try using several separate colors going in different directions!

A brayer is a hand roller typically used in printmaking techniques. Brayers are made of rubber or foam and can be purchased at your local supply store.

WASHES

Use water with acrylic paint to create a wash. First mix water and acrylic paint 90/10, and then wash over other colors or papers with a soft brush. You can use your washes in a variety of ways—as a background or over any of several methods used to create a substrate. You can create a finished piece by stenciling, stamping, and/or drawing over the dry wash and adding focal-point images.

GEL PRINTING

The Gelli Arts™ Gel Printing Plate has the same sensitive surface as gelatin but is easier to use and store than gelatin printing plates. This printing plate is nonperishable, nontoxic, has a sensitive surface that is always ready for printing, and is easy to clean!

Follow the simple instructions with Gelli Arts™ gel plate to create interesting painted backgrounds. Spread paint on the plate with a brayer; then draw in the paint or use mark-making tools or stencils to create designs. Lay paper (watercolor paper works great) on the surface. Press down while the paint is wet to impress the image.

BORDERS & EDGES

Artists often ignore the edges of their works; however, borders and edges can enhance certain themes or create a unique frame. Adding borders or otherwise finishing off the edges of a work also creates visual interest in a piece.

CUT AND TORN EDGES

Hard edges are created using a mat knife, rotary cutter, or paper trimmer. When cutting, cut along the outside of the ruler so the artwork will not be damaged. Thick, textural pieces may take several cuts.

Tearing can be done with wet or dry paper. Dry tearing creates an even edge, whereas wet tearing creates a deckled effect. For wet tearing, watercolor paper works best.

BURNED EDGES

Light the edge of a torn-edge sheet of watercolor paper with a lighter, one inch at a time, making sure the flame is extinguished before moving on.

COLORED EDGES

Colored accents can be added to torn or sharp edges using several mediums.

Lightly apply paint to edges using a blunt, short-bristled brush (top left) or a cosmetic sponge (top right).

Lightly apply Rub 'n Buff® or gilders paste to edges using your fingertips or a soft, lint-free rag.

Use pens and markers to highlight edges. Use the side of the nib or a brush-tip pen for best results.

SHARP-EDGE BORDER

Measure and mark a boarder using painter's tape. Brush two layers or acrylic medium or gel on the outside edge, allowing it to dry between layers. Stamp or paint on the edge, allow to dry, and then gently remove the tape.

APPLIED BORDERS

Scraps of painted paper, maps, napkins, and other printed paper materials make unique applied borders. Try using colorful strings, cords, leaves, or twigs for a more natural look.

Colorful strings, cords, and natural objects, including slender leaves and thin twigs, also make excellent borders.

Scraps of painted paper, maps, napkins, and other printed paper materials make unique applied borders.

COLORED BORDER EFFECTS

Dab a little paint on a used dryer sheet or dry baby wipe, and then apply it to the border, creating a sheer-color border effect. Stamped or stenciled borders can be created using a repetitive application or stenciling of found objects, such as a toilet paper role or sponge.

GESSO & MEDIUMS

Discover techniques for working with gesso and mediums to add texture and dimension to your artwork. Layered images, hidden messages, and three-dimensional textures are just a few of the mixed-media techniques you can use to create a personal, one-of-a-kind masterpiece.

FIBER PASTE

Fiber paste is a medium with a dry film that has the appearance of rough, handmade paper. Using a palette knife or spoon, place four to five tablespoons of fiber paste on a sheet of wax paper or acrylic board and add a small amount of acrylic paint. Blend with a palette knife, smoothing the top. Let the fiber paste dry completely. You can use additional paint to decorate the fiber paste with spatters, stripes, polka dots, etc. Once dry, lift the fiber paste off the wax paper and cut into any shape you desire.

MOLDING PASTE & STAMPS

Molding paste, which is great for building surfaces and creating texture, dries to a hard, flexible, opaque film.

STEP 1 Apply a thin layer of molding paste with your palette knife over the area you wish to add texture. Using the stamp of your choice, stamp all over the molding paste. You can stamp randomly or in a consistent pattern.

STEP 2 Once the molding paste is dry, rub paint over the stamped area, using your fingers or a brush. For a more textured look, don't try to fill in all the areas.

Paint drips are a fun way to add a finishing touch to your artwork. Add a small amount of pouring medium to a clean, clear plastic squeeze bottle, and then add paint. Place your finger over the tip and shake vigorously to mix well. When the consistency is right, start adding drips to your artwork.

GESSO & POURING MEDIUM

Pouring medium allows for even, flowing applications of color without cracking and dries to a high-gloss finish. Once dry, it is flexible, non-yellowing, and water-resistant.

STEP 1 Add one part gesso and one part pouring medium (approximately an ounce or two of each) inside a clean tube. With the cap on, shake the tube until the mixture is blended. Then start drawing on your blank substrate with the squirt tube. You can make random shapes or sketch an object.

STEP 2 Allow the mixture to dry completely. Then squirt paint colors randomly over the design.

STEP 3 Use a palette knife, brush, or old credit card to rub the paint over your design, creating texture and dimension.

IMAGE TRANSFER WITH GEL MEDIUM

There's no shortage of resources for images to transfer. Your image can come from a magazine, a catalog, or photograph. To print an image, make sure you print from a digital/laser printer, not an ink-jet printer.

▲ STEP 1 When making an image transfer, your canvas background can be blank or painted with a light color.

◀ STEP 2 Cut out the image that you wish to transfer or slightly rip around the edges to give it an "edgy look." Using a dry brush, apply gel medium to the area where you will place the image. Once you have covered the area, lay the image facedown on top of the gel medium. Remember: your image will be reversed once it has been transferred! Flatten the image as much as possible using an old credit card.

◀ STEP 3 Let dry overnight. Then use a spray bottle, or simply dip your fingertips in water, to start the process of removing the top layer of paper from the canvas. Work at this process until all the paper is gone and you can see the transferred image. Wipe off any paper shavings as you go. You can use a dry paper towel once all of the wet paper has been removed to rub off any dry "fuzz" from the transfer process. Once all of the paper is removed and your image transfer is dry, you can continue creating the rest of your painting (right)!

POWDERED PIGMENT & GESSO

When working with powdered pigments and gesso, just think of it as color tinting your gesso!

STEP 1 Start by mixing gesso and the powdered pigment together. The pigment is richer in color on its own and will only subtly tint the gesso, giving it a grainy texture.

STEP 2 Apply to any area of a painting where you want to add texture, or as a background for a new painting.

CLEAR TAR GEL

Clear tar gel is designed to create a stringy, tarlike substance. It is great for dripping and drizzling over surfaces and becomes stringier the more you mix it.

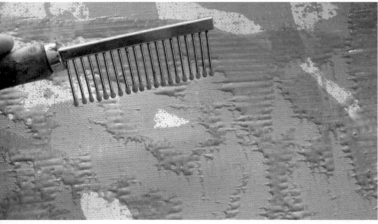

STEP 1 Add a small amount of acrylic paint to the gel and mix it thoroughly. Once mixed, seal the jar and let stand overnight. Drip or pour the tinted gel directly onto your canvas, and go over it with a pet comb or stiff bristle brush.

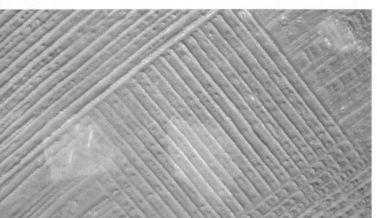

STEP 2 To add texture and dimension, go over these areas in different, crisscrossing directions. Allow the tar gel to dry completely before adding additional color or items to your painting.

HARD MOLDING PASTE

The key to this technique is the background that you have already created. Whatever your background looks like is what will come through when carving out the hard molding paste. Mix acrylic paint with a small bit of hard molding paste, and apply the paste to your painting.

When you are done applying the past mixture, use a rubber shaper to carve out any design you wish—it can even be a shape or word! Once dry, you can leave your piece as is, or you can add more paint.

SPACKLE WITH STENCILS

Spackle is similar to molding paste, but it dries white. The ideas is that you are creating dimension in your artwork! Any type will do—even the kind with sand in it. The spackle in this example is the type that goes on tinted (pinkish-purple) and dries white once it is completely dry. This helps you know when it is okay to move to the next step in your creative process.

GLASS BEAD GEL

Glass bead gel on its own adds unique texture to any artwork.

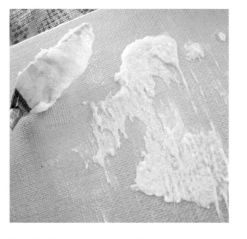

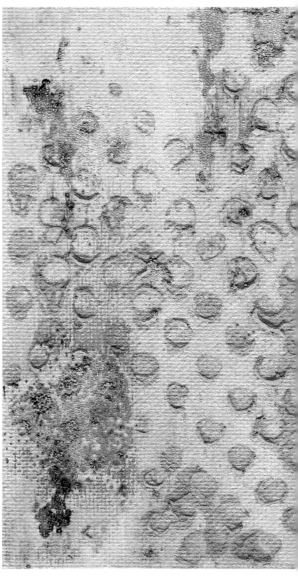

STEP 1 You can start with a blank substrate or have a light color wash as your background before applying the glass bead gel.

STEP 2 Using a palette knife, apply glass bead gel wherever you wish to add texture to your artwork.

STEP 3 Once the glass bead gel is completely dry, you can rub watered-down paint across the texture to add dimension to your artwork. You will notice that after additional color is added the glass bead gel creates one-of-a-kind grooves and crevices.

STAMPING

From carving your own stamps to stamping with acrylic paint, natural objects, sponges, and more— stamping is a popular and fun addition to mixed media art projects. Use stamping techniques extensively to create interest and variety in your backgrounds. In addition to paper, try stamping an assortment of surfaces for different effects.

STAMPING WITH ACRYLIC PAINT

When it comes to stamping, you can use readily available purchased rubber stamps or a variety of man-made found objects. We especially like the effect of a variety of tape spools, coffee cup sleeves, wine corks, and bubble wrap—objects you might use for this technique are limited only by the imagination!

With a paintbrush, brush a small amount of paint on your rubber stamp and press down on your previously painted substrate. Notice how this technique leaves a much different impression than an inked stamp would!

Use the same technique when stamping with man-made found objects, and apply a small amount of paint to your object with a paintbrush. Make sure you wash your tools immediately after stamping!

Use a large piece of cardboard as a place mat beneath your work-in-progress. You can also use it as a palette and to test color; check the amount of paint on your brush; and experiment with your stamps before stamping on your piece.

STAMPING WITH NATURAL OBJECTS

You can also use natural objects as stamps, such as leaves, seedpods, shells, and feathers. Flattened objects will work best.

Next time you visit your local park or walking trail, bring a large envelope or a plastic bag to collect natural objects you can use in your mixed media projects. Remember to respect the environment, and don't collect items from protected areas!

Brush a small amount of paint onto the object and press it on the substrate. You can use a brayer with flat objects to achieve a more crisp impression.

CARVING YOUR OWN STAMPS

You can create custom stamps by carving corks and erasers. You can do this freehand or make a template, lay it on the surface, cut around it, and carve, adding details after you remove the template.

Treat your carved stamps like you would any other. You can brush on a bit of acrylic paint, or you can use an ink pad. Make sure you clean your stamp before the paint or ink dries.

Handmade stamps can be created easily using a variety of household items. Don't be afraid to experiment with other items as stamping tools!

MAKING UNIQUE STAMPS

To make a rolling stamp, use a craft knife to cut pipe insulation foam to the desired length. Insert a wood dowel into the center of the foam. Use a wood burning or soldering tool to cut a design around the foam, barely touching the tip of the tool to the foam. Make sure you work in a well-ventilated area. To use, paint the surface of the foam and roll the dowel across the paper.

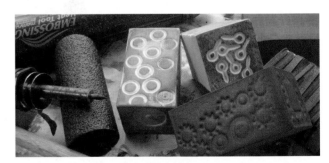

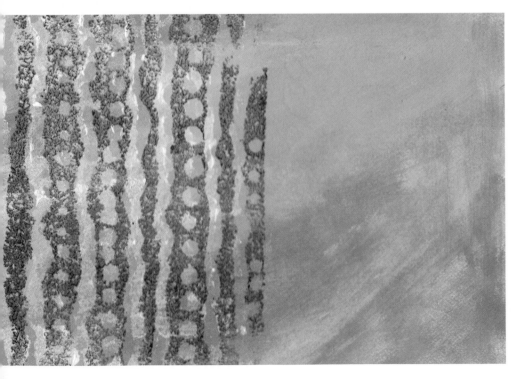

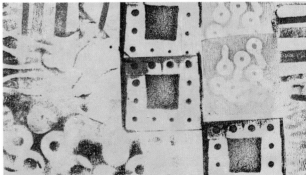

Try making another kind of stamp using colorful children's foam blocks. They are easily found at thrift stores—and all four sides can be used! You can use objects such as pins, paper clips, washers, and buttons to imprint your foam. Spread the objects out on your work surface. Then heat the foam on one side, using the heat tool, for 10-15 seconds. Press the heated side into the object to get an imprint. Use these stamps with waterproof ink pads or acrylic paint. Note that paint makes the foam brittle over time.

STAMPING WITH SPONGES

Keep a collection of both man-made and natural sponges on hand for stamping.

To stamp with a sponge, first lightly spritz with water. Then dab a small amount of paint onto the damp sponge with a paintbrush and stamp onto your substrate.

If some areas don't show up well or you're not happy with the look after you've lifted your stamp, try stamping more on top.

STAMPING ON TISSUE PAPER

Tissue paper and sewing pattern paper are great for stamping with any of the techniques in this section.

You can tear tissue paper or apply it whole to your substrate, using acrylic medium.

STENCILING

When stamping, we use a tool—the stamp—to apply paint or ink. When stenciling, however, we use a blunt, short-bristled brush to force the paint through a tool—the stencil. As with stamping techniques, it is always important to clean your stencil immediately to prolong its use.

DRYBRUSH BOUNCING

With a small amount of paint on a short-bristled brush, bounce the brush over the stencil opening, forcing the paint through. You can use this method for both purchased and found, repurposed stencils.

Before throwing away packaging from items you purchase, look at them carefully to see if parts can be used for stencils or stamps. You may be surprised!

LETTERS & NUMBERS

Letter and number stencils are available in many sizes and font styles and can be used in a variety of ways. Using acrylic paint may be most common, but here are a few other ways:

GLUE STICK RESIST Rub the glue thickly into the stencil opening, and let dry. Then rub over the glue with an ink pad or your brush with a light acrylic wash. Blot the surface with a paper towel to remove excess color from the glue.

ACRYLIC MEDIUM OR GEL RESIST Use the bouncing technique to apply the medium through the stencil. Once dry, apply the color wash and blot excess from medium.

MR. CLEAN® MAGIC ERASER® Paint your substrate first and, while still wet, blot the paint through the stencil with the dampened eraser, pressing firmly to remove, or "erase," the paint.

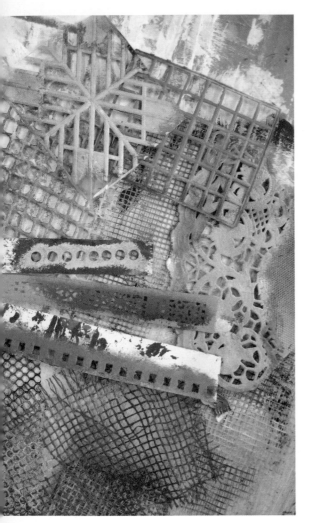

REPURPOSED ITEMS AS STENCILS

The number of items used for this technique can be limitless. Paper doilies, open-work plastic place mats, produce bags, fruit baskets, drywall tape—anything with an open-work design can be used!

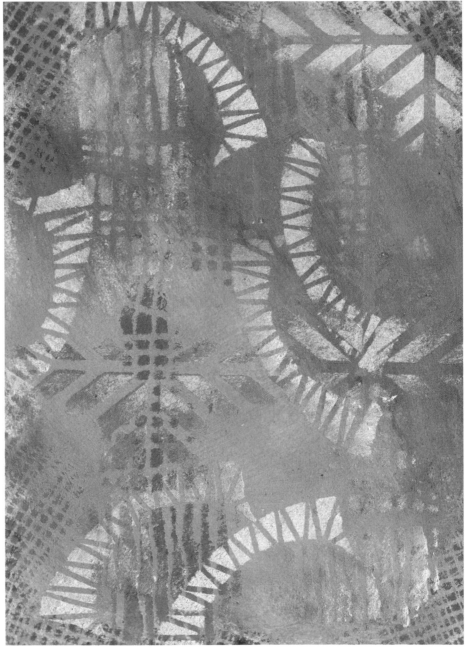

 Many of your repurposed stencil materials can also be used as collage material!

PURCHASED STENCILS & PUNCHANELLA

Using a mix of stencils or parts of stencils and punchanella, you can create design and textural effects for your backgrounds. Use the drybrush bouncing technique, color mixing, and repetition of patterns to create visual interest.

 Punchanella stencils are made from the material that's left over when sequins are punched out of a plastic sheet. You can make your own, or they can be purchased at most art-and-craft stores or online.

ENCAUSTICS

Encaustic is a versatile and forgiving medium, allowing you to "undo" almost anything. It's the process of painting with a mixture of beeswax, resin, and pigment to make paintings or collage with wax instead of glue. Encaustic is compatible with most types of media. Consider combining several techniques to find your own unique look, and don't be afraid to experiment!

GO WITH THE FLOW

You can buy commercial encaustic paints in many colors and thin them with any amount of clear encaustic medium to get the consistency you want and to extend your paint. Simply heat your paint in tins or directly on a pancake griddle at about 200 degrees Fahrenheit and use natural-bristle brushes—synthetic will melt. After you paint on each layer of wax, it must be fused with heat so that it bonds to the layer beneath—usually with a heat gun or torch.

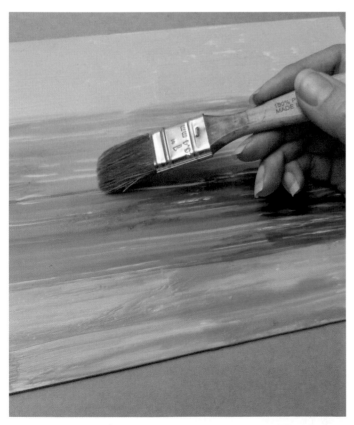

STEP 1 Paint stripes using four to five different colors of encaustic paint. Overlap your stripes a little when painting to create secondary colors.

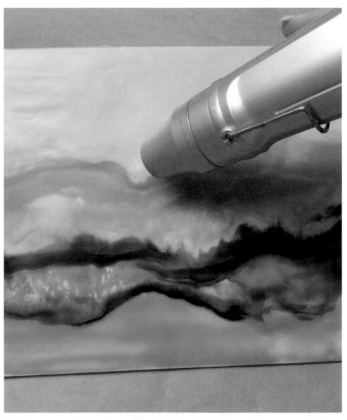

STEP 2 Fuse the stripes with a heat gun while moving around on the board until you create a "landscape."

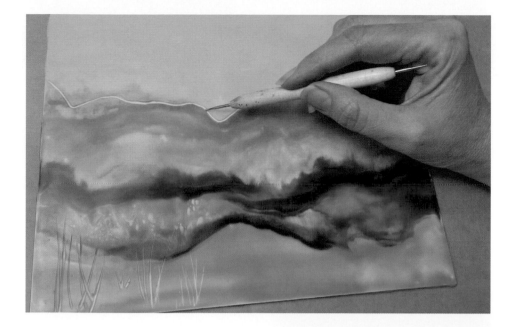

STEP 3 After the wax has cooled you can add more color and fuse again or use a stylus or dull pencil to carve lines into the wax.

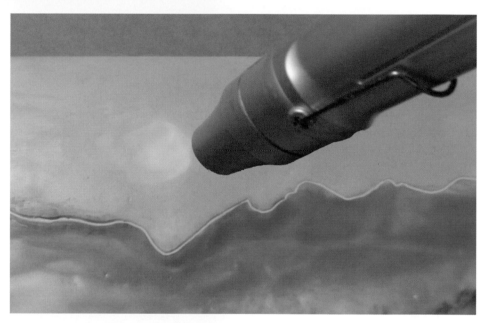

STEP 4 Use the heat gun to blow a "hole" in the wax to create a sun or moon in your landscape.

STEP 5 This technique helps beginners get a good feel for working with wax. Try using it to suggest tree branches, reflections on water, or other organic shapes.

PLAYING WITH
PAPER

There are many ways to play with paper when creating mixed media artwork. Paper may provide you with just a background or supply focal points for the work. Papers might create a picture out of various elements or make a new picture out of several different ones. The key is in the "play."

PAPER SOURCES

Here are some good sources to get started with your paper collection. Be open to all the possibilities for paper ephemera beyond these basics!

Transparent papers, such as tissue (printed and solid), sewing pattern paper, napkins (printed and solid), rice papers

Magazines and catalogs

Purchased papers, such as scrapbook and other specialty papers, origami papers, gift wrap, art papers

Transparent papers, such as tissues, sewing pattern paper, or napkins, can be used like a layer of paint or a wash. Colored images over a printed background add dimension.

Recycled papers, such as newspapers (including foreign language papers), security envelopes, old books and maps, old letters or papers, phone books

HOW TO GLUE PAPER

Use acrylic matte medium on a soft acrylic brush to adhere papers to your substrate. You may also use the medium over the surface of your work, as it will dry clear. With magazine images, it is helpful to spritz them lightly with water to limit wrinkling as you adhere them. For heavy papers, use an acrylic gel in the same manner.

HANDLING PAPER

There are many ways to use paper besides just adhering it straight to your substrate. Try some of these, and see what else you can come up with.

- **Cutting** Cut with regular scissors or those with specialty edges for interesting effects.
- **Tearing** Roughly tear papers or tear along a metal straight edge. White edges of torn magazines will absorb paint. Tear in different directions for different effects.
- **Punching** Use paper punches to create holes or designs in your papers.
- **Burning** Burn the edges of papers lightly with a match or candle flame or scorch in the oven. Keep a tray of water nearby just in case.
- **Wrinkling** Crumple papers and smooth them before adhering to create a crinkly or vintage appearance.

Sections of newspaper, phone book pages, maps, sheet music, etc. can be adhered over the entire substrate and painted with a light wash for a background or underlayer.

MIXED MEDIA

STAMPING, WRITING & STENCILING

Use transparent layers such as tissue papers, sewing pattern paper, and transparent art papers like rice paper. You can also use the layers you've saved from napkins.

RULE OF THREE
This technique is an easy-to-remember compositional gambit. The three elements used are: a focal image, a piece of patterned paper (such as a torn segment of scrapbook paper), and a torn piece of napkin or tissue.

Stamp or stencil on these papers using acrylic paints or waterproof ink pads. When writing, make sure to use a permanent, waterproof pen, available at any art supply store.

These pieces can be used whole over an entire piece or torn and used as accents or collage elements.

PAINTING WITH PAPER

"Painting" with paper can be either abstract or representational in nature and may be done with any of the available papers.

REPRESENTATIONAL Cut or tear papers to represent an image or images. This can be done over the entire substrate or over just a portion of it. Add highlights with paints, pastels, waterproof pens, etc.

It's fun to take images and reassemble them into something either real or surreal and different. You can also add transferred images to the mix!

ABSTRACT Use the color, texture, edges, and transparency of the papers to create a visually pleasing design.

ADDING TEXTURE

Texture—whether physical or visual—provides variation and relief and adds greater impact and interest to your work. Physical texture is something you can feel by running your fingers over it. Visual texture is an illusion you can create with the materials you use while the surface remains flat.

USING GEL MEDIUM

While gel medium is routinely used to adhere heavier-weight elements to a piece, it can also be used to create texture.

STEP 1 Apply the gel with a brush thickly over the surface. You can then create texture with any of your available tools, such as putty knives, credit cards, tape rolls, forks, etc. Let the gel dry completely.

STEP 2 The gel dries as a clear coat, so it can be used either as an underlayer or as a top layer.

USING GESSO

Gesso is an opaque primer that makes surfaces more receptive to paint. To adhere textural elements as an underlayer, first coat the surface with gesso, lay down the textural elements, smooth, and coat again. Add more coats for buildup. Some of the elements you can add are listed here:

- Natural: leaves, seeds and other flat items in nature
- Man-made: cheesecloth or gauze, lace, drywall tape, produce bags, crumpled tissue paper, etc.
- Gesso: drizzle onto the surface to create an interesting textural effect

Drywall Tape

Cheesecloth

Lace

A light wash of color may be used over gesso, gel, or texture paste to enhance the textures.

Use acrylic paint to drybrush stipple and stencil through produce bags or drywall tape, and apply light on dark colors to create the look of texture and depth.

ADDING VISUAL TEXTURE

The appearance of texture can be achieved with paint strokes, dark and light tones, or a vast array of other techniques.

With collage you can use images of texture from magazines and specialty papers to create visual texture.

Spackle and plaster are also good textural materials. You can make marks or embed sand, small beads, and other items in these textures, as with other materials.

Produce bag

ADDING OBJECTS

Use cheesecloth, gauze, drywall tape, screening, produce bags, lace, and other materials to add visual texture and interest. To attach these textural items to your piece use acrylic gel under and over them. Add embellishments, such as flat game pieces, keys, feathers, and coins.

Lace

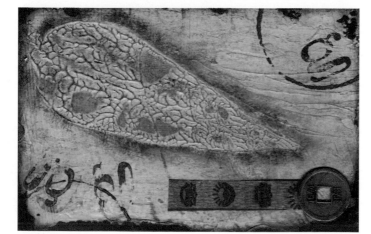
Coin

Reeds

CLOSING THOUGHTS

"I don't say everything, but I paint everything."
—Pablo Picasso

Our minds create images, even before we can find the words to describe what we are thinking and feeling. When we make art, we use this imaginative capacity of the mind to build bridges, connecting thoughts to feelings and ourselves to others. Using line, form, space, texture, and color as our language, we can create a work of art that communicates our ideas. On the other hand, we can change our ideas when we let ourselves forget about the end product and simply use the creative process to relax, focus, and energize ourselves.

Whether you're a seasoned artist or just beginning to explore your artistic side, the tools and materials, lessons, and advice in this book offer you a springboard upon which to find the style and direction that you are most comfortable with. It takes time to find your artistic voice, but with practice and patience you do not have to go searching for it—it will find you. Your style will begin to evolve in the way you draw, apply paint, the colors you choose, and the subjects that inspire you. Becoming an artist is a beautiful, captivating journey that begins with curiosity, determination and a blank canvas.